1977

This book may be kept

FOURTEEN DAYS

A fine will be charged for each day the book is kept overtime.

GAYLORD 142 PRINTED IN U.S.A.

Unofficial Art
in the Soviet Union

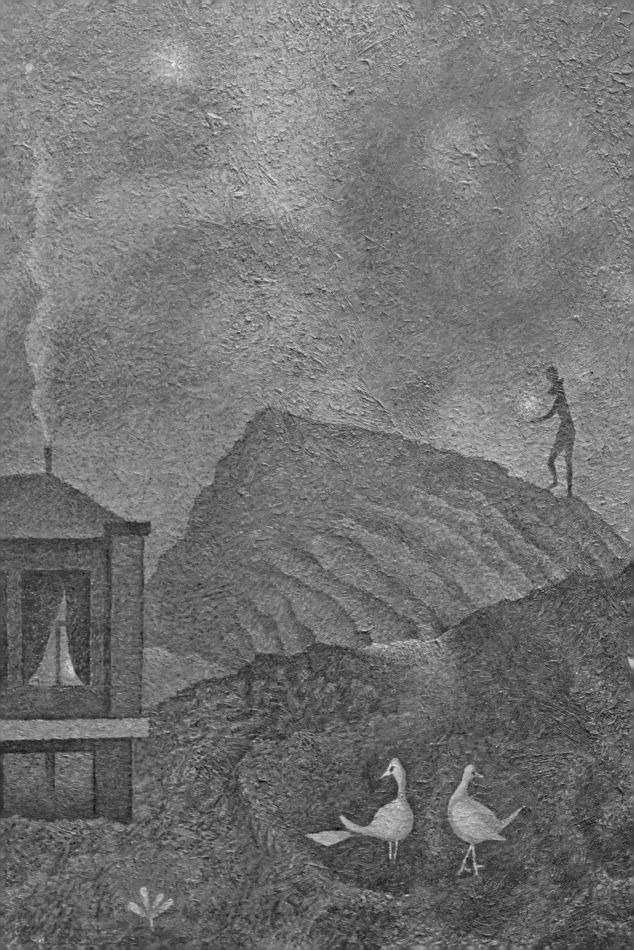

UNOFFICIAL
ART
IN THE
SOVIET UNION

by Paul Sjeklocha and Igor Mead

UNIVERSITY OF CALIFORNIA PRESS

BERKELEY AND LOS ANGELES 1967

Kharitonov, Man With Light **(1962).**
Oil on canvas, 12 x 17".

University of California Press

Berkeley and Los Angeles, California

Cambridge University Press

London, England

Copyright © 1967, by

The Regents of the University of California

Library of Congress Catalog Card Number: 67-28461

Printed in the United States of America

There is no force on earth which could say to art:
"You must take this and not another direction."

Plekhanov

Transliteration and Documentation

THE transliteration system employed here is designed for the convenience of non-Russian readers. Hence, the aim was to approximate the Russian sounds without diacritical marks, superscripts, or apostrophes.

The following transliteration table applies except for certain names such as Alexander or Moscow which are more recognizable in the traditional variation. Names of foreign origin such as Ehrenburg or Johansen are rendered in the version of the country of origin.

а	a	к	k	х	kh
б	b	л	l	ц	ts
в	v	м	m	ч	ch
г	g	н	n	ш	sh
д	d	о	o	щ	shch
е	e	п	p	ъ	[omit]
ё	yo	р	r	ы	y
ж	zh	с	s	ь	[omit]
з	z	т	t	э	e
и	i	у	u	ю	yu
й	i	ф	f	я	ya

The works illustrated in this volume come mainly from three sources. The first segment of the book (Chapters I and II), showing the development of official Soviet art, uses reproductions from official sources. Dimensions, medium used, and the year when the work was painted, were not always given, and hence are not included in the text. The illustrations in the following chapters come in part from photographs taken by the authors in the homes and studios of the artists. Descriptions here, too, are sketchy. However, works in the possession of the authors and various collectors are fully documented, and credit lines appear in the picture legends. Unfortunately, certain photographs taken under difficult conditions in the Soviet Union make the works appear slightly out of square.

Acknowledgments

This book owes a debt of gratitude to many people. It could not have been undertaken or completed without the encouragement, advice, and helpful criticism of so many, only a few of whom can be mentioned by name. First and foremost we would like to express our thanks to Jack Masey and Nick Moravsky, chiefs of the cultural mission we staffed. Their leadership, persistence, and capacity for organization made the American Graphic Arts Exhibition an unprecedented success in the East-West cultural exchange. The exchange itself has already proved to be an important step toward improvement of dialogue and understanding between East and West.

It has been our good fortune to study under Henry Borzo, Ray Nash, Louis Nemzer, and Gleb Struve, who kindled our interest in Soviet art and politics. We are grateful to Czesław Miłosz, Helen Vranich, Stan Vranich, Gerald Ackerman, William McFall Jones, and Joanne Morrison for reading the book in manuscript and offering informed and illuminating comment.

The bumpy road from manuscript to book was smoothed by Robin White and Dimitri von Mohrenschildt. The manuscript gradually assumed its final form through the devoted editing and advice of Susan Sears. Ernest Callenbach of the University of California Press gave generously of his time and assisted us in many phases of the operation. The impeccable editorial pen of Max Knight of the Editorial Department of the University of California Press was invaluable. Without the good will and material aid on the part of some individual owners, collectors, and galleries many illustrations could not have been included. Nancy Battalio, Mary Hird, and Evelyn Alley patiently and accurately performed the typing chores.

The authors take full responsibility for the views expressed in this book.

Berkeley, California

Paul Sjeklocha
Igor Mead

Contents

Introduction

DURING the past twenty years much has been written on Soviet Russia. Yet, a significant aspect of postwar Russia has been ignored: the "unofficial art" movement — the art school which does not adhere to the official tenets of socialist realism and whose followers do not belong to the Artists Union.

We had the rare experience of meeting many representatives of this movement, which embraces an increasingly important segment of the Soviet creative community. We were given the opportunity to staff the American Graphic Arts Exhibit, a collection of prints and related works, which toured the Soviet Union in 1963–64 under the auspices of the East-West Cultural Exchange Agreement. We visited Moscow, Leningrad, Yerevan, Alma-Ata, and some cities not officially on our list.

More than 1.5 percent (1,602,000) of the Soviet population visited the American exhibit in 105 showing days. We enjoyed the opportunity, extended to few Western observers to date, of meeting hundreds of "unofficial" artists, collectors, and critics. We were invited to their homes, studios, families, and social gatherings. We were often given samples of their works, photographed some, and purchased others. As we grew to know a number of unofficial artists, it became clear that they were anxious to have their work known abroad; they felt that acceptance abroad would prove an incentive to recognition at home.

Their reasoning was sound. International acclaim for the poets Yevtushenko, Voznessensky, and Okudzhava, for example, secured the respectful attention of the government at home. This, combined with the affection of the Russian people for these young poets, had

made it possible for them to work, more or less, as they pleased. The unofficial artists hope to gain recognition in the same manner.

The Soviet government listens to foreign opinion of Soviet arts and is sensitive to disparagement which implies that remnants of the Stalin era still exist. Although artistic freedom in the U.S.S.R. does not encompass the wide range of expression, political and artistic, that we are accustomed to in the West, the Soviet situation has markedly improved since the days of Stalin.

Yet, the memory of Stalin lingers despite the reorganization of the secret police, which with the rise of Khrushchev, curtailed their activities considerably. With the exception of the Hermitage-Shemyakin case, we never heard about any current KGB (Committee for State Security) involvement with the creative community, including those artists we met during our stay in Russia. We did not know whether, as Westerners, we were under security surveillance but, in any case, our meetings with the members of the unofficial art world were unhampered and without incident. However, it was obvious that the artists themselves could not easily forget the strictures of Stalinism and so elaborate precautionary steps were often taken in arranging meetings — which we, of course, honored.

Sometimes these precautions necessarily limited our efforts to collect a comprehensive view of unofficial Soviet art. For instance, the conditions under which we met some artists and the physical surroundings where the works were photographed often left much to be desired. Meetings were arranged on the spur of the moment and photographs were taken with natural or ceiling light. However, we always tried to obtain original works, properly signed and dated.

Many of the biographical sketches in this book are brief, and if the artist wished anonymity, no name is stated. We did not generally take notes, in deference to the prevailing fear which still remains in the U.S.S.R. of the written word found by the wrong person. Inevitably then, some particulars became general impressions by the time we were able to set them down on paper. However, the quoted comments and discussions are rendered as literal as remembered.

Some artists are discussed in greater biographical detail. These are the persons who have been in the news, and who were criticized

at home or exhibited abroad with official sanction; they could be categorized as belonging in the official or semiofficial groups. Where we felt that the disclosure of an identity might prove a difficulty we have omitted it even in instances where the artist had permitted use of his name.

Although the activity of the unofficial artists does not conform with socialist realism, it is not illegal. The work of the unofficial artists is well known to and occasionally sanctioned by the authorities, as in the officially approved exhibit of Ilya Glazunov, not a member of the Artists Union. Unofficial sanction by officialdom was, as far as we could determine, quite widespread. The unofficial artists are breaking no law, although individual introspective artistic expression is looked upon as somewhat less than patriotic.

A case in point: Readers will remember, perhaps, the Sinyavsky-Daniel trial which seemed to belie the news of greater artistic freedom in Russia. However, these writers *were* breaking Soviet law by printing abroad without permission and by the nature of their material, which a court labeled "slanderous" and "anti-Soviet." Their clandestine activity abroad had given "comfort to the enemy" (the Western propagandists) and the secret police had been trying to ferret out their identity for years. Too, illegal manuscript-writing and its distribution at home and abroad had become a thriving enterprise, an obvious rebuke to the Communist system. The trial was staged on the eve of the Twenty-third Party Congress, obviously as a warning to those still engaged in illegal activities.

The work of the unofficial artists, on the other hand, is generally nonpolitical. Indeed, its lack of concern with the furtherance of the Party line is its gravest error in the eyes of the Soviet government. However, unofficial art is not interested in the "Party lines" of the opposition either. Although it has attempted to copy the styles of Western abstract art on occasion, those styles could hardly be termed "political." Therefore, the Soviet government limits itself to official disapproval in critical articles or speeches; to our knowledge, painters have not been imprisoned in recent years.

Certainly we would have little to present here if it were not for the unofficial artists' eagerness for broader recognition. Collectors

were helpful. Dealers were even more helpful, naturally, since we bought many works from them. But even the unofficial collectors and dealers were informed mainly about the developments which were in their immediate vicinity. Their knowledge ended with their contacts. It is quite possible, although we think it unlikely, that the best of the unofficial art movement remains undiscovered and that we shall not have a true picture of contemporary Russian art until Soviet critics are allowed to discover it. And it is to the unofficial artists of many differing artistic persuasions that we owe our greatest debt for the glimpse into their world.

The few Western observers of the Soviet art scene have tended to overlook the existence of unofficial art and to minimize its role. This must be due in great measure to the inaccessibility of the artists, who, having no official status, cannot be met through the usual official channels. The visiting observer returns home with a reconfirmed impression of the singleness of the Soviet artists' imagery, reiterating the official line that Soviet art expresses only one viewpoint, one outlook, one reality, with one purpose in mind: to assist the cause of the proletarian revolution.

But there are 220 million personal realities in the Soviet Union and certainly more than one outlook. It is true that only one — the official —outlook is allowed to exist without interference and that individuality is discouraged and continues to be suppressed by various means. Consequently, what "deviationist" art exists is of a modest quality, contrasted with that of Europe and the United States. This, however, does not diminish the importance of this continuing development in the cultural history of Soviet Russia.

The difficulties we encountered in the attempt to make this study were compounded from its beginning by the scarcity and often nonexistence of up-to-date material on the subject. No publications, to our knowledge, comprehensively discussed it. Camilla Gray's authoritative work *The Great Experiment* covers only the period from 1863 to 1922. No Soviet or other literature was available comprehensively treating the post-1922 period; there were no modern art galleries or public exhibits of unofficial or modern art to visit in the U.S.S.R.; we were refused access to private collections of modern masterworks in

various museums. (This, by the way, is an example of the mode of official "discouragement" of unofficial art.) We do refer to the more generally known developments of the twenties and thirties and acknowledge the important contributions of Filonov, Tyshler, Falk, Altman, Kropivnitsky, and others.

At times we felt that perhaps the attempt to treat the subject at this time, with the limitations imposed, was premature. However, a certain amount of the unofficial art is artistically important in its own right. And we felt even more strongly that to ignore the existence of this artistic phenomenon in the Soviet Union would be unfortunate, for the works of the unofficial artists tell us much about current Soviet life which the Apollonian character of official Soviet art has sadly failed to do.

We can see little today of the realities of Soviet life through the façade of the political-poster standard of art. Whether unofficial art will turn further inward toward subjective expression or outward to deal with social issues (perhaps in the manner of Western pop art) is difficult to predict. It seems likely, however, that as Soviet life is liberalized, artists will enjoy more freedom in every direction.

Throughout the years, the art of the unofficial artists has found some room in the interstices of official reality to exist and express its own reality as vividly and naively as the flower of Yakovlev (Chapter VI), seeing no more than that reality can offer. Perhaps that is where the real value of this art lies — in the depiction of the genuine personal realities to which the artist is confined. It is upon this basis that the aesthetic value of these works should be judged.

Background on Soviet Art

T HE purpose of this chapter is to consider briefly the historical background which set the stage for "socialist realism," the official art of the Soviet Union.

The definition of socialist realism was set forth succinctly at the First Soviet Writers Congress in August, 1934. It was defined as "a truthful, historically concrete representation of reality in its revolutionary development," aiming at the "ideological education of the toiling masses in the spirit of socialism."[1] Translated into the functional language of the Soviet state, this meant that art was to become utilitarian; its duty was to educate and enlighten; its reality was no longer to be the private vision of the artist but the depiction of proletarian victory.

In the history of art, attempts to control and make use of the artist for the furtherance of the social good have inevitably met with difficulties. There is dissent, open or covert. Conformity attracts and holds the second-rate abilities; genius slips through the net. Even those artists who are in moral agreement with the ends to be achieved are reluctant to hand over their right of aesthetic decision. Being told *what* to paint is being told *how* to paint, as Harold Rosenberg has pointed out.[2] The "irreconcilability of art and ideological utility" in the Soviet Union has produced a counter-art, which we have termed "unofficial art."

Artists have always had their troubles with officialdom, be it of the church or the state. The artists' reality often does not please, nor enlighten or instruct, at least not in the sense which implies a passive

[1] See *Pervy vsesoyuzny syezd sovetskikh pisatelei* (Moscow, 1934), p. 716.
[2] Harold Rosenberg, *The Tradition of the New* (New York, 1960), p. 47.

beholder devoutly awaiting cultural uplift — an uplift beloved of officialdom. The power of art to engage its viewers in a reality which cannot easily be defined and therefore not easily be bent to authoritarian purpose has been a source of vexation to those who would have it serve a didactic purpose. Socialist realism, as it is practiced today in the Soviet Union, is an aesthetic theory begotten by the necessities of politics. The artist, as a member of the proletariat, is given to understand that he must focus his reality on the Marxist-Leninist future. There has been dissent, as we have mentioned, but there has also been a greater compliance with the state's dictates than perhaps one would expect from the art community, particularly if one cherishes the romantic nineteenth-century image of the Russian who seemingly tumbled from one schism to another with exotic aplomb or of the reformer with a mystical master plan. Such clichés have served to mask the fact that art in Russia has, for most of its history, been in bondage — first to the ecclesiastical state, then to the patronage of the aristocracy, and in the twentieth century to the secular state. The Russian artist, even in times of relative creative freedom, has been prone to explaining or defending his work in terms of its meaning to his homeland. Early in Russian history, fear of the corruptions of the Western world gave a xenophobic character to Russian art.

Social or philosophical tests have been applied to art since Plato's time; the notion that art ought to serve some ulterior purpose or illustrate some "good" is an ancient one. Whether art was considered to capture the essence of things, leading men to appreciate the truly real, or whether its role was thought to be the recording of the more mundane appearance of things, it was judged by standards outside itself.

The adoption of the icon as a standard form of religious art within the Orthodox Church was founded on the belief that "the true image reveals the essence of the model, material objects could be the seat of the divine object,"[3] and that the institution of Christ himself could be represented through imagery. The concept of the ruler as

[3] See Milton V. Anastos, "The Ethical Theory of Images Formulated by the Iconoclasts in 754 and 815" in *Dumbarton Oaks Papers* (Cambridge, Mass.: Harvard University Press, 1954), No. 8.

earthly representative of deity fitted logically into this relationship of image and divinity: originally developed from Platonic thought, it was reinterpreted by the Byzantines.[4] However, the icon, as intermediary between subject and ruler, had to be painted by man — by an artist. And the artist, the image-maker, was also the subject of a divinely appointed ruler. His lot was, literally, not to question why; his task was to reproduce faithfully the models created in Byzantium long before. Originality was heretical because it deviated from the "true image." Thus we find, at the very beginning of Russian art, the heresy of originality.

Despite the fact that the artist as deviant may be largely a romantic creation of the nineteenth century, it seems clear that artists have never relished direction from philosophers, patrons, or public. They reject the notion that they are highly skilled craftsmen with an inexplicable gift, who must be kept on the right path by the community. They wish to see and paint for themselves, and for those who will understand their particular vision. However, even though churches have had firm restrictions on subject matter, sacred art includes many masterworks, Russian icons among them. Perhaps it can be said that the subject matter transcended its earthly rules. Yet attempts by the state to steer secular art, to instruct man with the image of man, have generally cheapened man's image and art in the process. The art, then, becomes propaganda. Nonetheless, it can be said that sacred art was a kind of propaganda which managed to surpass its purpose. Why then cannot secular art under state control do the same? Why has socialist realism, for example, produced so few good works of art? Secular art depends on a one-to-one relationship between artist and subject (himself and other). This relationship exists in sacred art, too, namely, between man and his Maker. The ecclesiastical state was able to define the deity, for a time at least, to the satisfaction of the artist. But the state does not require of the socialist realist a definition of man, it requires a depiction of a proletarian victory, a reality which is guaranteed by Marxist ideology but which remains an abstraction,

[4] See Gerhard Ladner, "The Concept of the Image in the Byzantine Fathers and Byzantine Iconoclastic Controversy" in *Dumbarton Oaks Papers* (Cambridge, Mass.: Harvard University Press, 1953), No. 7.

at best, and cannot, in any event, take the place of the necessary "other." However, the attempt of the Soviet political planners to incorporate the power of art into their armory has succeeded in three ways: the state does have the kind of art it wants; the poster has replaced the icon; the artist has become a historical illustrator.

The Icon

The icon came to Russia by way of Orthodox Christianity in the latter part of the tenth century and became by the thirteenth and fourteenth centuries an omnipresent feature of Russian culture.[5] It has been said that "if Byzantium was preeminent in giving the world theology expressed in words, theology expressed in images was given preeminently by Russia."[6] The bitter battle of the iconoclasts, the opponents of the image representation of divinity, against the forbidden graven images of Mosaic law, which echoed the Graeco-Roman images, had been lost to the theologians who felt religious images to be important educational tools — although it was evident that religious instruction was not at the heart of the matter. The visual arts had been banned by the early Christians as part of the larger Christian denial of earthly "props," which were too reminiscent of paganism. Yet, by the end of the fourth century the sign of the cross was in wide use as a Christian symbol.[7] The vogue of sacred images continued to spread, as did its defense by theologians. The particular usefulness of icons in the fight against heretics was advanced as an argument.

But this argument side-stepped the central issue for the iconoclasts were shocked at the idolatrous turn that image worship was taking. The images had acquired a miraculous quality which smacked

[5] See James H. Billington, *The Icon and the Axe* (New York, 1966), and Paul Miliukov, "Architecture, Painting and Music," *Outlines of Russian Culture* (New York, 1960), Part III. These sources contain much interesting material on the history of Russian art and culture and the authors wish to acknowledge its value and their use of it. Henceforth cited as Billington and Miliukov.

[6] See L. Uspensky and V. Lossky, *The Meaning of Icons* (Boston, 1952), p. 46.

[7] The Armenian cross stones ("Khachkari") were the first examples of the Christian symbology, now in the catacombs of the Etchmiadzin Monastery near Erevan, Soviet Armenia.

of paganism, a reality that threatened a God-given tenet of Christianity. The images were thought to be, in an alarmingly "real" sense, those they depicted. They were intermediaries; they were heavenly presence (to their proponents); the iconoclasts were not so convinced that heavenly forces were in control. The power of art to suggest the power behind it and the need of the people for its succor is strikingly to the point here. The iconoclasts lost the battle essentially because they denied art any divine connection between man and his god.

The icon — the image — entered Russia with Orthodox officialdom triumphantly behind it. Russia inherited the victor's philosophy and, in the manner of a convert, as James H. Billington has suggested in *The Icon and the Axe*, inherited it without question. One wonders how Russian art would have fared if the iconoclasts had won? Or, for that matter, Russian history? The icon was found wherever people lived and gathered in Russia. It "provided an image of higher authority that helped compensate for the diminished stature of temporal princes."[8] In its presence, one "swore oaths, resolved disputes and marched into battle."[9] In other words, the role of art as a unifier and instructor of the people began early in Russia. "Each icon reminded man of God's continuing involvement in human affairs. Its truth could be immediately apprehended by even those incapable of reading or reflection. It offered not a message for thought but an illustration for reassurance of God's power in and over history for men who might otherwise have been completely mired in adversity and despair."[10]

Russian iconographers changed little the form of the icon. The stylized two-dimensional icon, which purposely lacked perspective in order to prevent the beholder from entering the holy picture, was kept. Inevitably, the colors of the Russian landscape were introduced, and simpler form modified the complex Byzantine compositions. But, always, the spiritual distance between icon and devout onlooker was maintained. Any hint of three-dimensional painting would have been to "humanize" the divine, to bring it down to earth. The purpose of

[8] Billington, p. 31.
[9] *Ibid.*
[10] *Ibid.*, p. 35.

the icon was to elevate the soul. Identification by the viewer with the divinity would have been considered sacreligious. And since the icons were generally copied from others, there was little room for experiment. The colors changed; tempera paints replaced encaustics; pine boards were used instead of the cypress and lime of Byzantine icons; but the development of other techniques was altogether stunted. Iconography reached its highest expression in Russia but at the expense of other art forms. Imitations of Greek and Roman classical art vanished, not to appear again except in the thirties in a mannered and decadent form; sculpture, which could not hope to achieve two-dimensionality, virtually ceased.

Nevertheless, the icons of the masters take their place as great works of art, and it is usual for one style to flourish at the expense of the others. The veneration of the icon brought the people together, and gradually the icon, although it kept to the Byzantine forms, took on a distinctive Russian character: more perspective, more sense of personality. It has been said that "some four hundred styles of repre-

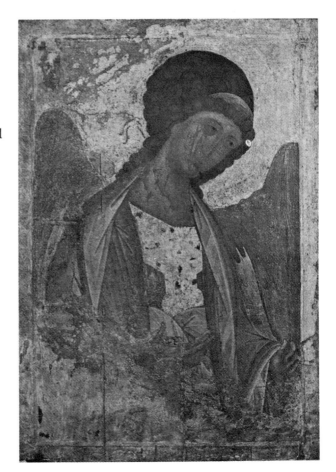

Figure 1. Rublev, Archangel Michail **(Early 15th century). Linden board, jesso and egg tempera, 61¾ x 42½".**

senting the Virgin have been counted in Russian icons."[11] During the late fourteenth and early fifteenth centuries, Andrei Rublev, who studied under Theophanes the Greek, was the greatest Russian icon painter.[12] He worked in Moscow, and to him credit is due for the supreme fulfillment of iconography. He succeeded in giving divinity a noticeable Russian character.

Art and history were linked in early Russia by the firm hand of Russian theology which placed the writing and illustrating of sacred history on a high creative level. Much secular information was included in the chronicles, though these were mostly written by monks. Frescoes of the time often took apocalyptic themes as their subjects; sacred literature grew increasingly prophetic. Russia, the prime Christian convert, began to see itself as the New Jerusalem or "third Rome" as Byzantium weakened under Ottoman conquest, schism, and wars, and finally fell in 1453. The "collective memory" of Russia was duly plumbed for corroborative evidence of ancient events which had presaged Russia's future as the head of Christianity. In order that history might take the anticipated turn, art became a proselytizer and again, a "justifier" for the church.

Secular culture in Russia during the fourteenth, fifteenth, and sixteenth centuries did not prosper. Ivan the Terrible virtually destroyed secular art in his land. Russian society reorganized along severely religious lines. Ivan's military and political schemes were but a part of his religious fanaticism, the means of establishing Moscow as the capital of Christendom. If Moscow was to achieve this divine function, it followed that its citizens had to live by strict regulations. Rules were set down "for everything from icon-painting to shaving and drinking."[13] The church code of 1551 proscribed secular material in the arts. The merger of church and state was frighteningly complete. The Messianic pretensions of Russian Orthodox Christianity were codified and justified by selective historical research; they affected each one of Ivan's subjects.

[11] *Ibid.*, p. 32.

[12] For two studies of Rublev, see V. Lazarev, *Andrei Rublev* (Moscow, 1960), and M. Alpatov, *Andrei Rublev* (Moscow, 1959).

[13] Billington, p. 69.

Western Influence

All Western influences, including Western art, became suspect. Although occasionally works displayed the influence of early Italian Renaissance (in art and architecture) — indeed, the Kremlin was rebuilt with the help of Italian engineers — the secular art of Western Europe was, in general, ill-regarded in Russia. Yet the West could not be ignored. Ivan, grudgingly, depended on the West for various services (particularly technical) and necessities; he entered the Western arena in his military campaign against his powerful Western neighbors; and in the seventeenth century Russia was at war with a Western country — Poland.

The confrontation with Poland represented the first frontal conflict of ideas with the West. This powerful Western neighbor represented almost the complete cultural antithesis of Muscovy. . . . In striking contrast to the mystical piety and formless folklore of Muscovy, Poland was dominated by Latin rationalism and a stylized Renaissance literature. Poland not only contradicted Russian Orthodox practice by using painting and music for profane purposes but was actually a pioneer in the use of pictures for propaganda.[14]

Moscow defeated the Poles and crushed their attempt to establish a Polish tsar in Moscow. But during the course of the struggle Western artistic notions filtered into Russia. The reign of Tsar Alexis from 1645 to 1676 and the religious schism within his church created an atmosphere which left room for new ideologies. Foreign ideas came to Moscow to the alarm and distrust of the religious community.

The iconograph tradition continued, although with more variation than sanctioned by those who set down church policy. The ancient models to which the artists were expected to adhere could be interpreted differently by their students. Besides, the artist began to have a greater scope of subject matter because the icon became the Bible of the poor illiterate Russian population — it appeared increasingly in homes illustrating the Scripture, depicting the lives of Saints, the meaning of holidays, and so on. Representation of the Saints' lives, for example, required a larger cast of characters and more var-

[14] *Ibid.*, pp. 103–104.

ied settings than portraits of the Madonna. There was more room for imagination, and for technical facility. The Scriptural story-telling icon became the "first product of original painting in Russia to achieve wide popularity."[15]

The role of art, then, as a proselytizing medium for Orthodox Christianity (with Moscow its temporal see, and the Russians its exemplary chosen population) foreshadows the much later use of art by the Soviet state. The cries of the churchmen against Westernization (secular contamination) are echoed today in the Soviet government's xenophobia. The view of Russia as a new and unpolluted fount of the Christian world, uniquely shaped by destiny to take over from the corrupt old Jerusalems and to guide the decadent Christian empire, profoundly shaped Russian character and culture. Russia's assumption of its historical destiny did not go unchallenged, but in its fight to achieve it, Russia came of age in Europe. The Messianic impetus which drove the Russian state toward maturity remains impressed upon Soviet art today, which is expected to instruct the Soviet peoples in their historical expectations. Soviet artists who paint to state specifications are following a tradition much older than the Soviet state. The present regime would hardly have succeeded so well in its control of the arts if there had not been this heritage. The identification of the artist as image-maker for the people has been put to use by the Soviet government.

The Russian artist's strong feeling of kinship with and obligation to his people is not new. When classicism finally crossed the iconographic barrier and a secular art developed, a group of Russian artists decried the exclusiveness of classical art, its lack of meaning to the people. The same complaint voiced by a Western artist would cite, more probably, classicism's lack of relation to reality — *his* reality.

Russia's long geographical and political isolation from Western Europe, its late arrival as a powerful but awkward newcomer into world society, its compensatory view of itself as an untarnished Christian leader of a fallen Europe, produced in its people a fear of the

[15] Miliukov, p. 40.

godless outside world, which affected the arts as well. The tender, protective affection shown by the Virgin for the Child in so many icons seems a reflection of the Russian artist's protective love for his people who were tried in a harsh land and found it hard to understand the divine purpose.

Perhaps surprisingly, the artists were generally recruited from the lowest ranks of society (they were most often former serfs who had become monks), and their sympathy for the people certainly stemmed, in part, from their acquaintance with them. But, as former serfs, they knew well the value of keeping their place and the danger of pretensions toward individuality.

To keep the iconographers in conformity with the Moscow style, provincial artists were dispatched to Moscow to continue their training, or Moscow-trained artists were sent to the provinces. Individual competence which developed independently of Moscow rule in distant provinces, was looked upon with disfavor. Yet, by the seventeenth century, foreigners had been imported to paint secular subjects, which were apparently considered too profane or too sophisticated for Russian artists. The foreigners received much higher salaries, an irony which must have aroused xenophobia in many domestic iconographers. However, the Russian artists began to borrow from native Russian decorative art and portraiture, to the dismay of the church fathers. The Church Council of 1667 condemned the pernicious Western influence but by then it was too late. Gone were the days when Patriarch Nikon hurled icons painted in the Latin style onto the church floor and pierced the eyes of their Saints before he ordered them burned.[16] The church fathers continued to rage at the innnovations but the tide was against them.

Joseph Vladimirov, an iconographer of the seventeenth century, found it necessary to defend the artist's choice of style and subject when his work was criticized by a Serbian archdeacon who took umbrage at Vladimirov's depiction of Mary Magdalen. Vladimirov wrote to the archdeacon:

[16] But Nikon himself was accused by his arch-opponent Avvakum of favoring the German school — which was not true; he favored the Greek.

Who found the instruction about painting the faces of the saints in dark, swarthy shades? Was the countenance of all mankind created alike? Were all the saints dark and gaunt? Even had they mortified their flesh here on earth, in heaven their souls and bodies would appear revived and radiant. . . . Who among reasonable people would not laugh at the folly that prefers darkness and gloom to light? No, this is not the idea of a wise artist. He outlines in form and faces what he sees and hears, and in accordance with his seeing and hearing he pictures them. And as in the Old Testament, so in the New have many saints, both male and female, appeared comely.[17]

This letter was in defense of the pictorial icon which exalted its subjects in a naturalistic setting. Three-dimensional treatment of the icon had been introduced. "Interiors" replaced the monochromatic flat background. Figures were placed in a chamber setting which opened to other rooms. Knowledge of perspective had been achieved in the West by the fourteenth century; it was not achieved in Russia until the end of the seventeenth century and even then was only grudgingly accepted and imperfectly understood. It was the unusual artist who experimented, since artists were trained to follow exactly in their masters' footsteps. To excel at art was to imitate the masters and to better their style, but not to change it.

The arts were supported by those who had the money — the rulers of church and state, and their hierarchies. As this aristocracy's contact with the West broadened, so did its taste in art. The frescoes in Tsar Alexis' chambers, for example, showed the Passions of the Lord — a subject which treated emotions not easily depicted in the formal Byzantine manner. (The frescoes include an explicit treatment of the torments of hell.)

But the movement toward naturalism in icons was not widespread. The masses of people had been so well brought up in the Byzantine tradition that they rejected the "new" icons. Western influence had actually little effect on iconography. Some art historians today consider even these few effects unfortunate.

Renewal of Secular Art

Alexis introduced many Western innovations in the court during the

[17] Miliukov, p. 44.

last years of his reign and was an admirer of Western technology. His court included many foreigners. The *Book of Titled Figures*, published at that time, included sixty-five portraits of foreign and Russian statesmen done in a relatively naturalistic style and signed by individual artists.[18] Under Alexis, the "semi-sanctified title of tsar was giving way to the Western title of Emperor. . . . To the large group of dependent foreigners in Muscovy, Alexis was no longer the leader of a unique religious civilization but a model European monarch. . . . Icon-painting in the Kremlin was placed under the administrative supervision of the armory, and the most important new construction inside the Kremlin in the late years of Alexis' reign was undertaken not for the church but for the foreign ministry, whose director surrounded himself not with icons but with clocks and calendars."[19]

The clocks and calendars began to tell Western time. The Russian Academy of Art was founded in St. Petersburg early in the eighteenth century, during the reign of Peter the Great, Alexis' son. Classicism returned, adopted by the aristocracy with a touch of the same fervor which, long ago, had been given to the religion from Byzantium — and with the same lack of thought, since classical art had long been played out in Western Europe and had become mannered and dull. Iconography continued but wealthy patrons of art were newly eager to own works of art which represented noble themes of Greek and Roman times, or Biblical panoramas. Genre-painting was looked down upon for its lack of classical "purity," as were depictions of Russian national history. The pseudo-classical contempt for landscape painting, however, was somewhat altered when the aristocracy commissioned artistic renderings of their handsomely landscaped manor houses and grounds. Engraving proved a handy medium with which to keep up with the new architecture, and foreigners were imported to teach the finer points. The Russians caught on quickly, and etchings became popular with the people for they could be done cheaply and reproduced in quantity. Russian folklore and news of the times, fancy and fact, became well-liked subjects. For example, for fancy,

[18] Billington, p. 148.
[19] *Ibid.*, pp. 148–149.

Illuminated News about Monsters, and for fact — hopefully — *Illuminated Announcement of Military Campaigns.*[20]

Beginning of Genre-Painting

Portrait-painting came into its own in the eighteenth century. Russian artists began to go abroad to study or Europeans traveled to Russia to tutor them. Genre-painting, although viewed with disdain by the academics, soon showed itself popular with the Russian artist. The every-day scenes of mundane life were not considered worthy of art's ennobling brush but nevertheless a few artists persisted in trying their hand at it.

One of the best-known genre painters was A. O. Orlovsky, the son of an innkeeper, who "worked not only with the brush, but with the point of a match, a candlewick, or with his fingers and his nose dipped in ink."[21] Orlovsky sketched "peasants and merchants, cadets and generals, Kalmucks and Tartars, thoroughbred horses and work horses," in many mediums, and his works were circulated widely. But Orlovsky was an exceptional painter and far ahead of his time. It would be fifty years before genre-painting was to come of age in Russia. Alexis Venetsianov (1780–1847) was to reject his twelve years of study at the Hermitage and discover "naturalism."

"The idea," wrote Venetsianov, "was that nothing should be represented except as it appears in nature: to follow its dictates and not to mix with it the methods of any painter, that is, not to paint *à la* Rembrandt or *à la* Rubens, but simply, so to speak, *à la nature.*"[22] In the Russian world of that time, which was *à la* many things but very rarely *à la Russe,* this was a provocative statement indeed. Actually, Venetsianov's concern was not so much with a nationalistic art but with a naturalistic one taken from the life around him which happened to be Russian. His concern was with technique. He worked to obtain the effect of "full light" on a subject and so set himself outdoors, away from the confines of the studio, an avant-garde giant step

[20] Miliukov, p. 50.
[21] *Ibid.,* p. 53.
[22] *Ibid.,* p. 54.

for that period.[23] Others followed. One, Krylov, painted a winter landscape seen from a hut which he built in the middle of the field.

But these men were ahead of their time, too, and academism continued to control the arts. Romanticism, or at least a movement so styled, was heralded in Russia when Karl Bruellow (1799–1852) introduced his painting "The Last Day of Pompei," which enjoyed great success with the public, although its value as a work of art depreciated rather rapidly. The painting was academic, though it used bold, theatrical colors. However, it did serve as a diversion from the refined vistas of classicism.

The rise of genre-painting was slow partly because of the tastes of art patrons who preferred "exalted" art which reflected favorably upon their aristocratic pretensions and indeed furthered them, and partly because the artists themselves were often no less prone to pretensions than their admirers. Artists who most pleased the aristocracy could become a part of the favored court circle. Yet, however imitative and mannered much of academic painting was, it still represented a triumph for secular art in Russia.

Iconography continued, of course, and remained "the art of the people" since the academic works were certainly not that. The subjects of classicism were little related to the lives of the common people. The distant air of a lost and golden world full of the "best people" could hardly capture the affection of the masses who had no such age to remember. And although religion had lost much of its control over the monarchy, it retained a strong hold over the populace. Yet the icon did not further develop. Its form was set. The secular "art for the people" was yet to be born.

It was a long time in coming. Academism acknowledged genre only as an exercise — for instance, a class at the Academy required of pupils that they paint "a bourgeois having a slight seizure and preparing to take medicine."[24] However, the market for such portrayals was probably small. And, too, it might be said that "exalted" art, in a curious way, had a link with iconography. The subjects portrayed were

[23] See Venetsianov's "Sleeping Shepherd," in *Gosudarstvenny russky muzei: Zhivopis* (Moscow-Leningrad, 1963), plate 19.
[24] Miliukov, p. 53.

14

far removed from the viewer, and they were the objects of, in a sense, spiritual, if not sacred, veneration. One looked up to such art; one did not enter into it. Art's role was to represent the pure and the beautiful, and if beauty was to be found in genre-painting, it was felt to be of an inferior, earthy sort, all right in its place — but its place was a very minor one.

Therefore, even the genre painters were careful to keep their subjects well-combed and brushed, and their manner respectful. The peasants were portrayed as simple, stalwart, and happy and the land-owners were invariably of noble mien.

Realism

Not until the middle of the nineteenth century did realism come to dominate. There had been forebodings. Fedotov's painting entitled "The Morning of a Bureaucrat upon Receiving His First Decoration," was shown in 1848 at the Academy, listed cautiously, however, in the catalogue as "The Result of a Carousal." And when the painting was reproduced in lithograph, the decoration in question was removed. Fedotov's work received wide public recognition but was neverthe-less passed over by the academics who continued on their impassive way.[25]

Alexander Ivanov, who was a friend of Gogol, epitomizes an-other turn in Russian art in the middle of the nineteenth century. Ivanov was the son of an aristocratic painter in St. Petersburg and studied the classical style, in which he excelled. But soon he rebelled at its narrowness and left Russia to study in Italy. Ivanov, although not a member of the Orthodox or Catholic church, was imbued with "a kind of fantastic eschatological chauvinism."[26] His legacies to Rus-sia were heroic canvases depicting Biblical scenes, attempts to return to the people their religious heritage.[27] But Ivanov's work reflected his anguish of spirit as well. The painter tried, literally, to become like

[25] *Ibid.*, p. 58.

[26] Billington, p. 343.

[27] See the artist's famous painting "Christ Before the People" in Tamara T. Rice, *A Concise History of Russian Art* (New York, 1963), plate 212.

Christ, himself the image. But his Messianic dream was diseased with the disquieting knowledge gained by science, the doubts raised by contact with the West. What and where was the new imagery to be found?

The prophetic cast of Russian art had to find another arena or perish. By the nineteenth century, religion had become a "cursed question" among the intelligentsia. The character of the artist had changed. He was no longer the simple iconographer working in devout harmony with God, the tsar, and the people. He was now more than likely a member of the middle or upper class, an educated man who looked about him and saw that all was far from good, and that under the system it was not likely to improve. His feeling of kinship with his motherland was lacerated by his pity for her sufferings. The artists were forced to a choice by the Messianic conscience of their tradition which pricked at their academic, bourgeois pretensions. It had taken the artists a long time to win their comfort but they did not keep it for long. The aristocractic art patrons themselves were in intellectual ferment, uneasy in their gilded seats. The Messianic impulse turned the artists to the people, the masses who were suffering in Christ-like fashion. A populist art began. And realism finally gained the upper hand in Russia.

Nikolai Chernyshevsky, a critic who was a leader in the fight for aesthetic realism, published *The Aesthetic Relations of Art to Reality* in 1855, and began by rejecting the Hegelian notion that art is superior to nature.[28] He maintained that the common people consider life and nature superior to art, that "the concepts of beauty vary according to the social class to which one belongs . . . that art should not only reproduce; it should also explain and judge the world."[29] Chernyevsky's criticisms are considered by some to be precursors of socialist realism. They struck a refreshingly realistic note at the time he wrote them and did much to advance the cause of realism.

But undoubtedly the temper of the times, the revulsion against

[28] See, N. G. Chernyshevsky, "The Aesthetic Relation of Art to Reality" in *Selected Philosophical Essays* (Moscow), 1953, pp. 281–381.

[29] Max Rieser, "Russian Aesthetics Today and Their Historical Background," *Journal of Aesthetics and Art Criticism*, XXII: 1 (Fall, 1963), p. 48.

the neurotic miasma which infected the ruling classes and shook the faith of the masses, was the true cause, the *raison d'être* of realism. It simply was high time to be realistic.

The Wanderers

In 1862 a group of young painters refused to enter the painting contest for the gold medal at St. Petersburg Academy. The theme for the contest was "Odin in Valhalla." These angry young men were to become the *peredvizhniki*, the Wanderers, so called because they were to forsake academic painting entirely and to travel throughout their native land, painting every aspect of the life they encountered. Their work was realistic, critical of social injustice, and, above all, concerned with the common man. The lot of the common man was pitiable. The Wanderers set out on their travels with an idealized picture of the simplicities to be found among the people, but they were shocked by the conditions they found. The effect upon their work was salutary. Traces of romanticism were cleansed away, and genre-painting came to its maturity.

Ilya Repin was the leader of the Wanderers. His paintings portrayed the tragic bondage of his people without sentimentality. The Wanderers were criticized for their single-minded concern with the masses, which did sometimes lead to painting more literary in content than adept in execution; but such criticism is valid only in a very narrow sense. Excess marks any new movement in the arts, and it is unjustified to criticize all for the naivetés of the few. Repin's canvas of 1870–1873, "Haulers on the Volga,"[30] has been well termed by Billington the "icon of populism," a great secular icon.

The work of the Wanderers and its effect upon the public did not go unnoticed by the government which commissioned Vasily Vereshchagin to paint his impressions of the Russo-Turkish War. Unfortunately for the government, Vereshchagin did not view the war with quite the same enthusiasm.[31] The artists had won their freedom from the Academy and were not about to relinquish it to the state.

[30] See plate 30 in *Gosudarstvenny russky muzei: Zhivipis*.
[31] Billington, p. 406.

Realism in the arts was gathering considerable strength. Its foundations had been laid, at great cost to themselves, by men who were never to know the importance of their work. The Wanderers and their followers profited from the courage of their elders, but paradoxically they also benefited from the lack of tradition in genre-painting. They were free to paint as they liked, whom they liked. Spontaneity, certainly an unusual element in Russia before this time, was a trademark of the Wanderers. Their works, at their best, served a redemptive purpose, both for the artist and the viewer. The artist found once more his link with his people, and the people found in art a true reflection of themselves. Yet, the earnest attempt of the artists to connect with the masses and, by doing so, purge themselves of the vacuities of classicism, was to meet an inevitable setback. The complexities of Russian existence could not be solved by populist art or letters. The utopian went to the peasant for spiritual rejuvination and found the peasant as complex as himself, and as prone to doubt and fear. Populist art foundered on the discovery that the popular mind was resigned to its apathy and distrustful of change; and the best intentions

Figure 2. Repin, Haulers on the Volga **(1873). Oil on canvas, 51¾ x 110½".**

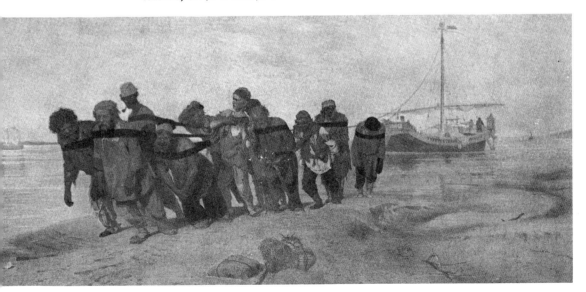

of the intelligentsia could not alter the repressive reign of Alexander III who swiftly cooled their ardor, forcing the artists back into a retreat, where their dreams soon took on an elegiac quality.

During the rule of Alexander (1881–1894) the young rebels became hardened and disillusioned men, their ambitions blunted and their ideals cruelly tested by the repressive government. The next stages in Russian art required a different tack, and after Alexander's death, art took two opposite paths, both reactions to the populist fervor of the seventies, and the loss of faith in Alexander's time.

The World of Art Painters

The World of Art group, named after a periodical published between 1898 and 1902,[32] rejected academism *and* the Wanderers. "In the opinion of the new school, the simplest way to cause a revolution in Russian art was to bring it into closer contact with that of the West."[33] The Wanderers had more or less ignored Western art and, in particular, the developments taking place in France at the time. Their emphasis on realistic subject matter, their intense nationalism had led them to ignore the work of men from other countries. (And the revolt against classicism was, of course, against foreign influence). It would have been strange, indeed, for the rebels of the seventies to adopt a contemporary cosmopolitanism in the stead of a classic one.

However, it was understandable that their heirs would break away from the confines of nationalism. Cosmopolitanism was the banner of the World of Art group, and study abroad, knowledge of happenings in the West, was all important. There was great enthusiasm for the post-Impressionists — Cézanne, Gauguin, and Van Gogh. The Impressionists' revolutionary use of color was of great interest to Russian artists who had always enjoyed lavish use of color. The Expressionists, who were gaining in importance in Germany, also took the Russian eye. The *Weltschmerz*, the tender melancholy of expressionism, appealed to those Russian artists who blamed the World of Art group with lack of inner feeling. All was flux, change, discovery.

[32] See A. Benua, *Vozniknovenuie "Mira Iskusstva"* (Leningrad, 1928).
[33] Miliukov, p. 63.

And, as in art circles the world over, each group was right, their rivals completely misled, charlatans or worse. Diaghalev, a member of the World of Art, would later in 1906 arrange an exhibition in Paris to display the work of the Russian avant-garde artists who had not only become cosmopolitan but had gone beyond the international trends of the time and created an authentic Russian modern art.

Proletkult

The other path taken after the discouraging reign of Alexander III was in a different direction. Alexander Malinovsky, a young journalistic critic, who took the name of Bogdanov (meaning "God-gifted"), defined the theory of a proletarian culture which would transform society. Malinovsky's pseudonym fitted his Messianic aspirations. If the motto of the World of Art had been "Art for Art's Sake," Malinovsky embodied the principle of "Art for the Proletariat's Sake." *Proletkult*, proletarian culture, could transform and unify the ailing Russian society. The familiar Messianic theme was again taken up and given a new scientific window-dressing. Many Russian intellectuals, searching for meaning in a world of vast disorder, had eagerly seized upon scientific methodology — with the hope that it could be called upon for massive reconstruction of society.

Proletkult differed from the Wanderers movement in several important respects. It was to be art for all the people, not merely a sympathetic rendering of the plight of one class by another. The traditions of the past were to be jettisoned, and every object of daily life would ultimately come under the review of proletkult. However, this freewheeling utopian arrogance was ultimately to seal proletkult's fate as we will see. Proletkult was very much the property of the intellectuals whose ideas of what the masses needed were not often approved by the masses. The avant-garde artists who became involved left their public in a state of shock more often than in a state of edification.

Yet, in the first decade of the twentieth century, Russian art became at once both international and original. The period of ferment, the exchanges of theories and cross-theories, the success of Diaghilev's ballet troupe in Paris, the effect of the revolution upon the artists

who hailed the bright new world and saw opportunity within it to aid their country, and to be independent of the bourgeoisie — all these created an art ahead of its time, not only in Russia, but in the world. Diaghilev arranged an exhibition in Paris in 1906 to display the new art, and among the painters were Goncharova, Larionov, Petrov-Vodkin, Pevsner, and Falk.

The Avant-Garde

These artists and others were the exponents of new forms of art which made the forays of the World of Art group seem like a decorous day in the park. They had assimilated the techniques of the French school early in their training and advanced swiftly toward unique expression. Cézanne had a decided effect on many of these painters. Kasimir Malevich, the father of suprematism which eschewed the superfluities of nature in preference to the essence of form, wrote: "There are no lines, there is no modelling, there are only contrasts; when there is richness of colour, then there is fullness of form."[34] This could be a leaf from Cézanne's diary but Malevich was not to be content with another man's work as his guide. Malevich worked first in primitivist fashion, then turned to a cubo-futurist style, both flat two-dimensional approaches, and finally evolved suprematism, a straightforward abstraction of geometrical elements melting into an infinite space. His early suprematist palette was delicate and rich; as his work progressed, it became paler and more forceful, culminating in the superb "White on White" series of 1917–1918.[35] Malevich defined suprematism as "pure sensation,"[36] and eventually gave up painting almost entirely in order to write about it. In 1919 he wrote:

At the moment man's path lies through space. Suprematism is the semaphore of color in this endlessness. . . . All art of utilitarian purpose is of no account, of small dimension, it is simply applied art, perfecting that moment, discovered by awareness, the conclusion of a philosophic thought

[34] Camilla Gray, *The Great Experiment: Russian Art, 1863–1922* (New York, 1962), p. 143.

[35] *Ibid.*, p. 140.

[36] *Ibid.*

in the horizon of our angle of vision, serving a daily taste, or creating a new one. . . . I have established the semaphore of suprematism. I have beaten the lining of the colored sky, torn it away and in the sack which formed itself, I have put colors and knotted it. Swim! The free white sea, infinity, lies before you.[37]

Constructivism, "real materials in real space," was achieved by Vladimir Tatlin, born in 1885, whose constructions owed an initial debt to Picasso but radically deviated from the works of that master. The first constructions were compositions of objects in relief upon a flat background which could be wood, metal, or whatever served the artist's purpose. Tatlin sought to destroy the artificiality imposed by the framed painting, its sense of removal from the viewer. The space which surrounded the observer and the objects placed in relief were one. The objects were not portrayals of themselves, they *were* themselves. The appeal of constructivism to those who propounded proletkult was immediate. Here was the art form which could be truly of the people. Yet the constructivist principle that "the fundamental bases of art must rest on solid ground, real life"[38] was not as comforting to the revolutionary social planners as it might appear. Real life, in the constructivist sense, was composed, to begin with, of the abstracts, time and space. The "supreme example" of constructivism was a building conceived and proposed by Tatlin as a monument to the Third International.[39] The architect planned a gigantic spiral 400 meters high, leaning at a 45-degree angle; enclosed within this spiral were to be three separate stories made entirely of glass, in the shapes of a cube, a pyramid, and a cylinder, designed to rotate at the speed of a year, a month and a day. This structure was planned to house various Soviet institutions; however, it was never built.

Futurism — a general term for a diverse and rambunctious art movement which sheltered many different and eclectic styles — was

[37] Quoted *passim* from an essay by Malevich published in the catalogue, *Suprematism: X-ya Gos. Vystavka* [Suprematism: Tenth State Exhibit] (Moscow, 1919).

[38] See the "Realistic Manifesto, 1920" by Naum Gabo, in *Gabo: Constructions, Sculpture, Paintings, Drawings, Engravings* (Cambridge, Mass., 1957), pp. 151–152.

[39] See Gray, pp. 219–221; plate 168.

supposedly inspired by Marinetti, the Italian futurist whose use of simultaneity created interest in Russian art circles. But as Camilla Gray has said, futurism in Russia should be more properly termed cubo-futurism since the works of the cubists were obvious inspirations for much of the Russian effort. The rhythmic strokes of Russian futurism were heavy and deliberate, and the displacement of space and form owed more to Picasso than Marinetti. Marinetti's fascination with machines was taken up in a different way. Marinetti saw the machine as an object which served his purpose as a painter; the Russians saw machines in a somewhat redemptive sense.[40]

Mikhail Larionov and Natalia Goncharova led the Futurist school but Larionov soon followed a new path, called "rayonnism" — that is, regionalism defined in the Rayonnist Manifesto as "a synthesis of cubism, futurism and orphism."[41] Larionov sought to introduce a "fourth dimension" by following "the specific laws of color and its application to canvas."[42] Larionov's concept was not so lofty a vision as suprematism or constructivism (which followed rayonnism) but is nevertheless notable for its analytical and imaginative power.

The dynamic avant-garde art in early twentieth-century Russia became a vital ingredient in the Revolution of 1917, hailed by the artists whose work had given indications of its advent for years. Their intuitions had anticipated the Revolution; they were eager to give mind and heart to its fulfillment. Adherents of every "ism" sought to win command of the streets. For a short time — four years — they did. At the first anniversary of the October Revolution the square of the Winter Palace in Petrograd was decorated in Cubist and Futurist designs, museums of avant-garde art were set up by their proponents all through the country, and the reorganization of art for the proletariat began.[43] However, the honeymoon was not to last. The government, initially taken up with the awesome task of establishing itself, gradually began to see that the ambitions of the art world for the education of the proletariat were confusing to the masses and at cross-purposes with Marxist ideology.

[40] See *Manifesty italyanskovo futurizma* (Moscow, 1914).
[41] Gray, p. 126.
[42] *Ibid.* [43] *Ibid.*, p. 217.

It is necessary at this point to examine briefly how Marxist ideology views the arts. It is interesting to speculate upon the fate of proletarian art in Russia if Stalin had not curtailed the aesthetic prerogative of the artist. Socialist realism, after all, is practiced in other Communist states; but in Poland and Yugoslavia the leeway allowed the artist is considerable. It is ironic that the Soviets' successful campaign to discredit the icon was part of a larger drive which, at the same time, purged those artists whose work was iconoclastic in the finest sense. Sacred and secular imagery, by the time of the Revolution, had been abandoned by the avant-garde which had advanced to a purity remarkable for the time.

Marxism

Marx and Engels left the realm of aesthetics relatively unexplored. Doctrine on the social function of art and the relationship between art and politics was not developed until after the establishment of the Soviet state; as its officials came to base their political rule on undemocratic traditions, their coercive policies were extended to the domain of art.[44]

Soviet artistic doctrine stemmed from the Marxist view that history is a process of class struggle in which men, as members of different classes, come to subscribe to various religious, philosophical, artistic, and political ideologies, corresponding in general to their particular class interests.

However, the class struggle will inevitably end with the victory

[44] See Robert K. Merton, *Social Theory and Social Structure* (Glencoe, 1949); and particularly Rieser, XXII: 1 pp. 47–53; Burton Rubin, "Plekhanov and Soviet Literary Criticism," *American Slavic and East European Review*, XV (December, 1966), pp. 527–542; and Swayze, *Political Control of Literature in the USSR, 1946–1959* (Cambridge, Mass., 1962), pp. 1–25, to which the following discussion is partly indebted.

[45] On the class character in art and other theoretical interpretations of Marxism, see the early Soviet theoretician G. V. Plekhanov, *Sochinenia* (Moscow, 1923–1927). For a more recent discussion, see the contemporary Soviet aesthetician, V. A. Razumny, who dwells on this very point in his study on artistic truth and social function of Soviet art, *Problemy sotsialisticheskovo realizma* (Moscow, 1963), p. 195.

of the proletariat — the ultimate, classless class.[45] Hence, reality seen from the proletariat viewpoint is superior to the realities espoused on the basis of other class interests. The theory of dialectical materialism, from which the mentioned position derives, thus provides the Marxists with a world view in which the proletariat (and its vanguard, the Communist party) has been relieved of conflicting realities. According to this view, how could there be a true reality, in a class-structured society where the artist of each class depicts and glorifies that class?[46] But to the Marxist there is only one reality: that which arises from proletarian consciousness, which appears in history with the rise of the proletariat. All other "realities" are false.

As the Soviet aestheticians perceive it, the purpose of art is therefore not only to reflect but to advance the interests of the proletariat. The proletarian consciousness must be freed from false representations of the stricken bourgeois world. Clearly, "art for art's sake" is not art for the proletariat's sake. The artist cannot afford to neglect the ultimate historical truth.

Marx deplored the "exclusive concentration of artistic talent in a few individuals," which he laid to the class conflicts of the bourgeois society. It was his hope that, in the Communist society, the common people would, "among other things, paint."[47] Positive historical science, Marx reasoned, will do away with the various forms of "false consciousness" producing the differing philosophies which set one man against the other. The artist will be free to reflect the material and spiritual reality of the classless society, in content and form free of economic and class pressure.

The party theoretician G. V. Plekhanov,[48] whose views on art were influential in the Soviet Union throughout the twenties, held that such theories as "art for art's sake" came to serve the interests of

[46] Karl Marx and Frederick Engels, *The German Ideology* (New York, 1947), p. 69.

[47] *Marx and Engels, Literature and Art: Selections From Their Writings* (New York, 1947), pp. 61, 76.

[48] As a chief propounder of modern Communist aesthetics, Plekhanov contributed his share of contradictions to the Marxist doctrine of art. For the opening epigraph, see P. F. Yudin *et al.* (eds.), *Literaturnoe nasledie G. V. Plekhanova* (Moscow: 1936), III, 201.

25

the bourgeoisie, asserting that "the merit of a work of art, in the final analysis, is determined by the 'specific gravity' of its content."[49] Therefore, the Marxist concept of truth — the truth of social relations — is held by Plekhanov to be the principal criterion for making aesthetic evaluations.

Plekhanov stated that the value of a work of art is measured by the "loftiness" of its idea, that art "is one of the means of spiritual intercourse among men, and the loftier the sentiment expressed by a given work, the better will the work fulfill its role as a means of intercourse."[50]

Plekhanov took the position that art was an aspect of the economically determined superstructure. "The ideologies of the ruling class lose their intrinsic value in the same measure as that class ripens for destruction; the art created in the spirit of that class declines with it."[51] The implication is plain that only a "vigorous" art, one with "lofty" ideals, can be the art of the proletariat. Plekhanov, incorporating art into the Marxist system, regarded the liberation of the proletariat as the sole point upon which all valid art might pivot.

Lenin

What the Soviet theory of art was to add to the Marxist theory is the "ideology" and the "ideological content" as it was laid down in the Stalinist period. Lenin's contribution was an extension of the Marxist theory, based primarily on his application to art of ideas borrowed from Social-Democratic revolutionary theory. Essential factors in Lenin's thought were his emphasis on conscious action as an element of social change, his insistence on the final authority of a disciplined revolutionary party, and his reliance on the *narodnik* (national heritage) movement as the basis for the popular character of art and literature. Concerning himself with the social questions raised by art, Lenin, in 1905, declared in his famous article, "Party Organization and Party Literature":

[49] For a discussion of this thesis, see G. V. Plekhanov, "Iskusstvo i obshchestvennaya zhizn" [Art and the Social Life] in *Sochinenia*, XIV, 120–182.

[50] *Ibid.*, p. 138.

[51] *Ibid.*, p. 150.

Literature must become Party literature. . . . Literature cannot be an instrument of gain for persons or groups; it cannot altogether be an individual matter, independent of the whole proletarian cause. . . . Literature must become a "part" of the general proletarian cause, the "wheel and the screw" of a single great social-democratic system, set in motion by the entire politically conscious vanguard of the whole working class. Literature must become a component *part* of the organized, planned, united social-democratic party work.[52]

This article became the basis for control of the arts after the new regime solidified its power. The echoes of Lenin's dicta are heard to this day. Leonid Brezhnev, addressing the 23rd Party Congress in 1966, said:

The Communist party of the Soviet Union has always manifested and will continue to manifest concern for the development of literature and art. The Party has guided and will continue to guide the activity of creative organizations and institutions, giving them all-round support and assistance . . . we are unfailingly guided by the principle of Party spirit in art and class approach to judging everything that is done in the sphere of culture. We shall always remember the words of Vladimir Ilyich Lenin that "literature must become a *part* of the general proletarian cause."[53]

Lenin's insistence on the principle of *narodnost* (national character) in the arts originated from his awareness of Russia's cultural backwardness, which he was determined to combat by making art easily accessible to the masses. However, as a member of the Russian intelligentsia, he had been brought up on nineteenth-century traditional realism; having little contact with the avant-garde circles of the time, he had naturally acquired a conservative outlook on art.[54] This attitude was typical of the nineteenth-century academic realism largely based on French academism.

In addition to his desire to elevate the ignorant masses, Lenin was also aware of the emotional impact of art, its educational and

[52] Mikhail Lifshits, ed., *Lenin o kulture i iskusstve* (Moscow, 1938), p. 112. Hereafter cited as Lifshits.

[53] *Pravda*, March 30, 1966, p. 7.

[54] According to Klara Zetkin, Lenin boasted of not understanding the art of "expressionism, futurism, cubism and other such 'isms'." For this enlightening statement, as well as Zetkin's reminiscences of Lenin, see Lifshits, p. 299.

politicizing potential in mobilizing the broad masses behind the Bolshevik Revolution. This factor played the decisive role in shaping the future cultural policies and the ultimate fate of Soviet arts. It was Lenin with his obscure but now sacred pronouncements on revolutionary art who paved the way for the rise and enforcement of the political-poster standard in visual arts under Stalin. With this prophetic statement he set the stage for the aesthetic control of all Soviet arts which is enforced to this day: "Art belongs to the people. It must penetrate with its deepest roots into the very midst of the toiling masses. It must be intelligible to these masses and loved by them. It must unite the feeling, thought, and will of these masses and elevate them. It must awaken in them artists and develop them."[55]

Admittedly, in the revolutionary and civil-war period the poster with its combined visual and communicative character (vivid colors and large slogans), served a useful function in "inspiring the masses to action."[56] However, when the civil war was over, and when poster art should have ended, it was intensified, as peacetime mobilization and reeducation of the masses in the "spirit of socialism" were introduced. Not only did political-poster art continue but its agitative and propagandistic character was forced onto the visual arts generally until it was difficult to discern between the poster and canvas productions. In brief, the political poster became part and parcel of all recognized art and remains to this day the hallmark of official taste in the visual arts.[57]

Thus, after the Revolution, the Soviet artist became the voice of the Party, illustrating the ideological dogma of the new state in an unsophisticated and direct manner. In practice he was forced to lower

[55] Lifshits, p. 299. Visiting the Second All-Union Poster Exhibit, held in the Manège Gallery in Moscow in the winter of 1963–64, the authors found this quotation written in gigantic red letters hovering over the entrance like a message from the heavens.

[56] We see the manifestation of this medium in time of war even in America, where the masses are sufficiently mobilized.

[57] It was disclosed at the First All-Union Artists' Congress in 1957 that, in the six years preceding the event, more than 665 million posters with 32,000 titles were published. See *Materialy pervovo vsesoyuznovo syezda sovetskhih khudozhnikov* (Moscow, 1958), p. 161. Henceforth cited as *Materialy*.

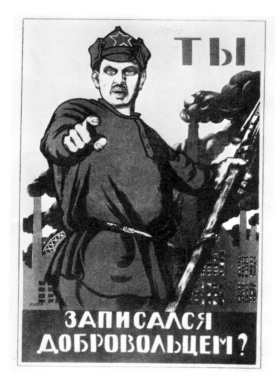

Figure 3. Moor, Have You
Volunteered? **(1920).**

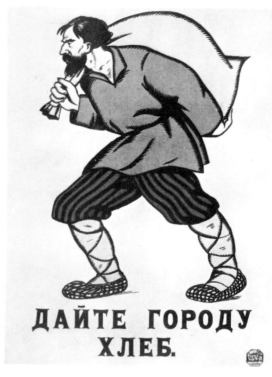

Figure 4. Sapozhnikov, Give Bread to
the City **(1920).**

the artistic standard of his work in an effort to make it "intelligible,"
"loved," and "understood" by *all*. In time it became evident that the
state saw art as an effective instrument of social mobilization; hence,
the requirement of intelligibility, national character, Socialist con-
tent, and other demands placed on art in the Stalin era, and the ruler's
personal appeal to the artist to become the "engineer of human souls."
In the end, inevitably, all form was sacrificed for content.

Socialist Realism

Stalin, with the aid of Maxim Gorky, is credited as being the chief
architect of socialist realism as it is known in the U.S.S.R. today. The
phrase was supposedly coined at Gorky's *dacha* (summer cottage).

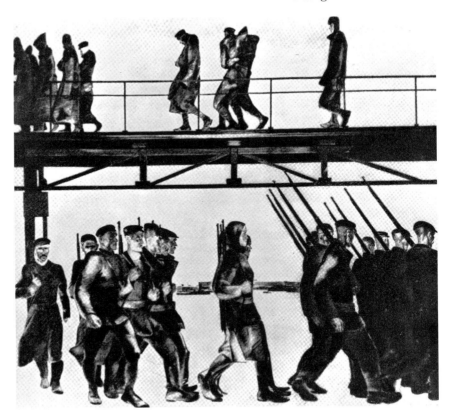

Figure 5. Deyneka, Defense of Petrograd **(1928). Oil
on canvas. 85¾" x 139½".**

The occasion of Stalin's and Gorky's meeting has been depicted in a
painting once prominent in the galleries of the Union of Soviet Artists.
The painting, indeed, is an excellent example of socialist realism.

By 1931, Socialist direction of the creative arts had been consoli-
dated, and a lexicon evolved for those who would follow it. The three-
fold concept of *partynost, ideinost,* and *narodnost,*[58] was to become
the official standard and measure of the worth of a work of art.

This concept held a specific significance for Soviet literature,
although it was vigorously applied to all arts. According to Lenin's

[58] For a definition and brief discussion of these three concepts, see *Kratky slo-
var po estetike* (Moscow, 1963): *partynost,* pp. 255–261; *ideinost,* pp. 107–110;
and *narodnost,* pp. 223–227.

first thesis, *partynost* (party character) in literature meant that literary activity had to "become a 'part' of the general proletarian cause . . . a part of organized, systematic, united social-democratic party work."[59] Lenin stressed that writers "must without fail enter Party organizations," that newspapers must become attached to such organizations, and that publishing houses, libraries, and so on must account for their activities to the Party.[60] It was on the basis of this thesis that the Party ultimately justified its control of the arts; in the April 1932 decree of the Central Committee of C.P.S.U., it was directly specified that the Union of Soviet Writers would be formed "with a Communist faction therein."[61] The 1936 constitution also provided that the Communist Party be the "directing nucleus of all organizations of working people, both state and public" (Article 126). At the First Soviet Writers Congress in 1934, the precepts of *partynost* were revealed as the "guiding principles" of all Soviet creative activity. Clearly, the identification of the artist with the proletarian cause emerged as the essential aspect of this broad theory.

Ideinost (Socialist content) was defined as the ideological direction of artistic works; it meant stressing the importance of content in art, based on the principle of Marxist-Leninist aesthetics and viewing art not only as a powerful means of realizing reality but also as an active influence upon it.

Narodnost (national roots), which is closely related to *ideinost*, was defined as the expression in art of the interests, ideals, and spirit of the working masses. Art comes from the people as "makers of history," from their folklore, language, and customs; and "belongs to the people," as Lenin's second thesis indicates. Both *ideinost* and *narodnost* merge in the all-embracing *partynost*, for the party is "the guardian of the ideology, the embodiment of the people's will." Its program is at once the projection of historical laws and an instrument for

[59] Lifshits, p. 112.

[60] *Ibid.*, p. 113.

[61] "O perestroike literaturno-khudozhestvenikh organizatsy: Postanovlenie TsK VKP(b) ot 23 aprelya 1932" [On Reconstruction of Literary-Artistic Organizations: Resolution of the Central Committee of the Great Communist Party (Bolshevik) of April 23, 1932], *Na Literaturnom postu*, No. 12 (April, 1932), p. 1.

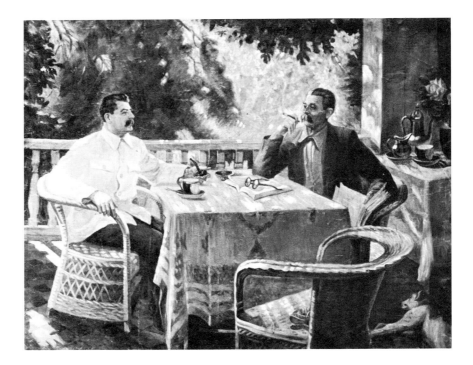

Figure 6. Koltsov, Stalin and Gorky at the Dacha
(1947). Oil on canvas, 55 x 66".

The coining of the phrase "socialist realism" is credited to Maxim Gorky and
Stalin. Gorky's novel *Mother* (1906) is said to have been the first work of socialist
realism. This painting by the official artist Koltsov marks the historic occasion
which took place at Gorky's *dacha* in 1932. Once owned by the Union of Soviet
Artists, adorning its august halls, it now is in the possession of the authors.

achieving the inevitable, ethically desirable outcome of the historical
process.

Accordingly what is true, as well as what is ethically good, in a
classless society, must correspond to Party policy and serve the Party's
aims, since the Party is the single source of truth. If representation of
truth is the essence of a work of art and truth the final aesthetic cri-
terion, it is evident that the aesthetic value of the artist's work de-
pends on his faithful reflection of the Party viewpoint. Consequently,
"any deviation from the principle of *partynost* produces an unwitting
distortion of reality."[62] "Whoever is not armed with Marxist-Leninist
ideas loses perspective in his daily work and inevitably makes mis-

[62] See A. Tarasenkov, "Zametki i kritika" [Notes and Criticism], in *Znamya*,
No. 16, 1949, p. 176.

takes,"[63] for if ideas reflect and serve class interests, any ideas diverging from the proletarian ideology would represent hostile class interests resulting in a distortion of reality and a loss of aesthetic value. Thus, the artist who deviates from social realism serves interests alien to the proletariat and to his creative efforts: "Socialist realism is the only method of our art. . . . Any other method, any other 'direction' is a concession to bourgeois ideology. . . . In our country, where socialism has been victorious, where there has arisen a moral and political unity of the people unprecedented in the history of mankind, there is no special basis for different directions in art."[64]

In the Soviet view, then, art is not solely an "image" of man's intellectual perceptions, but must serve as an image of the state as well. Art must become "an ideological device or instrument in the reeducation of people in the organization, mobilization and activization of their revolutionary, militant consciousness."[65]

Consequently, little recognition was given to the distinctively personal quality of artistic creation, the quality that distinguishes creative endeavor from other kinds of human activity. In other societies, particularly those in the West, fine art serves no ulterior purpose — that is, artistic productions are valued in and for themselves. In the Soviet Union, however, art serves an outside purpose lying beyond the works which themselves become a means to an end — the aggrandizement of the proletariat revolution. This Revolution is still in process and will remain so until the final victory of communism. The recognition that art conveys information and has a moral impact puts aesthetics in a compromised position, transforming art into a doctrinal motivator, with consequent heavy pressure on potential aesthetic qualities.

In this representation, "reality" became dependent upon adherence to the inflexible world view of Marxism-Leninism; and socialist realism — the end product of this evolutionary process — became

[63] See "Vyshe znamya ideinosti v literature" [Raise the Banner of Ideological Content in Literature], *Znamya*, No. 10, 1946, p. 30.

[64] See Za dalneisy podyom sovetskoi literatury" [For Further Development of Soviet Literature], *Kommunist*, No. 9, 1954, p. 24.

[65] Todor Pavlov, *Pytanya teorii ta istorii literatury* (Kiev, 1959), p. 26.

more than an aesthetic theory to which the artist is obliged to adhere. It became more than a matter of taste or preference for one style or another. In both art and literature, it forbade the artist, in the words of Czesław Miłosz, "to look at the world from his independent viewpoint, to tell the truth as he sees it."[66] On the contrary, it required conformity in viewpoint and aesthetics, reserving judgment of values to the state.

As we saw earlier, the First Congress of Soviet Writers in 1934 officially defined socialist realism as "a truthful, historically concrete representation of reality in its revolutionary development," aiming at the "ideological education of the toiling masses in the spirit of socialism."[67] Translated into the functional language of the Soviet state, this meant that art was to represent reality not as it actually appears to the artist and as he perceives it, but as it ought to be or will be in the future.

In most Western societies (and in a few Socialist countries) artists have the freedom to create according to their ideals, subject to relatively loose and general social controls and influences. For the Soviets, the artist becomes "a participant in the general constructive labor in the building of communism" whose sole purpose is the "engineering of human souls in the spirit of socialism."[68] By becoming an artist he acquires political responsibility; in "leading the masses" he is not a *reflecting* but a generating, driving force, and responsible so to remain.

Reality for the artist in the West is based upon individual perception and free choice in the form of expression. In expressing his own point of view he presumably serves society if only because he is a part of it. Reality, then, becomes a sum of individual points of view. For the Soviets, on the other hand, reality is a monolithic dogma which must be the only point of view of every artist. Only then does art become intelligible to all, loved by all, evoking in every beholder the identical response. In common with most Western artists, we find

[66] Czesław Miłosz, *The Captive Mind* (New York, 1953), p. xii.

[67] *Pervy vsesoyuzni syezd sovetskikh pisatelei*, p. 1.

[68] See *Kratky slovar terminov izobrazitelnovo iskusstva*, (Moscow, 1959), pp. 60–61.

this policy utopian and impossible, since in fact no two intelligent and complex human beings can ever be in total concurrence, let alone an entire nation. In this sense socialist realism, as it has been practiced in the U.S.S.R., at best remains a contradiction in terms. To us, this realism implies a dispassionate analytical stance which is assumed by the artist without sentiment. If emotion enters into realism, it is generally of a critical nature intended to instruct by way of a bad example rather than a good. If a noble element is to be portrayed, it is generally in juxtaposition with the ignoble forces which hold it in thrall. In short, although such realism is essentially didactic, it is also essentially negative. Visionary artists have not been found among the realists. However, the Soviet state requires that its artists combine realism and visionary art. The point here is not to impugn the Marxist view of history and its hope for the future; whether the classless society will come to pass or not is not the question. The question is: is socialist realism genuine art?

Max Rieser has said that in contemporary Italy, socialist realism might be termed a "poetics" rather than an aesthetics, an agreed-upon cognition of the society. V. Dneprov in *Problems of Realism*,[69] has argued that socialist realism is a "method" rather than a "style," but the distinction seems a bit subtle. Subject matter is not method. The Soviet aesthetician, V. A. Razumny has written:

The contents of his [the artist's] work must mark the ideological searchings of his contemporaries. When solving his individual problems of creation and embodying his subjective ideas of beauty, the artist is consciously or unconsciously the aesthetical interpreter of the political, moral, and philosophical ideals of certain social forces. . . . Only artists faithful to the destiny of their people, artists defending progressive democratic ideals, create works of lasting and genuine artistic value. . . . Some artists try to avoid moralizing but become thereby bogged down in a mere description of their own milieu; they therefore become unable to reach the culmination of great typical generalizations. Socialist realism does not prevent the artist from searching new unexplored ground. . . . Its main requirement

[69] See the chapter "O tvorcheskom metode i khudozhestvennykh stilyakh" [On the Creative Method and Artistic Style] in *Problemy realizma* (Leningrad, 1960), pp. 232–279.

remains, however, a true presentation of life.[70]

Socialist realism is an art of the ideal — the Marxist ideal. It represents moral good in terms every man can understand, which means that its form is limited to the photographic or naturalistic portrayal of man and his environment. Techniques which exaggerate or stylize are suspect. Abstractions are hardly moral if they cannot mirror ideology, therefore they are immoral. The "great typical generalizations" to which Razumny refers are not art forms but symbols of the people, images. But such secular iconography is more than "poetics" or "method." It is a medium of creative expression which, by Western standards, may have failed as art but evidently is an effective political instrument.

[70] See V. A. Razumny, "Iskusstvo i esteticheskoye vospitanie" [Art and Esthetical Education], *Kommunist* (Moscow), No. 2, 1957.

Official Organization of Art

AFTER the October Revolution Russia's art was disorganized and ideologically divided. The measures of the new government to bring about *obshchestvennuyu otvetstvenost* (social consciousness) was met with hostility by many artists and members of the intelligentsia. As discontent in the ranks of art increased, government coercion became stricter. Artists went into exile or maintained a passive role as best they could. Chagall, Gabo, Pevsner, Lissitsky, Malevich, Kandinsky — to name but a few — became voluntary exiles. Filonov, Tyshler, and Altman are examples of those who remained but pursued their work in obscurity. Stravinsky, Diaghliev, Nijinsky, Fokine, Pavlova, Gontcharova, Massine, Bakst, Balanchine, and others continued their work in emigration and were thus lost to Russia.

Those artists who welcomed the promise of the new regime disagreed among themselves as to the means of fullfilling it. The various groups of the artistic community vied for the chance to head the vanguard of the new ideology. Some artists of the "left" — the Futurists, Suprematists, and Constructivists — managed to install themselves in positions of influence until the "wheel and the screw" of the new system was applied to their individualistic, nonobjective art.

These artists included the Constructivists Tatlin and Rodchenko, and the Suprematist Malevich. They came to be called the "revolutionary formalists" or "Communist Futurists," *Komfuty.* They opposed illusionistic representation in painting, claiming that the camera had already made the art of representation painting obsolete. Accordingly, the strict study of anatomy and animal life was also outdated, as the artists no longer needed it in their search for abstract expression. In an effort to reach the public, or the proletariat, a cam-

paign was launched to bring their art to the masses under the slogan: "Art belongs to the streets, squares, and public buildings!"[1]

Almost overnight these artists succeeded in placing their art in the forefront of the "marching Communist society" and managed to set up their own museums throughout the country, introduce abstract art in the school curricula, and take charge of street decorations — for example, for the 1920 May Day and October Revolution parades. Tatlin designed a monument in homage to the Third International.[2] And a little later, in the wake of the NEP (New Economic Policy) period, Lenin's mausoleum at the Red Square in Moscow was designed by the former constructivist, Alexei Shchusev, although the building itself is not constructivist.

[1] For a general discussion of this phase, see Camilla Gray, *The Great Experiment* (New York, 1962), pp. 215–240.

[2] *Ibid.*, plate 168.

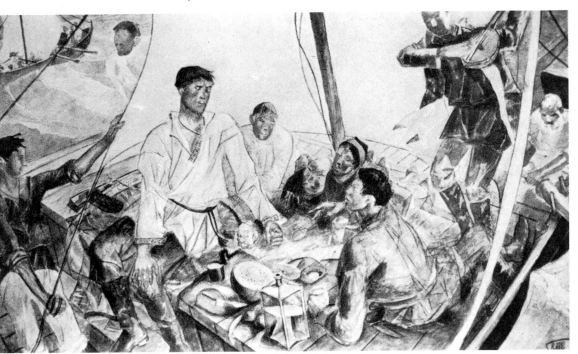

Figure 7. Petrov-Vodkin, Stepan Razin. **Petrograd (1918). A sketch for a decorative panel for the Theater Square in Petrograd.**

By 1922, however, the Formalists were challenged by the official edicts on art and, in addition, by the conservatives in the art world itself. Among the challengers was the AKhRR (Association of the Artists of the Revolution). The AKhRR called on artists to enlist their talents to glorify the achievements and goals of the Revolution, to assist in building socialism — the same tasks in which *Komfuty* had been engaged. The artists of the AKhRR, however, were traditional in outlook. Their numbers included such excellent academicians as Brodsky, Katzman, and Sokolov-Skalya. They were, it should be noted, easel painters.

Another group, the "October Society," sought to unite all the artists, left and right. Some of the avant-garde group found refuge in industrial design. The OST (Society of Easel Painters) demanded protection from the attack of the avant-garde and won again its place in the Socialist society. And there were other groups — the "Red Rose" (a group of Leningrad expressionists), the "Circle," the "Four Arts," the Society of Landscape Painters, and many more. There was little unity between the various factions; controversy flourished as each group considered its method best. Despite the bickering, most circles showed sincere desire to play their role in the "building of socialism," and many controversies centered on this point: which group would play the leading role as the reflection of the new state.

During this time of ferment, the Party generally acted as an arbiter among the various groups and made little effort to establish an official aesthetic theory and control over the arts;[3] it was kept busy with the complexities of problems arising from the Civil War, the NEP, change in the leadership (the rise of Stalin), and preparations for the First Five-Year Plan. However, further mobilization of the social forces was soon considered necessary to carry out the goals of the new state. Finding the art of the leftists "unintelligible," at a time

[3] The *proletkult* (Proletarian Culture) faction did meet its fate at the hands of the Party. Proclaiming itself an "autonomous organization of proletarian artists ...working side by side with the Communist party and the trade unions," it put its claim to "rightful" leadership in Soviet arts. This group of self-appointed "specialists in proletarian culture," headed by A. Bogdanov (pseud. for Malinovsky), antagonized Lenin with their tactics, and he dissolved the organization in 1923.

when the masses had to be reached, the Party soon abandoned formalism for the more traditional and visually communicative art of realism. As early as 1922, on the occasion of the fifth anniversary of the October Revolution, an exhibit was held in Moscow at which the old Wanderers school, with a new generation of followers, gained noted success in the eyes of both officialdom and the general public. As a result, the Wanderers were quickly nurtured back to life. The right wing, consolidating its forces in the AKhRR organization, began to maneuver the left wing out of its position of influence. By 1924, Anatoly Lunacharsky, head of *Narkompros* (the Commissariat of Enlightenment), who had earlier favored the work of the modernists, under mounting pressure switched his support to the right wing.

That same year an exhibit, the so-called "Discussion Exhibit," was held in Moscow, where the works of the left and the right were deliberately juxtaposed for public view and comparison. In the discussion and debates which followed on the exhibit floor, presided over by the Party theoretician Bukharin, the leftist artists lost considerable ground. The unenlightened public had never seriously taken to their art, and now, given a rallying point, went over to the realists. By 1925, the leftists were fighting for survival.

Debates on socialist realism began to play a major part in the events of the day. Stalin and the Party elite wanted an art which would powerfully contribute to the economic development of the country by moulding the mentality of the Soviet citizen in the spirit of socialism. In 1929, painters, graphic and decorative artists, sculptors, and architects were united in a single artists' cooperative, the *Vsekokhudozhnik*, under the leadership of Yu. M. Slavinsky. It was hoped that it would bring about the unity and creative uniformity capable of placing Soviet art behind the industrialization-collectivization drive. By this time the older generation of realists such as Favorsky, Kupriyanov, Petrov-Vodkin, Brodsky, and Lebedev were training a young generation of realists. Favorsky, for example, trained the painters Deneyka and Pimenov as well as the graphic artists Echeistov, Goncharov, Pikov, and other outstanding engravers. Kupriyanov trained the Kukryniksy trio, and Lebedev worked with Pakhomov, Charushin, and others.

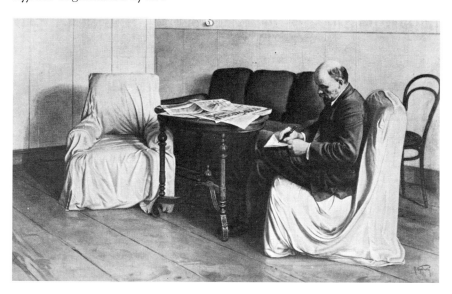

Figure 8. Brodsky, V. I. Lenin in Smolny **(1930).**

It was during this time that the first socially conscious works of Soviet painting and sculpture were created: Petrov-Vodkin's "Death of a Commissar," Deneyka's "Defense of Petrograd," Sokolov-Skalya's "People and Years," pictures by Pimenov, Williams, Nissky, Yohanson, S. Gerasimov, and sculpture by Vera Mukhina, Shadr, Somova, Korolyev, and others; the graphic artists Deny, Lebedev, Mayakovsky, Goncharov, and Kravchenko — their art strongly reflecting the spirit of the Revolution — had attained a realistic contemporary quality from the outset. The "Rosta Windows" of Mayakovsky had already become a legend.[4]

When the First Five-Year Plan ended, it was realized that there was a need for citizens who would consciously contribute to the development of the country — citizens who would seek the common good (in contrast to those who seek their own welfare, as in the bourgeois societies). Hence, Soviet art, to fulfill its function, must be "So-

[4] For a historical and illustrated documentation of the 1917–1934 period, see the official history of Russian art *Istoria russkovo iskusstva* (Moscow, 1957), Vol. XI.

cialist in content." Since the Soviet Union is a Socialistic society of collective owners of state property, and a democratic state of multi-national character, its art must reflect both its multinational and So-cialist-content character. Thus, this fusing of the national cultures emanating from the numerous peoples of the U.S.S.R., guided by the principles of socialism, social consciousness, and socialist reality would bring about the new Communist art.[5]

In 1932 the fate of Soviet art was decided by the resolution of the C.P.S.U. Central Committee decree "Reorganization of Literary and Art Institutions,"[6] which set the stage for the monolithic doctrine of socialist realism and the final Party control over the arts. The decree specified that all independent or unofficial art and literary groups be liquidated and replaced by unions, "with a Communist faction

[5] Addressing the Sixteenth Party Congress Stalin called for an "art that is national in form and socialist in content." See Y. V. Stalin, *Sochinenia* (Moscow, 1951), XII, 369.

[6] "O perestroike literaturno-khudozhestvennykh organizatsii: Postanovlenie TsK VKP (b) ot 23 aprelya 1932" [On Reconstruction of Literary-Artistic Or-ganizations: Resolution of the Central Committee of the Great Communist Party (Bolshevik) of April 23, 1932], *Na Literaturnom postu*, No. 12 (April, 1932).

Figure 9. Sokolov-Skalya, The Storming of the Winter Palace **(1939).**

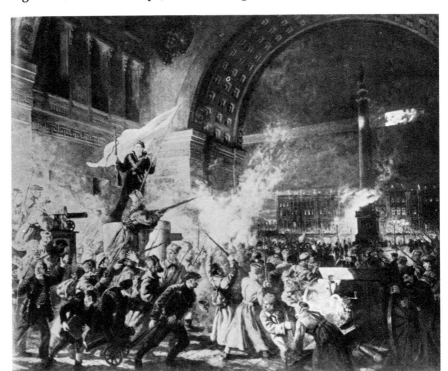

therein"[7] carrying out Party policy. This gave the Party the exclusive right to concern itself with every aspect of artistic and literary life in the country.[8] Soon every art organization in the country had its influential Party faction. The Party organizations from the central offices of the *Vsekokhudozhnik* down to the local artists' groups in the provinces became responsible for ideological education of its members.

The outcome of the 1932 decree, which resulted in quick organizational and doctrinal measures, revealed to the Soviet artist the inevitability of conformity and compliance with the precepts of socialist realism, which now required the artist to render examples of real life in a style of "artistic realism." As it was propounded in the 1932–1934 period, realism became social-realistic when it took portrayal of the new life in the context of "revolutionary development" with the "ideological education of the masses in the spirit of socialism" as its chief task. This meant that the artist had to create in a certain form, and that the content of the work — being most important — must express Communist ideology, or at least be in sympathy with it. In other words, as Engels once said: "In the beginning form is always neglected for content. . . . "[9]

Once the artist accepted the Party's formula that "artistic quality is judged by its content," conformity was achieved to such a degree that the Party found no further need to centralize its control over the visual arts; the formation of the Artists Union was postponed until 1939. However, in the spring of 1936, two years after the formation of the Writers Union, the Committee of Art Affairs was founded under the leadership of P. M. Kedzenzev to supervise musical, theatrical, film, and fine-art affairs, but only as an intermediate step until separate unions could be formed.

By the mid-thirties, then, the blow dealt to "formalism" was so severe that the Party postponed the organizational and centralized

[7] *Ibid.*, p. 1.

[8] Also guaranteed by the Soviet constitution which provides that the Communist party is the "directing nucleus of all organizations of the working people" (Article 126).

[9] See Engels' letter to Mehring of July 14, 1893, in *Karl Marx's Selected Letters to Frederick Engels* (Moscow: Marx-Engels-Lenin Institute, 1934).

control of the visual arts until the end of the decade. ("Formalism" is a pejorative word, applied loosely today in the Soviet Union to works of art — and to some extent to literature — that lack ideological emphasis.) In an authoritarian state, lack of centralization in a particular facet of the society suggests that ample conformity has been achieved. When pressure is applied, however, manifesting itself in the creation of centralized agencies, it is to affirm control. This was the case with the abolition of the literary organization RAPP (Russian Association of Proletarian Writers) in 1932, followed by the formation of the Writers Union in 1934. Had RAPP been successful in securing conformity on the literary front, it would probably have continued for several years more.[10] We can assume, then, that the *Vsekokhudozhnik,* founded in 1929, was effective enough until 1936, when it came under the Committee for Art Affairs. The latter lasted until 1939, when its supervisory and organizational-political activities were taken over by the *Orgkomitet* (Organization Committee of the Artist Union).

Before the organizational, professional, and functional aspects of the Artists Union are discussed, it is worthwhile, for the sake of chronological continuity, to consider briefly some of the events of the World War II period, during which the union was left formally intact, although various interim events influenced its character. In the immediate prewar period, following the great purge of "Trotskyite traitors" and "Fascist spies," during which many modernists perished, Stalin, further defining the role of the artist, said at the Eighteenth Party Congress in 1939:

A follower of Lenin cannot be just a specialist in his favorite science or art; he must also be a social and political worker taking a vital interest in the destinies of his country. He must be well acquainted with the laws of social development; he must be able to apply these laws and must actively participate in the political guidance of the country.[11]

[10] Gleb Struve, *Soviet Russian Literature, 1917–50* (Norman, 1951), p. 237.
[11] See Stalin's speech in *XVIII syezd vsesoyuznoi kommunisticheskoi partii (b): Stenografichesky otchyot* [Eighteenth Congress of the All-Union Communist Party (Bolshevik): Stenographic Report], (Moscow, 1939), pp. 174.

44

In other words, the artist had to be an "engineer of men's souls" — Stalin's favorite term for the artist in the Soviet society. By the end of the decade all artists who wished to live by their art had indeed turned their labor to producing works of art in accordance with "the laws of social development."

In view of the restricted range of subject and style made available to the artist by the precepts of socialist realism, in addition to the official artistic homage paid to Lenin and Stalin, the artist's choice of subject was almost entirely confined to the general theme of the "new Soviet man" and the "new Soviet society" depicted by scenes of industry, construction, and collective farm work.

Landscapes, seemingly a nonpolitical subject, were only permitted if they showed the countryside in "Socialist transformation" using such devices as dams or electric power stations. All portrayals had to be optimistic because the victory of the proletariat had been achieved — "negative pessimism" was not permissible. Already the artist, in accordance with official dogmatism, had to accept and guide himself by the immutable law of "kritika i samokritika" (criticism and self-criticism) in which he knew what to paint and what not to paint. In other words, he had become his own personal state censor.

Figure 10. Solovyov, Toward Communism! In One Rank, Toward a Single Goal! **(1963). 22½ x 45″.**

This political poster, epitomizing what Stalin called "art national in form and socialist in content," depicts the multinational character of the current society marching united toward the Communist future.

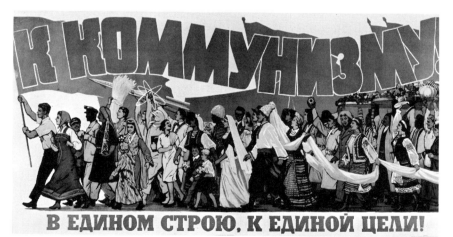

В ЕДИНОМ СТРОЮ, К ЕДИНОЙ ЦЕЛИ!

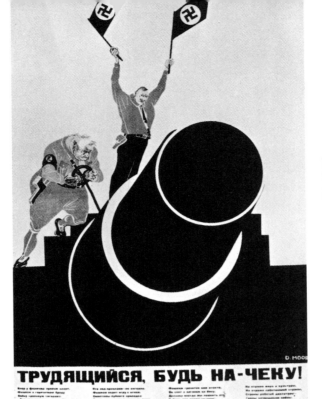

Figure 11. Moor, D., Worker, Beware! **(1936).**

ТРУДЯЩИЙСЯ, БУДЬ НА-ЧЕКУ!

At this stage of development Soviet Socialist art was interrupted by the struggle for national survival in World War II, when the precepts of socialist realism, along with many of the extremities of Soviet Communist ideology, were abandoned for the moment. Many artists exchanged the brush for the rifle and went to war with the rest of their countrymen. Some fought and died in the war while others worked behind the lines in propaganda departments illustrating for the news media and turning out posters. The poster once again took on the leading role in a national crisis, as the main visualizer of the state, in the never-ending task of keeping the masses mobilized behind the giant war effort. The old 1917 revolutionary spirit was given new vitality, with some veterans of poster art such as Moor, Yefimov, Radakov turning out a stream of propaganda combating the Nazi propaganda machine. They were joined by many newcomers, trained in Soviet schools, such as the Kukryniksy group, Deyneka, Kanevsky, and others.

Throughout the war the control of the arts remained relaxed but the war's end radically changed this situation. In the aftermath of the German retreat (from 1943 on), with the real threat of the invader

diminished, artists took the opportunity, particularly in literature, to regain some of their expressive freedom.[12] But the end of the war brought an abrupt tightening of the ideological lines. Content once again became the sole criterion of artistic evaluation.

Defeating twelve German armies on the Eastern Front by the stamina of its leadership and the fortitude of the Russian people, despite the useful but not decisive Allied aid, the Soviet Union emerged from World War II as a powerful Communist nation and leader of the Communist world. After the war, the alliance with the capitalist West, which was nothing more than a strategic move in a time of crisis, came to an abrupt end in 1945 when the Soviet leadership found it no longer necessary, and the former struggle between the two opposing world systems was fully resumed. Also, the country had just gone through an unprecedented devastation, genocide, and famine, with its industrial might seriously crippled; hence new sacrifices had to be made by the Russian people to rebuild the fatherland. In both these factors ideology was deeply involved. If the Soviet Union was to remain an effective world power it quickly had to reach the masses through many avenues, and art was an old and proved method. It was necessary to drive away the fog of sentiment which had gathered during the war years; the Soviet position on the capitalistic West had to be communicated in a decisive fashion; and the massive job of reconstruction at hand demanded use of every method of communication with the people. State control over the arts was tighter and omnipresent.

[12] At the end of 1943 the writer Mikhail Zoshchenko wrote and serialized in the journal *Oktyabr*, a collection of autobiographical sketches titled "Before Sunrise," in which he attempted to discover the cause of his melancholia. Official critics attacked the work for its unpatriotic overtones, and the author for distorting life, selecting "the ugliest and most trivial facts in his biography," and being preoccupied with his own "philistine emotions, interests, and notions." See L. Dmitriev, "O novoi povesti M. Zoshchenko" [About the New Story of M. Zoshchenko], *Literatura i Iskusstvo*, December 4, 1943. For the two installments of the autobiography, see Mikhail Zoshchenko, "Pered voskhodom solntsa" [Before Sunrise] *Oktyabr*, No. 6–7 (1943), pp. 58–92; and No. 8–9 (1943), pp. 103–132. For a good case study of the Zoshchenko affair, see Rebecca A. Domar, "The Tragedy of a Soviet Satirist: The Case of Zoshchenko," in Ernest J. Simmons (ed.), *Through the Glass of Soviet Literature* (New York, 1954), pp. 201–243.

A decree issued by the Central Committee of the Party on August 14, 1946, laid down the direction that postwar literature, as well as the other arts, would take in the future.[13] A particular attack was made on two Leningrad journals, *Zvezda* (Star) and *Leningrad*, which were denounced for their lack of ideological content and for being "ideologically harmful."[14] The editors were criticized for their apolitical orientation and for having forgotten the basic tasks of Soviet journals:

The Soviet system cannot tolerate the education of youth in a spirit of indifference to Soviet politics, to ideology, with a carefree attitude. The strength of Soviet literature, the most advanced literature in the world, consists in the fact that it is a literature in which there are not, and cannot be, interests other than the interests of the people, the interests of the state. The task of Soviet literature is to help the state educate youth correctly, to answer its requirements, to bring up the new generation to be strong, believing in its cause, not fearing obstacles, ready to overcome all obstacles.[15]

The Central Committee decree then ordered *Leningrad* to cease publication and *Zvezda* to mend its ways, which it soon did under the editorial direction of the Party appointee A. M. Egolin, the deputy chief of the Central Committee's Propaganda Administration. After that, *Zvezda* was ordered to stop publishing the works of the writer Mikhail Zoshchenko and the poetess Anna Akhmatova. The former was denounced for writing only about the seamy side of Soviet life in order to paint an anti-Soviet picture and to ridicule the Soviet people, and the latter was attacked for portraying "moods of loneliness and hopelessness, alien to Soviet literature."[16]

This reversal of the cultural policy ushered in the so-called Zhdanov era or Zhdanovism, one of the most sterile periods in Soviet arts, which lasted from 1946 until 1953. Andrei Zhdanov, secretary of the Party's Central Committee and chief of the Propaganda Administration, had been active in the arts since 1934 when he took over the

[13] See *Pravda*, August 21, 1946, or *Bolshevik*, No. 15, 1946, pp. 11–14.

[14] See "O zhurnalakh *Zvezda* i *Leningrad* [About the Journals *Zvezda* and *Leningrad*], *Zvezda*, No. 7–8, 1946, pp. 3–6.

[15] *Ibid.*

[16] See Andrei Zhdanov's speeches in *Bolshevik*, Nos. 17–18, 1946, pp. 4–19.

ideological work of the Party after the murder of Kirov, the secretary of the Leningrad Party Committee and a popular national figure. Zhdanov could hardly have been responsible for the over-all repressive policy, but he energetically delivered, supported, and administered the cultural policy of this era which bears his name. His success or failure is illustrated by the fact that he fell in official disfavor, just before his death allegedly from heart attack in 1948. It has been suggested that his death was arranged either by Stalin who feared his takeover (possibly because of Zhdanov's bungling of the Cominform affair in Eastern Europe — the case of Tito), or by Malenkov, standing most to gain by it, who replaced Zhdanov and later became Stalin's successor.[17] In any case, Zhdanov's name remains associated with the hard-line political orthodoxy of the period, and the decrees which he promulgated in 1946–1948 on literature and related arts remain as legacy of his era. In fact, the third volume of the Academy of Sciences *History of Soviet Literature*, published in 1961, refers to the decrees as "retaining in principle their significance even today."[18]

It was at the peak of the Zhdanov era, during the general purge of not only literature but the theater, cinema, music, and architecture, that another control agency entered the artistic scene. The Academy of Arts of the U.S.S.R. was established by the Council of Ministers in 1947 to serve as the organizing center of Soviet fine arts. Alexander Gerasimov, the exemplar of socialist realism (famous for his portraits of Stalin) and a leading figure in Soviet art from 1932 to 1953, was named as the president. No other Soviet painter did so much to glorify Stalin's image. Perhaps no other court painter as familiar with his subject as Gerasimov must have been (in more than twenty years of continuous association) ever overlooked the shortcomings of his ruler so thoroughly — including Stalin's small stature.

[17] See Zbigniew Brzezinski, *The Permanent Purge* (Cambridge, 1956), pp. 23, 151–167, 241; and the valuable analysis and text of the 1956 Krushchev secret speech, in which for the first time he officially revealed the magnitude of the Stalin purges, by Bertram D. Wolfe, in *Khrushchev and Stalin's Ghost* (New York, 1957).

[18] T. K. Trifonova, "Literatura poslevoennovo perioda", *Istoria sovetskoi literatury* (Moscow, 1961), III, 56.

The seventeenth-century Spanish court painter Velasquez, who was also expected to glorify his ruler, King Philip IV, managed to portray him honestly by representing the King's human weaknesses, which was not too pleasing to the royal court. Gerasimov, on the other hand, confined his imaginative technique to what the image of Stalin "ought" to be like, in accordance with the personal likes of the subject and the national image of the ruler, both consistent with the precepts of socialist realism — representing reality not as it is but what it should be.

Gerasimov's ennobling portraiture of the *Vozhd* (leader, as Stalin was often called), reproduced in millions of copies in the form of office portraits, posters, newspaper and magazine illustrations, distributed all over the world, added much to Stalin's charisma, which Stalin effectively employed in his rule over Soviet society and the in-

Figure 12. Gerasimov, Stalin and Voroshilov at the Kremlin **(1938).**
Voroshilov was in fact taller than Stalin.

ternational Communist movement. In that respect, Gerasimov played no small part in promoting what later came to be called the "cult of personality" and the "excesses of Stalinism." Hence, in the post-Stalin era Gerasimov disappeared from the creative scene almost as quickly as the leader and his portraits from Soviet life. Both left their indelible mark on the country's political and creative life, reflected, as we shall see, in the organizational aspects of the Artists Union.

The Union of Soviet Artists was formed in June, 1939, when a group of thirty-eight persons was named to serve on the *Orgkomitet* to work out the organizational and cadre problems of the new union. By the end of 1940, the committee had formed artist unions in eleven republics (Azerbaydzhan, Armenia, Belorussia, Georgia, Kazakhstan, Karelo-Finnish Republic, Kirgizia, Tadzhikistan, Turkmenistan, Uzbekistan, and Ukraine) and fifty-three regional creative groups in autonomous republics, regions, and districts of the R.S.F.S.R. Republic, including the artist unions in Moscow and Leningrad. By 1941 the union had a membership of 3,724 painters, sculptors, graphic artists, theater and film actors, and art critics.[19]

The organizational and functional framework of the new union was not established in this period. World War II interrupted its activities. The union's formal integration was postponed until several years after the war. Its organization was first impeded by the Zhdanov cultural purges in 1947–48; then by the purging of Zhdanovists after the latter fell into disfavor. Before any formal unity could be achieved, Stalin died; the Party succession struggles, the 1956 discrediting of Stalinism, and the Eastern European difficulties followed. It was not until Khrushchev was firmly in power that the First All-Union Congress, the governing organ of the Union of Soviet Artists, convened in February-March 1957, eighteen years after the formation of the union. However, between 1939 and 1957, eighteen plenums of the *Orgkomitet* had met and carried on the union's usual business. It served its function for eighteen years until orthodoxy was successfully challenged on the creative front in 1956, compelling the new leadership to usher in the last instrument of centralization and call to ses-

[19] This figure and much of the following data are taken from *Materialy*.

sion the First Congress of Soviet Artists on February 28, 1957.

The governing organ of the Artists Union was the presidium of the Organizational Committee, elected at the first plenum of the *Orgkomitet* in July 1939. It served as the functioning organ until March 1951 when it was replaced by the *Orgkomitet Secretariat*.[20] Both the former presidium and the present secretariat handled all creative and administrative problems of the republic unions, creative homes, the journals *Iskusstvo* and *Tvorchestvo*, exhibits, the publishing house Sovetsky Khudozhnik, the Artists Fund, and the Office for Protection of Authors' Rights.

The membership of the Artists Union is composed of painters, graphic artists, and art critics. To become a member of the union, the artist has to file a formal application accompanied by representative examples of his work or, in the case of critics, publications. Recommendations from three reputable members of the union, vouching for the applicant's talent and good moral character, must be submitted with the application, whether he is applying for candidate or regular membership. Application may be submitted to the central organs of the all-union, republic, and Moscow and Leningrad unions; however, the final decision is made by the central union in Moscow, and membership in any of these automatically includes membership in the main body. Regular dues are made out to the central union, but paid to the local affiliate.

Acceptance is based on the applicant's political and educational record (young artists must be members of the *Komsomol* youth organization and have a thorough grounding in Marxism-Leninism). Talent is, of course, important but not prerequisite, as long as the desire to work and the inclination toward Socialist art is genuine. Assistance from influential artists and friends is a common occurrence.[21]

[20] For a breakdown of the secretariat and the 143-member praedisium of the union, elected at the Second Congress, see *Iskusstvo* (Moscow, 1963), No. 16, p. 18.

[21] In the aftermath of the Manège Affair (see Chapter IV), when sharp lines were drawn between conservative and liberal camps in the creative community, the sponsors were criticized more than their dissident young protegés. The latter were simply refused membership into the union, while their older colleagues and

But even in cases where membership is secured under the protection of a VIP, politician or artist, the applicant's record is checked all the way back to the art studies taken at the "Pioneers' Homes" — schools and workshops for youths. It is relevant at this point to say something about the artist's early training.

Drawings of Soviet children up to the age of seven do not differ much in form or content from those of their counterparts elsewhere. They are full of the usual fantasy and naiveté, displaying a strong feeling for color and form, and containing no elements of socialist realism. To the contrary, the representative and abstracted figures, which Soviet children also draw, are highly individualistic. Formal instruction begins at seven and continues until twelve, but socialist realism is absent from this period, too. Drawing lessons taught to children stress the rules of perspective and chiaroscuro discovered by Leonardo da Vinci. Those with a predilection for art are encouraged early in life (nine to fifteen) to attend art courses at the Pioneers' Homes, where they are taught to paint more complex objects and landscapes (after the manner of the nineteenth-century Russian painters such as Repin, Levitan, and Serov). During this instruction they are taught how to judge works of art by the criteria of "resem-

backers were threatened with loss of their jobs.

The conservative elements in the union continue to fear creeping *sub rosa* modernism. In our discussions with young applicants, they related personal experiences indicating that a closing of the ranks, on behalf of the conservatives in the union, had taken place after the Manège Affair. By 1964, the situation was so tight "you couldn't even get in with a portrait of Khrushchev," complained one young artist; his colleague, an excellent illustrator of children's books, added jokingly: "Of course not, you jackass, don't you know that 'kukuruzny' doesn't like to be eulogized!" Evidently true, for Khrushchev in fact, had refused to be rendered in the monumental arts: we found no busts or statues of him. Even the placards and posters, although they paid tribute to him, did not represent him as frequently as the previous leaders.

Born in the agricultural Ukraine and identifying himself over the years with sweeping agricultural policies — for example, the corn-growing drive in the virgin lands of Central Asia — Khrushchev gained the nickname "kukuruzny" or "corny." The expression was widely used, and not necessarily in the derogatory sense, although, as some conceded, there was more to the meaning than the professed agricultural association, as Khrushchev was also well known for his unsophisticated style and barnyard Russian.

blance" and "beauty." Still, the precepts of socialist realism remain to be introduced.

Generally, the training of young artists lasts for about fifteen years. Between the ages of twelve and eighteen many students study at secondary art schools which also provide them with a general education. Upon completion of school they may take competitive examinations for higher educational art institutions, which require five years of study. Another procedure is to study in a regular school for seven years and then enroll in an art school or a technical school which graduates art teachers and applied artists. After completion of this school students who distinguish themselves may enroll in the art institutes. To be accepted in any art educational institution the student must take competitive entrance examinations in practical drawing, history of the U.S.S.R., Marxism-Leninism, foreign language, and other subjects. The way to the membership in the Artists Union depends on the student's good academic record and character reference from such an institution. Upon successful completion of his studies (which require a thorough mastery of the forms of socialist realism) the new graduate usually secures employment in the commercial field or in an educational institution, at which time or some later date he may apply for membership in the union.

The list of channels through which the application of a young artist must travel is long. An application for membership first has to be made to the creative section of the local organization where, if desirable, it is accepted by the admissions commission and the local secretariat. Then it is sent to the Artists Union headquarters in the appropriate republic, where it enters another bureaucratic channel. If it passes through the republic organs, it has a fair chance of being accepted by the All-Union Admissions Commission, that is, if the commission acts on it before the two-year expiration date. There are people with perfect qualifications who have refiled several times, each time the central organs failing to take timely action. It is on the central level, where admissions policy is shaped, that consideration is given to the union "quota," basing it on political pressures and cultural policies.

Once in the union the new member is enjoined to "actively par-

ticipate in the work of the Artists Union, raise his ideological-political level, and professional craftsmanship, observe the institutionalized discipline of the union, and abide by the laws of the constitution of the Union of Artists of the U.S.S.R."[22] He must participate in elections and take posts in the organs of the union; personally attend sessions at which his work is evaluated and criticized by the union organs, as well as take heed of criticism made. Every member has the right to use all the material and educational resources at the union's disposal.

Loss of membership results from: loss of a citizen's voting rights by law; commission of antipublic acts; failure to support the goals and to pursue the tasks as set by the central union; prolonged inactivity without a valid excuse; failure to pay membership dues; and personal choice or resignation. Recommendations for expulsion from the union may be made to the governing board or the presidium of the central union. These expulsions from the union are not publicized, with the exception of certain sensational cases intended as exemplary lessons to the other artists.

Comprehensive information on the median age of the union membership is not available. Judging from data given on delegates attending the congresses of the Writers Union which should correspond closely, and from articles and symposiums, which give occasional biographical information, the membership, as a whole, is older than one might expect, particularly the most influential group in the union — the so-called "architects" and supporters of socialist realism.[23] Younger members and nonmembers express the opinion that what has contributed to the older years of the membership is the admissions policies, which have become more restrictive over the years toward the young artists. As the fear of losing ground by the older, conservative, and nonproductive elements of the union has increased, the admissions policies have become more rigid because, as one young artist put it, "our work has moved further and further away from socialist realism." Presently the union's membership stands at

[22] See *Materialy*, p. 333.

[23] *Ibid.*, p. 335. See specifically the data concerning the 497 delegates that attended the Third Writers Congress in 1959, in *Literaturnaya Gazeta*, May 21, 1959, p. 1.

about 10,000 "older" artists.

Why do artists want to join the Artists Union? For political and economic security, because the political control of the creative output is complemented by a system of incentives akin to those in the Western societies. With one major difference: while unusual talent is sought out in the West, in the U.S.S.R., once the artist is in the union, it is his quantitative output that counts; his work is aesthetically judged on its ideological merits, which are not difficult to earn for any moderate artistic talent. This is the primary reason, one artist felt, that the union is full of opportunists and men of mediocre creative ability.[24]

Indeed, the rewards made available to official artists and writers, to induce them to enlist their art in the service of the Party, are unique in the Soviet Union. No other professional group, with the possible exception in recent years of highly placed scientists, enjoys such a privileged position in Soviet society. In addition to the regular salary that every member of the union receives (which can vary considerably with seniority, popularity, public stature, role in cultural policy-making), every artist is paid commissions on his works, published or not, sums which can reach millions of rubles annually.[25] The system of royalties, calculated to provide artists with substantial

[24] The young artist Ageyev, in a story by Yury Kazakov, complained to his girl Vika: "I am kind of stale. . . . I keep thinking about myself and van Gogh. . . . Do I really have to kick the bucket too before they take me seriously? As if my colors, my drawing, my figures weren't as good as theirs. All those opportunists — I'm sick of the whole business!" She answered: "You don't expect time servers to admit you're any good. . . . I just know. . . . For them to recognize you they'd have to recognize they've been wrong all their lives." Yury Kazakov, "Adam and Eve," *Encounter* (London), April 1963, p. 43.

[25] The Artists Union does not actually pay the artists, although it disburses a certain amount of funds. However, the union secures and awards projects to the union members. The artists are salaried by the institutions where they teach and by the publishing houses where they work as illustrators and advisers. Complaints have been raised in recent years that many artists continue to be paid handsome salaries, although they have not worked for years. One official artist complained that after a little recognition or fame, such as receiving a Lenin prize, the winner can go into retirement. "Some artists have not worked for thirty years, while they continue to be paid and to enjoy full privileges," he concluded.

material resources, is complicated by numerous categories and scales.

Another important source of aid for the artists is the Artists Fund of the Artists Union. Established in February 1940, it is an all-union organization with branches on the republic, regional, and local levels. The fund is administered by a board responsible to the governing organs of the central union. The Artists Fund now engages in extensive and diverse operations controlling considerable sums of capital[26] with which it builds and maintains sanatoriums, medical clinics, artists' clubs, retreats for creative work, apartment buildings, summer cottages, camps for children; it makes loans and grants to artists, finances the so-called "tvorcheskie komandirovki" (creative missions, under which fall creative business trips) and other activities. It is supported by publishing, contracting, and exhibiting activities, and membership dues. The fund controls the opening of various creative enterprises such as workshops, institutes, and factories;[27] it organizes and finances exhibits, maintains art salons for public consumption, contracts large orders from other publishing enterprises, organizes artists' clubs, libraries, public and individual exhibits. In a way, the Artists Fund is the general functioning organ or agency of the Artists Union.

The rest homes, operated by the Fund, are of special interest. There is a chain of these homes for artists and their families on whose maintenance, for example, was spent 16.4 million (old) rubles between 1945 and 1956, during which period it catered to 21,467 artists and members of their families. In a four-year period alone, between 1952 and 1956, 11,527 artists used the creative homes with an average of 3,500 staying for more than two months. In one of the most popular rest homes, the "Snezh-ozero" (Snow Lake), fifty miles from Moscow on the shores of the Senezh Lake near the town of Solnechnogorsk, 4,500 artists and members of their families worked and rested between 1946 and 1956.

Two other famous homes are the "Mayori" on the picturesque

[26] In 1956, the fund grossed 461 million (old) rubles.
[27] In 1957, the fund boasted of controlling 67 departments with 125 enterprises in which it employed more than 16,000 persons.

shores of Rizhsko Lake; the other is "Khosta" near Sochi on the Black Sea. These and other pleasure spots have become "homes away from home" for many members of the official creative intelligentsia. Official "komandirovki" or creative and business trips are frequently directed in the neighborhood of such homes so that the weary traveler can take from a week to a month of rest. In 1957 alone, 3,000 such trips were made by official artists.

In addition to salary, commission, and the Artists Fund privileges there is a system of prizes conferred annually on the "best" artistic productions. For many years the highest awards were the Stalin prizes, which have now become Lenin prizes, awarded to the best examples of Socialist realism — works usually eulogizing these leaders. In earlier years large resources were expended on prizes.[28] However, in recent years the enthusiasm has abated and a somewhat different system of awarding prizes has been instituted. Nevertheless, the advantages placed at the disposal of the official artist, and the manner in which rewards are distributed, have produced a sense of professionalism and stratification within the creative community — conditions which are not wholly compatible with the Party line, for there is seemingly little proletarian about annual salaries reaching into millions of rubles or dividing one's time between the Moscow apartment, suburban *dacha,* and the rest home. Yet this situation of a class of artists supported by the Party — the former unwilling to give up its highly rewarded and privileged position in the society, and the latter, its ideological goals — has created an artistic vacuum which is now being filled with activity outside of the union.

The rule of the Artists Union continues: but creative activity thrives outside the union. For one thing, thousands of artists work in the fields of commercial, decorative, and applied arts. However, these are daily workers, salaried by state enterprises, and their creative ambitions are primarily confined to their job. They cannot publish, sell, or exhibit their works. Some of the members of the "unofficial" community work in this capacity, but once home they revert to unofficial

[28] In March 1951, for example, the 170 Stalin awards in art and literature alone amounted to 7 million rubles ($1,750,000). However, only four Lenin prizes were conferred in 1958.

art and the creative world to which they belong. Admittedly, there is nothing unusual about their situation — artists struggle everywhere. The difference lies in the state's disapproval of their creative output.

It is increasingly more difficult for the state to control unofficial art activity as this endeavor has become widespread rather than the exception. It is the union membership card which sometimes divides the creative output of some of the semi-official and unofficial artists. However, their interests, activities, influential friends, and patrons have, in fact, in large measure been the same for years. The aging membership of the Artists Union is losing influence and slowly decreasing. There is an increasingly evident qualitative and quantitative drop in the official output. The cultivated taste of a more enlightened public, the rise of young talent with a predilection for the more progressive, vital, and experimental contemporary art and the return by many official and unofficial artists to the tradition and inspiration in the national historical and artistic heritage — all these are significant signs of widespread social change in the U.S.S.R. The Artists Union, with its outmoded concepts framed in the 1930's, now faces different circumstances in the 1960's which the static character of official art cannot accommodate.

Liberalization of the Arts in the Khrushchev Era

T HE DEATH of Stalin in 1953 ended a quarter-century-long iron rule over Soviet society. The era which passed still bears Stalin's name, and "Stalinism" is a pejorative term used in wide circles of Soviet society. After Stalin's death, Soviet society began to change rapidly. Khrushchev stripped the repressive apparatus of the Internal Security Organs (KGB) of much of its power and removed those who hewed to the Stalinist line. The professional elite which had remained more or less passive under Stalin came to life again in the Khrushchev era, and played a part in fashioning the course of the liberalization.

To understand the power of the intelligentsia in Soviet Russia, one must remember that the Soviet Union, unlike most authoritarian states, has never attempted to freeze its society at a desirable historical point. To the contrary, it has persisted in adapting the latest technology and methods of social science to its needs. The success of the Soviet system is due, in good measure, to the services rendered by the professional elite which the Soviet establishment, like other modern societies, has drafted into its service to become the standard bearers of the social revolution. In return for the services of the intelligentsia, Soviet leadership has had to grant them a certain amount of functional autonomy.

The passivity of the professional groups under Stalin undoubtedly covered much ferment but monetary gain and professional rewards for services well done in the eyes of the state kept dissent down (as well as fear of Stalin's displeasure, which could take a deathly tack). But the beginning of the Khrushchev era marked the beginning of the trend toward liberalism in the arts. The intelligentsia

within the establishment, nuclei of often potent political power, managed to gain a considerable degree of functional freedom and won concessions from the state.

However, concessions to one group or groups cannot for long remain an exclusive monopoly of the select; sooner or later concessions spill over into the mainstream of national life. In the postwar period, the combination of these and other factors packed a force which the strictest regime could not stop. The death of Stalin served to release this energy but, had he lived longer, the gathering force would conceivably have gained a momentum which even he might not have been able to resist.

The creative intelligentsia gave the first signal for liberalization in the Khrushchev era with a series of new and revealing novels, which will be discussed later. The tendency for painting to follow the banners raised by literature has been apparent in Russian history since the time of Alexander II. The restlessness in the painters' camps heightened in the early 1950's. Abstract expressionism was winning the day in the West, and news of it had trickled through the communications barrier. The creative intelligentsia had never been fully integrated into the framework of Soviet society; it could remain unruffled by political pressures only to a certain degree, even when the rewards given to those who pleased the state were at stake. As a result, concessions were carefully rationed, and denied when likely to be abused by the intelligentsia. The Party-artist relationship has been characterized by continuous tensions of give-and-take throughout the short history of Soviet politics. No other professional group has been more difficult to integrate into the totalitarian structure than the artistic community. The artist's demand for creative autonomy is countered by the state's demand for political use of his creative energy, and the state has humored requests for individual expression only as it has been necessary to gain its object.

The conflict, then, which has developed during the past half-century stems from the inherent flaw in state-controlled art — the denial of the artist's right of aesthetic prerogative. The state insists on viewing the artist's gifts as its own. Possession of artistic talent is, in effect, possession of material which belongs to the state. Attempts by

the artist to explain the necessity of individual freedom have encountered bureaucratic scorn, which covers the real dismay of the social planner when he encounters an unchartable force. The artist is handicapped by having to explain the inexplicable (for while he understands the need of individual expression, he is often as vexed as the bureaucrat when the muse goes off schedule), and the bureaucrat deals with the inexplicable in time-honored fashion — he ignores its existence and plans on, as if the question had never come up.

During the Stalin era the artists were denied the right to study Russian masters of the past. The moderns of the early twentieth century — Kandinsky, Malevich, and Gabo, for example — were placed under lock and key. Modern art galleries were closed. And news of work from abroad got through very rarely. The artists were placed, with great care, into a studio marked "Socialist Realism, No Visitors Allowed." The literature of the twenties suffered the same fate. Communication between varying schools became impossible as there was now only one school. Cut off from tradition and from developments in art in other countries, the artists did what they were told, stopped painting, or emigrated. And those who rebelled did not talk about it; nor, of course, did they sell their works on the open market.

With Khrushchev's advent, almost everything officially banned under Stalin now reappeared. From the nineteenth-century Russian literary heritage new editions of Dostoevsky, Tolstoy, and other classical writers appeared. Yesenin, Bunin, Ilf and Petrov, from the first Soviet period, once more became a part of the school literary curriculum. Recently, such modern writers as Marina Tsvetaeva, Velimir Khlebnikov, Inokenti Anensky, and Boris Pasternak have been reprinted, albeit on a selective basis. The works of the Western modernists such as Renoir, Monet, Degas, Gauguin, Cézanne, Matisse, Picasso, which had disappeared before the war with the closing down of the Neo-Western Art Museum in Moscow, appeared once again in the Pushkin and Hermitage museums. However, the works of the Russian formalists have remained in the museum vaults.

Soviet writers, poets, playwrights and later the unofficial artists, together with their public, came forward in the Khrushchev era, and a genuine artistic intelligentsia has once again emerged in Soviet Rus-

sia. It is composed not only of the young avant-garde writers, poets, and painters, whose experience with Stalinism was slight, but also of older writers like Ilya Ehrenburg, Konstantin Paustovsky, the composer Dmitry Shostakovich, the film director Mikhail Romm, and others who endured the entire Stalin era. There is a spirit of mutual trust, encouragement, and common cause among them. These older artists actually spend much time helping their young colleagues, battling with editors for publications of each other's works, arranging exhibits, writing letters of protest for those who get into trouble, admitting others into the official unions, defending one another in the press against conservative critics, and bringing young and promising talent from the provinces to Moscow and Leningrad. Clearly, this new intelligentsia has elements of cohesion, a quality long buried by political controls and the suppression of the arts under Stalin.

In the late fifties this intelligentsia succeeded in splitting the Writers Union and much of the creative community in the country into two camps: the "liberals" who demand freedom of expression in order to raise artistic standards, and the "conservatives" who support the traditions of strict socialist realism, that is, Stalinism. Solidly opposed to change, the conservatives are constantly at odds with the liberals. The Party considers the conservative group as a useful check to the liberal. Every time the liberals have strayed from the path of socialist realism the conservatives were used to enforce conformity.

The emergence of these two camps on the creative front and the Party's hesitance to control the differences between them is a novel situation in Soviet society, precipitated by the cultural maturation of Soviet society — the new public taste for a more sophisticated art and literature. Soviet officialdom has begun to recognize this fact, despite the recent crackdown on the arts; the Brezhnev-Kosygin leadership is continuing the Khrushchevian trend in slowly liberalizing Soviet society, including the arts.

The Party finds itself in a modern dilemma — it must resolve the paradox of retaining totalitarian power and at the same time control a fairly sophisticated, literate society: a society which has become as immune to Party slogans as Americans have become to television commercials. Caught up in this dilemma Khrushchev was forced to

dispense with the excesses of totalitarianism inherited from Stalin and to introduce what has come to be called "enlightened" totalitarianism. In his cultural formula, at which he arrived partly under pressure of social transformation from below and partly to serve his own ends, freer play was given to art (within ideological limits, of course). The new policy, which he introduced in 1957 after the unseating of the so-called anti-Party group (Malenkov, Bulganin, Molotov, Zhukov, and others) and the establishment of his personal power, acknowledged the need of art to give its members individual recognition in their search for personal expression, accommodating and accepting that borderline experimentation which hitherto had been unacceptable.

Thus encouraged, avant-garde (for Soviet Russia) art began to manifest itself. Jazz, for example, made its way into public places, even concert halls. Young painters, picking up where Kandinsky, Malevich, Popova and Filonov left off, began to exhibit Impressionist and abstract works to closed audiences, and soon modern-art collectors in Moscow and Leningrad became prominent. The young poets such as Yevtushenko, Voznesensky, and Okudzhava began using blank verse, irregular meter, and startling imagery. In prose, a greater stylistic freedom emerged, making possible a broader range of permissible themes. There was a definite move away from the crude "production" theme of the thirties toward the deeper study of human relations seen in the works of such writers as Ehrenburg, Zorin, and Panova; and of the nature and complexity of the individual as a unit apart from society often at odds with the wards of the state. Writers were officially encouraged to exhibit the evils of Stalinism to which Solzhenitsyn's *One Day in the Life of Ivan Denisovich* bears witness. Those who perished in the purges of the thirties were posthumously rehabilitated and the "cult of personality" became a wholly new and acceptable theme.

At the Writers Congress in 1959, the creative intelligentsia found relief in Khrushchev's speeches in which he granted the writers relative autonomy accompanied by guarantees that there would be no return to Stalinism. By the end of 1962, liberalization in the arts achieved dimensions seemingly incompatible with official policy

which, as a result, came under serious reappraisal after the Manège art exhibition in December of that year, to be discussed later.

The main difficulty in examining the liberalization process in this period lies in the ambiguity, inconsistency, and sometimes the lack of general policy during the Khrushchev era. We will briefly touch upon the events surrounding the three cultural thaws and subsequent crackdowns which characterized the Khrushchev era in its relationship with the arts.

With the death of Stalin an immediate feeling that a great burden had been lifted from Soviet culture seemed to pass spontaneously throughout the creative realm. A poet inaugurated the new era — Olga Bergoltz, who had served time in prison under Stalin. She wrote that Soviet lyrical poetry was nearly nonexistent, crushed under the weight of descriptive and objective analysis; the "I," in other words, had to be brought back into poetry.[1] Bergholtz's article raised what was then (and, for that matter, remains) a significant issue: the poet's vital need to listen to the voice from within, unhampered by the pronouncements of socialist realism.

The writer, Alexander Fadeyev, who was the first secretary of the Union of Soviet Writers, addressed the union's fourteenth plenum in October 1953 and observed that democratic procedures had been neglected in the union's work and that the author's individuality had been similarly neglected. His remarks were of special interest, as he had been for some time the union's leading functionary.

As has been stated before, the words of Russian writers often make explicit similar sentiments felt by the painting community, and, perhaps, strengthen these sentiments for the painters. Therefore, a look at what the writers were saying in the early fifties can give an idea of the surge toward freedom of personal statement, occurring in all the arts.

The "Pomerantsev Affair" caused by the publication of V. Pomerantsev's article on sincerity in *Novy Mir* (December, 1953) set a precedent for liberalization in the arts which still continues. In the article which brought him fame overnight, Pomerantsev declared:

[1]Olga Bergoltz, "Razgovor o lirike" [Conversation About Lyrics], *Literaturnaya Gazeta,* April 16, 1963.

"Sincerity — that is what is lacking in some books and plays. . . . It is necessary to write books about man. . . . Genuine conflict must be introduced into novels. . . . Enrichment of subjects seems to me that most acute need of our literature . . . and in a year or two you [the readers] will get genuine art."[2] At one point he said: "The degree of sincerity, that is, the directness of things, must be the first standard of evaluation."[3]

If Pomerantsev's standard had come to be widely used, it would certainly have undermined *partynost* as the fundamental criterion for appraising literature. His views encouraged subjectivism and suggested pluralism — incompatible with ideological conformity. *Novy Mir* followed his article with several others in the early part of the next year, introducing a "social-critical" trend. The trend found an increasing number of adherents, some from the related arts. Voices were raised against inhibiting bureaucratic controls; dissidents demanded recognition and status in Soviet society.

The open revolt was tolerated for a short period. The Party was weak because of internal power struggles. But when state power was consolidated, the bureaucracy hastily repaired the gap made by the vagaries of political confusion. Pomerantsev's article was denounced in *Pravda* by A. Surkov, who declared: "It is essentially directed against the foundations of our literature — against its Communist *ideinost*, against the Leninist principle of the *partynost* of literature, against the most important requirements of socialist realism. . . . It orients writers toward turning mainly to the shady, negative aspects of our life."[4] Shortly thereafter, the union's leaders, following the advice of the official organ of the Central Committee, the *Kommunist*,[5] passed a resolution condemning the articles published in *Novy Mir*.[6]

[2] V. Pomerantsev, "Ob iskrenosti v Literature" [On Sincerity in Literature], *Novy Mir*, No. 12, pp. 218–245.

[3] *Ibid.*, p. 231.

[4] A. Surkov, "Pod znamenem sotsialisticheskovo realisma" [Under the Banner of Socialist Realism], *Pravda*, May 25, 1954.

[5] "Za dalneishy podyom sovetskoi literatury" [For Further Development of Soviet Literature], *Kommunist*, No. 9, 1954.

[6] "Za vysokuyu ideinost nashei literatury" [For High Ideological Content in Our Literature], *Literaturnaya Gazeta*, August 17, 1954.

The tendencies of some writers to turn over rocks and find unpleasant ("shady" or "negative") aspects beneath had once served socialist realism well, particularly when these aspects reflected bourgeois bureaucracy or the old system. But in the early fifties the writers' attention had turned from the old bogeyman represented by the decadent outside world to the deficiencies exemplified by the group which Milovan Djilas has termed "the new class."[7] This class is typified by Soviet bureaucracy. Implied criticism of the institutions, values, and ways of life which had developed after thirty-five years of Soviet rule did not sit well with those who had created them. The bureaucracy was particularly outraged at criticism from writers who had been reliable Party spokesman in the past. Ilya Ehrenburg is a notable example.

Ehrenburg's controversial novel *The Thaw*, bitterly condemned the political terror and repressions of the Stalin era. Ehrenburg shocked the Soviet reader by referring to the purge trials of the thirties, to sudden arrests, and to other facets of the police state never mentioned in a Soviet novel during Stalin's lifetime. Ehrenburg vividly pictured the atmosphere of fear, suspicion, and distrust which dominated Soviet society. He even exposed the anti-Semitic nature of the notorious "Moscow doctors' plot." With the publication of *The Thaw* in 1954 Ehrenburg squarely placed himself in the liberal camp and became its leading spokesman. Yet, as late as 1953, Ehrenburg had called for limits in argumentation in the novel.[8]

Ehrenburg's novel unleashed critical wrath. He had been too candid about the political excesses of Stalinism. *The Thaw*, Panova's *The Seasons*, and Zorin's *The Guests* were all, in fact, vigorously criticized at the Second Congress of Soviet Writers at the end of 1954.[9] The three novels had these themes in common: the evils of bureaucracy, contrasts between the old Bolsheviks and the new generation,

[7] Milovan Djilas, *The New Class* (New York, 1957).

[8] See *Znamya*, Moscow, October 1953.

[9] See Gleb Struve, "The Second Congress of Soviet Writers," *Problems of Communism* (March–April 1955), p. 3; and the excellent study by Jeri Labor, "The Soviet Writers Search for New Values," *Problems of Communism* (Jan.–Feb. 1956), pp. 14–20.

the development of bourgeois values in Soviet society, and the gap between personal and social productivity. The "villain" in each work was a bureaucrat who abused a position of authority by setting his own interests above those of the collective. Ivan Zhuravilov, Ehrenburg's villain, is a careerist factory director, intent upon maintaining and improving his own position by whatever means he can. Zhuravilov's removal from his post at the novel's end coincides with the advent of spring and the "thaw," which presumably signifies the end of Stalinism.

Ehrenburg was promptly accused of showing "only the darker side of Soviet life,"[10] of "distorting Soviet reality,"[11] and of implying that there is "much that is bad in Soviet life and little that is good."[12] Ehrenburg's portrayal of a cynical young artist, Volodya Pukhov, as the victim of the unhealthy pressures of socialist realism was, predictably, criticized but Ehrenburg had not stopped there. The artist Saburov, whose ideas smacked of "formalism" is presented as a favorable counterpart to the unhappy Pukhov. The writer, Konstantin Simonov, took Ehrenburg severely to task for this damaging attitude toward Soviet art, accusing him "of caricaturing . . . artistic life."[13]

Yet, despite criticism, Ehrenburg, Panova, and Zorin, as well as others, found much support which enabled them to retain their prominence in Soviet literature. Ehrenburg — who was a deputy to the Supreme Soviet, Party member, and a member of the Soviet Commission for Foreign Affairs — was allowed to publish a defense of *The Thaw* in *Literaturnaya Gazeta* in response to Simonov's criticism. Then the Party, partly because of his prominence and partly because of his convincing and sincere argument for "Soviet humanism" decided to publicize the controversy as an example of the new "freedom of discussion" in Soviet arts. Although the leaders of the Writers Union came out against Ehrenburg, they seemed willing to tolerate

[10] *Komsomolskaya Pravda,* June 6, 1954, p. 2.

[11] Speech by S. Mikhalkov at the Second Writers Congress, *Literaturnaya Gazeta,* December 22, 1964, p. 4.

[12] Konstantin Simonov in *Literaturnaya Gazeta,* July 17 and 20, 1954, pp. 2–3.

[13] *Ibid.*

the Ehrenburg group, which, during the next decade, was to become a powerful instrument of liberalization in the arts.

Both the atmosphere and conclusions of the 1954 Writers Congress, however, indicated that the bureaucratic alarm was no more than a verbal dressing-down when compared to the repression of the Zhdanov period. The moderate attitude, although unquestionably confirming the Party's dominant role, plainly indicated that a new stage of flexibility had been won by the dissenters, and that the restrictions of Zhdanovism were perhaps lost to the past.

There was no question, however, that the bureaucratic guard was up. The writers had given the Party some idea of the creative ferment brewing. Had they given them a hint, too, as to what might be expected from the painters? It is not unreasonable to conjecture that the Party watched for more of the same in the allied arts. One wonders if "Soviet humanism" would have been the next stage in unofficial Soviet art, if the news of abstract expressionism had not filtered through the communications barrier. It is safe to say that the painters closely followed the writers' proceedings — common prerogatives were at stake. But while the writers were eager to present a truthful society which was uniquely Soviet, the painters were eager to regain the ground they had lost in the years of socialist realism. Avant-garde Western art, by that time, had little semblance to the popular conception of humanist art, but it was, by all means, deeply personal. It was, at its best, a profound intellectual and human experience, akin in concept and daring to the Russian modern art of the early 1900's, which had, in part, made it possible. The liberal writers turned to the new world they saw and felt about them; the unofficial painters looked surreptitiously toward the West; the Party kept an often bewildered eye upon both camps, searching for precedents which sometimes did not exist.

The reasons for the mildness of the 1954 crackdown and its failure to provide a clearly defined policy stem from conflicting pressures of the period: first the new Party leadership, although perhaps amenable to some cultural liberalization, was willing to experiment only slightly for fear that the trend might become unmanageable. Second, many Stalinists within the cultural sphere itself countenanced no

change from the previous policy and were thus prepared to attack any "reactionary forces" either at the Party's command or by their own volition. Caught between these two factions was the whole creative intelligentsia, whose hopes for attainment of some functional autonomy had been greatly raised by Stalin's death and the short relaxation that followed it.

The cultural crackdown generated by the Second Writers Congress continued from late 1954 until the Twentieth Party Congress in February 1956, when all Soviet life was shaken by the secret Khrushchev speech.[14] Even before the congress there were indications that a greater measure of freedom was being offered to the Soviet creative intelligentsia. The Ehrenburg controversy over the novel *The Thaw* continued as a significant public issue. Such open debate of a work that had officially been attacked on political grounds, and whose content was clearly of controversial nature, made it obvious that the Party would allow new but limited freedoms.

Many of the creative intelligentsia interpreted the de-Stalinization process set in motion by Khrushchev's Special Report of February 24–25 as an earnest "second thaw." Specific indications of far-reaching official reforms in the creative professions gave reason for hope. The posthumous recognition of approximately half of the Soviet authors purged during the thirties and forties was one. Isaac Babel, Vladimir Kirshon, and Sergei Tretyakov who had been liquidated as "enemies of the people" were officially returned to places of honor.[15] This was a great step forward, because between Stalin's death and the Twentieth Party Congress official re-recognition was restricted just to writers who had fallen into disfavor only on general principles; "enemies of the people" had remained beyond the pale. The Soviet literary intelligentsia thus reclaimed a vital part of its national heritage.

Pablo Picasso's works, removed earlier from public view, along with Renoir, Monet, Degas, Gauguin, Cézanne, Matisse, and others

[14] See Bertram D. Wolfe, *Khrushchev and Stalin's Ghost* (New York, 1957).

[15] Kirshon and Tretyakov were executed as "Trotskyite spies," while Babel simply vanished in the 1938 purge.

were brought out of hiding for a retrospective exhibition.[16] This proved to be one of the most important events on both the official and unofficial calendar during the second thaw. It opened in the Pushkin Museum in Moscow in October, 1956. The exhibition caused a great stir in Moscow and Leningrad. Numerous open-meeting discussions took place on the problems of art. Ilya Ehrenburg presided over an important meeting organized by the Academy of Arts of the U.S.S.R. attended by every segment of the scientific and creative communities. The venerable representative of social realism, Alexander Gerasimov, also attended this session, sat at the reception table, dwarfed by a huge portrait of Picasso. Picasso himself did not attend the exhibition, perhaps because of the Hungarian revolution.

Nevertheless, the reception which his works received in Moscow (and later, Leningrad) was probably never equaled in the West; people lined up for blocks from early morning until closing time trying to get a glimpse of the hitherto proscribed works of art which most had only read or heard about but were never given the opportunity to judge. Exhibit halls in both cities were packed with groups discussing aesthetics, schools of art, emerging trends, and the status of official art. Never before had such openness been allowed in official circles, not to mention among lay members of the public. Khrushchev's secret speech made possible such an atmosphere of frankness and tolerance by the officials.

The Picasso exhibit in Moscow sparked discussion in the art world for some time. After the show, organized exchanges of views about Picasso and modern art were held at the University of Moscow, the Stroganov Art School, the Institute of Architecture, the Institute of Cinematography, and elsewhere. An interesting meeting was held in the Department of History at the University of Moscow organized by student leaders who received permission from the university administration to discuss a controversial article against impressionism published in *Pravda*.[17] After reviewing the elaborate preparations

[16] See Vladimir Slepian, "The Young vs. the Old," *Problems of Communism* (May–June, 1962), pp. 52–60.

[17] P. P. Sokolov-Skalya, "Khudozhnik i narod" [Artist and People], *Pravda*, October 15, 1956.

made by the students, which included papers to be read, the administration realized the turn that the meeting might take and canceled it at the last moment. But the students, enraged by the administration's action, held the meeting on their own. The cancellation of the meeting only added to the already charged atmosphere, and speaker after speaker criticized the official controls of the arts and called for freedom of expression for all the arts.

The summer and fall of 1956 were particularly significant for painters, because the right to disagree had been banned since the modernists of the revolution had been silenced. No other branch of the intelligentsia had been silenced to such a degree. Clearly, the literary thaw had provided the basis, along with political events, for this freedom of exposition.

In addition to the Picasso show other significant events unfolded at the same time. There was a show of the Symbolist painter James Ensor, an exhibition of Mexican drawings, a show of contemporary Indian painting, and others. In 1956 preparations were made for the international art exhibition at the World Youth Festival which was to be held in Moscow the following year. In this atmosphere the selection was made of many modernists to be shown at the exhibition. The early works of such official artists as Saryan,[18] Deyneka, Konchalovsky, and others, which before had been condemned for "formalism" and had been removed from view, were also exhibited.

Before the events of Hungary developed, which presumably triggered the reversal of the liberalization process, there was some indication that masters of the modernist period, such as Kandinsky and Malevich, would be shown. Bitter debate centered on this point; at least one delegation called on N. A. Mikhailov, the Minister of Culture at that time. But in early 1957, the official reaction to the cultural ferment evidently put an end to the hopes of the artists; Khrushchev personally undertook the task of setting the artistic world in order in

[18] The postrevolutionary work of Soviet-Armenian master Martiros Saryan, for example, bears virtually no relationship to that of his Impressionist period at the turn of the century. However, one of his friends remarked proudly to the authors that Martiros would have given Picasso a run for his money — had the Revolution never occurred.

March of that year. In a meeting at his *dacha,* attended by many prominent artists, Khrushchev informed them that although the Party's continuing noninterference policy toward the arts would continue, the adherence by the artists to the precepts of socialist realism must also continue. In any case, the works of the modernists remained under lock and key, and still are to this day.

Again, concessions once given are rarely taken back, at least not without a struggle on the part of the loser.[19] The Picasso exhibit was perhaps only a gesture to a renowned Communist figure, but it provided an argument for the display of other members of the French school who were soon placed on public view, including Renoir, Monet, Degas, Gaugin, Cézanne, Matisse, and others. They were foreign painters from another world, from another age, surely too far removed (officials reasoned) to have any appeal for imitation at home. In addition, these artists could serve as examples of "bourgeois, decadent formalism" for Soviets and as valuable propaganda attractions for the visitor from abroad who might have questioned the narrowness of Russian art policies. However, the group of early Russian moderns, who were even then in many ways more progressive than their Western counterparts, were felt to have a dangerous appeal to the young intelligentsia, and hence were not shown.

The young artists were desperately interested in picking up the thread of modern Russian art which was broken in the twenties. Even before Stalin's death teachers of painting had used reproductions of

[19] The Soviet military establishment was reluctant to give up its professional prerogatives and concessions gained in many years during the 1960–61 confrontation with the Party leadership. The Party leadership in 1960 initiated a new program of employing military personnel from the conventional forces in civilian agriculture and industrial establishments. Under this policy, the so-called military "shefstvo" (patronage) field marshals became commanders of "cornfield commando" armies, tilling land in the steppes of Soviet Central Asia. The military soon effectively challenged this policy as an infringement on the professional competence of the armed forces; the move was halted in August 1961, and the reason given was that precautionary measures had to be taken in observance of the growing Berlin crisis. As later events would prove, however, Khrushchev, in intimidating the ground forces by pursuing a policy of systematic replacement of land armies by missile forces, was in fact laying the ground for his 1964 overthrow, in which the military establishment played a decisive part.

Russian masters and books about them in training young artists. They used original works where, rarely, these were obtainable. This practice, by the way, has become widespread in the sixties.[20] Unofficial art was bred in just such circles, centered on individual influential artists and art teachers. In addition to their desire to preserve the official dogma in art, the cultural authorities have always been aware of the appeal of the modernists to the unofficial artists and the intelligentsia and continue the ban on these artists to this day. Officialdom is also correct about the influence of the French school, which has had little effect upon unofficial art. Most unofficial artists were well acquainted with the works on view in the Pushkin Museum and the Hermitage, but they showed no more than passing interest in the well-known masters, who for them no longer held any validity. They are more interested in abstract expressionism, pop art, and surrealism — movements that continue to permeate even the ranks of the official Artists Union. To them, too, the French school had become art history.

While a mild crackdown on "revisionist" literature in Moscow and Leningrad followed the events in Eastern Europe — the Petofi literary circle in Hungary was in part blamed for sparking the revolution — the liberalization on the visual-arts front continued seemingly unimpeded.

The First Congress of Soviet Artists met in a congenial atmos-

[20] To illustrate the interest evidenced by the younger generation of artists in the Futurists and Constructionists of the early period, we would like to add another personal footnote. The American Graphic Arts Exhibition, which we staffed, contained a fairly representative art library, which included works on Kandinsky, Chagall, Soutine, Gabo, and others. The book by Gabo, *Gabo: Constructions, Sculpture, Paintings, Drawings, Etchings,* published by Harvard University Press (1957), contained a reproduction in Russian of his "Realistic Manifesto" of 1920. The book disappeared from the library; it was replaced by another copy and disappeared again; this happened four times. Later we learned that copies of the manifesto had been made and distributed to other parts of the country. Incidentally, the library contained about 400 books most of which disappeared by the end of each showing and had to be restocked before the exhibition opened again in another city —and there were four showings. We also understood that other libraries, particularly the Lenin Library in Moscow, was meeting with the same fate; but its replenishment policy was not as liberal as ours.

phere in February–March of 1957 and succeeded in installing a new board of directors composed primarily of the liberal artists in the union. Preparation for the art exhibit at the World Youth Festival included an international jury to judge the paintings to be exhibited there; surely the jury would include "formalists" from the Western community of artists. But preoccupation with the developments on the literary front and lack of knowledge of the artistic left the artists' community relatively without supervision. In fact, the Minister of Culture, N. A. Mikhailov, visited the exhibition on the eve of the opening and had to order on-the-spot removal of several works by a number of painters and sculptors, after the exhibit had been judged by the jury and reviewed by the foreign press. It was precisely the banned artists who were to win the prizes from the international jury at the festival.[21] Numerous letters, telegrams, and congratulatory notes in support of the international jury came from the world-wide intellectual Communist community. All these developments made a deep impression on officials and artists, and undoubtedly had considerable influence on the temperate and measured course of the liberalization which unfolded in the months and years thereafter.

Since these developments in the arts threatened the validity of socialist realism, hence the official dogma and the regime itself, how is the change in the Party's practice in allowing the showing of many previously prohibited works to be explained?

One reason was a conscious desire on the part of the Khrushchev leadership to do away with the "excesses of Stalinism," that is, overt control over every facet of society, including art; clearly the creative community was opposed to and served in the Khrushchev faction's stand against Stalin and Stalinism. Another reason was that writers, artists, critics, and editors finally took the risk in bringing pressure on the Party — at first tentatively in the unified thaw and then resolutely — to restore the normal artistic creative activity interrupted by Stalinism. Thus, liberalization, first permitted as a calculated political move

[21] See the illustrated article by Louis Aragon, "Une exposition de jeunes à Moscou" [Youth Exhibition in Moscow], *Les Lettres Françaises*, July 11, 1957, pp. 1, 6–7.

to further the aims of de-Stalinization, grew because of the pressures from the artistic intelligentsia which wanted more creative freedom. Starting then with the 1956 de-Stalinization drive, coupled with other events in the artistic and political spheres, the Soviet artist took the cry of liberalization, and, as later events would prove, carried it further than the Party had meant to permit.

Already it had become apparent that doubt was being cast on the validity of the hitherto unchallenged concepts of the theory of art: *partynost, ideinost*, and *narodnost*. The writers had again taken the most direct action, from the viewpoint of the Party, assaulting the principle of *partynost*.

Literaturnaya Gazeta responded, declaring that some people "are forgetting about the 'partynost' of literature" and disclosing that at writers' conferences speakers had declared "in an alien voice" that literature should not be a "servant of politics."[22] The Party's concern became apparent over the generating notion that the principle of "Party spirit" in art (which in practice is the utilization of art chiefly for propaganda purposes) should be replaced by the concept of proximity to the people, interpreting the social duty of the writer to the people, unaffected by power politics, and linked with the best historic traditions of Russian literature in the last century. In 1957, during the drive to restore order on the literary front, the charge of "anti-Party" was fairly common. An editorial in *Kommunist,* for example, denounced the writers and artists who demanded "anarchic" freedom from control, and acknowledged that attacks were made on Party guidance itself.[23] The drive for autonomy in art and literature, as it progressed in the few post-congress months, showed that the writers actually did hope to abolish the general notion of Party guidance.

The most vehement attack on Party control was written by B. A. Nazarov and O. B. Gridneva, appearing in the journal *Voprosy Filo-*

[22] "Zhizn i literature" [Life and Literature], *Literaturnaya Gazeta,* May 8, 1956.

[23] "Za Leninskuyu printsipalnost v voprosakh literatury i iskusstva" [For Leninist Principles in Questions of Art and Literature], *Kommunist,* No. 10, 1957, p. 15.

sofii.[24] The article dealt specifically with drama but its implications were obviously capable of extension. The authors asserted that "the higher a person's cultural level, the stronger will be his urge to examine everything independently, the more vigorously will he defend his right to 'judge about everything'," a remark which explicitly demands for the artist the right of "autonomy of judgment." This feeling had not been expressed in Soviet belles-lettres since the writer Marietta Shaginyan speaking at the second plenum of the Writers Union in 1935 stated that "only a writer is competent to judge literary works"[25] — for which sentiment she was duly reproached.

The article denounced any guidance other than that of the artist in charge of his work. It assigned the dogma "that it is possible to attain success in art by instructions, orders, decrees and resolutions" to the personality cult of the Stalin era. It asserted that the imposition of harsh controls not only over works of art but over the creative process itself signified a lack of trust in the artistic intelligentsia. Here it is evident that the intelligentsia has begun to gather strength as an "interest group." The trend toward pluralism is implicit in the freedoms demanded. The article spoke not for one branch of the arts but as representative of the needs of all Soviet arts; the goal was autonomy for all and restrictions for none.

Startling as it was, the outburst against Party controls and demand for self-regulation was in many ways characteristic of numerous articles after the Twentieth Congress. Before long *Pravda* and *Izvestia*[26] launched official attacks in what was to become the second tightening of cultural controls and drive for orthodoxy in art.

[24] B. A. Nazarov and O. B. Gridneva, "K voprosu ob otstavanii dramaturgii i teatra" [Toward the Question of Lagging in Drama and Theater], *Voprosy Filosofii*, No. 10.

[25] See speeches of I. Nusinov and Gofferensheifer in "Vtoroi plenum pravlenia Soyuza sovetskikh pisatelei SSSR [Second Plenum of the Board of the Writers Union of SSSR], (Moscow, 1935), p. 5.

[26] *Pravda* and *Izvestia* simultaneously printed articles which criticized Nazarov's and Gridneva's effort, and *Voprosy Filosofii* repudiated the article in its next issue. *Pravda* and *Izvestia*, November 25, 1956; *Voprosy Filosofii*, No. 16, 1956, pp. 3–10.

Despite the official crackdown on the arts in 1956–1957, however, brought about by the Party's concern over developments in the satellite countries, the demands voiced by the *Voprosy Filosofii* article were scrutinized by the Kremlin leadership, and important concessions were made in the following years. The third plenum of the board of the Writers Union which met in May 1957, honored by the presence of Khrushchev, Shepilov, and Pospelov, laid plans — delineating a middle way by criticizing both the right and the left deviations — to heal the breach in the ranks of the Writers Union, a move surely endorsed by the Party elite. A report prepared by the union's secretariat read: "The union [of writers] has done too little to put into action such powerful means of democratic management of writers' affairs as collective editorial boards in the case of newspapers and magazines, collective editorial councils in the related arts, which would function collectively and be collectively responsible to the literary community as a whole."[27]

These remarks are reminiscent of proposals advanced by Nazarov and Gridneva, which showed the union's willingness — after being prodded by the Central Committee — to place increasing reliance on the writers. A few months later, the idea of placing more reliance on writers and artists to solve their own problems, was carried to the extreme, at least verbally. An editorial in *Kommunist* stated: "The Central Committee of the Party places full trust in the art intelligentsia to solve crucial and creative questions itself, in its own organizations. . . . Experience shows that our creative organizations — the unions of writers, artists, composers and others — have achieved a high level of ideological and political maturity."[28] This concession by the Central Committee was brought about not by the lone voices of Nazarov and Gridneva, but by the entire creative intelligentsia for whom the authors of this article were speaking.

The Party's confidence in the artist was carried a step further in 1957 when the Congress of Soviet Artists met and installed a new

[27] *Literaturnaya Gazeta*, May 16, 1957, p. 2.

[28] See "Za Leninskuyu printzipalnost v voprosakh literatury i iskusstva" [For Leninist Principles in Questions of Literature and Art], *Kommunist*, No. 10, 1957, p. 13. For a similar comment see *Kommunist*, No. 3, 1957, p. 24.

board of directors composed entirely of liberals.[29] Alexander Gerasi-mov, the hitherto leading social realist, was not elected. In fact, he soon lost his post of president of the Academy of Arts of the U.S.S.R., and, along with other notable champions of socialist realism, found himself on the fringes of Soviet creative life. By 1959 the process of liberalization had moved so far that the top posts in the two most important writers organizations — the Writers Union of the R.S.F.S.R. and that of the U.S.S.R. — were filled in 1959 by non-Party members, Konstantin Fedin and L. Sobolev respectively. This non-Party character among the top leadership is impressive considering the road the liberal intelligentsia had to travel to arrive at such a point of victory.

In 1959, at the Third Writers Congress, Khrushchev summarized the official view on the subject of "writers' trust" and their responsibility to run their own affairs. Referring to the difficulty of deciding whether a work should be published or not, he observed: "You know it is not easy to decide right off what to publish and what not to publish. The easiest thing would be to publish nothing — then there would be no mistakes. . . . But that would be stupidity. Therefore, comrades, do not burden the government with the solution of such questions — decide them yourselves in a comradely fashion."[30]

These remarks were a promise of significant concessions to the writer, or, as one observer put it more cautiously, "a certain abdication by the Party of its exclusive prerogatives in control of literature" and a "grant of relative autonomy" to the creative community.[31]

Throughout this period, the Party's relaxation of controls proved that dissent among writers had been organizational in nature; it had been so effective that from the viewpoint of some cultural Party leaders it had even spread into other spheres of Soviet life. At the Twenty-second Party Congress, N. Gribachev and V. Kochetov, members of the Central Committee of the C.P.S.U.,[32] expressed their dissatisfac-

[29] See *Materialy*, pp. 361–363.

[30] *Trety zyezd pisateli SSSR*, p. 288.

[31] Max Hayward, "Soviet Literature in the Doldrums," *Problems of Communism* (July–August, 1959), pp. 15–16.

[32] Gribachev was an alternate member, while Kochetov was on the Central Inspection Commission of the Central Committee of the CPSU.

Figure 13. Avetisyan, Women of Armenia **(1960). Oil on canvas, 26 x 33″. Private collection, New York.**

Figure study by Minas Avetisyan, an Armenian painter working in Leningrad, showing influence of German expressionism and resembling the works of Hans Hoffman.

tion with current trends in belles-lettres — trends which they dubbed "revisionistic" — and demanded immediate changes in personnel on some of the leading journals, publishing houses, and other organs of the literary establishment, in order to force conformity back on art.[33] They lashed out against revisionism, liberalism, ideological discontent, and increasing interest in the inner world of man or the subcon-

[33] See Gribachev's speech in *Pravda,* October 28, 1961, and Kochetov's in *Pravda,* October 31, 1961.

scious, replacing Communist reality. They personally attacked Ehrenburg and Yevtushenko, especially the former for his open support of the avant-garde. "There are still . . . morose compilers of memoirs who look to the past or the present day rather than the future and who, because of their distorted vision, with zeal worthy of a better cause rake around in their fuddled memoirs in order to drag out into the light of day mouldering literary corpses and present them as something still capable of living."[34] Referring to the younger poets of the Yevtushenko brand he said: "We also have some poetic, as well as prosaic, chickens who have still scarcely lost their yellow down, but who are desperately anxious to be thought of as fierce fighting cocks."[35]

On the other hand, the editor A. Tvardovsky replied in defense with hostility toward the Stalinists.[36] Defending the liberal point of view, he said the most important thing in a work of art is the art itself; where there is no "artistic quality," all good intentions are worth nothing.

The Party allowed the issue between the conservatives and liberals to be debated in a forum on the congress floor, the first event of this kind since the rise of Stalin. Kochetov emerged as a spokesman for the conservative group, while Tvardovsky unmistakably led the liberal camp. Tvardovsky in his speech to the congress did not once use the term *socialist realism* and *partynost*; Kochetov, on the other hand, actually suggested a purge of the leadership of the Writers Union: "The Congress should have been told about the state of our literary affairs by the leadership of the Writers Union . . . as you can see yourselves, [it] lost its combative spirit and is in need of radical regrouping."[37]

The emergence of the two camps and the Party's reluctance to control them present a novel situation in Soviet society. The congress had revealed the open clash between the two groups; by the close of the Congress the liberals were victorious. For the first time in Soviet

[34] See Kochetov's speech in *Pravda*, October 31, 1961.
[35] *Ibid.*
[36] For Tvardovsky's speech, see *Pravda*, October 29, 1961.
[37] See Kochetov's speech in *Pravda*, October 31, 1961.

cultural policy a conservative faction could not rally behind decisive Party support. In addition, the liberals gained firmer footing with the election of Tvardovsky to the Central Committee of C.P.S.U.

But the battle was hardly won. The conservatives still sported such influential members on the Central Committee as Demichev, Yermilov, Gribachev, Kochetov, and Surkov, as well as Leonid Ilychev, the head of the Ideological Commission of the C.P.S.U., and other influential cultural policy makers of the Party elite. In fact, the liberals were soon to suffer a setback with the firing of Valentin Katayev,[38] editor-in-chief of the avant-garde journal *Yunost*. Kateyev had deviated too far, publishing an anti-Party story by the writer Viktor Aksyonov,[39] and was replaced by the conservative Boris Polevoi. In his story, titled "Ticket to the Stars," Aksyonov had challenged the Party by publicly declaring, "You won't push us from our path," for which he temporarily fell out of favor.

The spring of 1962 unfolded favorably for the liberals. Khrushchev personally interceded to lift a ban on a volume edited by the writer K. Paustovsky: *Tarusskie stranitsy* [Pages From Tarusa] a controversial volume of liberal writing, published in Kaluga in 1961. This new atmosphere carried the liberals to a position of influence in the organizations of writers, traditionally controlled by the conservative camp. At the elections of the administrative board of the Moscow branch of the R.S.F.S.R. Writers Union, held in April 1962, the liberals scored an unprecedented victory. They elected seven members to the administrative board, among them Yevtushenko, Voznessensky, and Slutsky.[40] As Michel Tatu, Moscow correspondent of the French daily *Le Monde*[41] reported, such staunch conservatives and long-time cultural policy makers as Kochetov, Gribachev, and Sofronov were not even proposed for reelection. The feeling against the conservatives was very evident before the election, Tatu observed. Six hun-

[38] Valentin Katayev is the author of a well-known novel of the thirties, *Vremya vperyod!* [Time Forward!].

[39] Viktor Aksyonov, "Zvyosdny bilet" [Ticket to the Stars], *Yunost*, Nos. 6–7; 1961.

[40] *Literaturnaya Gazeta*, April 11, 1962.

[41] Michel Tatu, *Le Monde* (Paris), April 17, 1962.

dred writers who took part in the secret balloting literally black-balled from the position of influence such people as N. Albakin, literary editor of *Pravda,* and L. Sobolev, chairman of the board of the R.S.F.S.R. Writers Union, as well as the others mentioned. The Moscow literary community had acted for the first time from a position of strength, and had won.

As summer approached the liberal camp gained further ground, because it now had a foothold in the Moscow Writers Union. By fall some works published in *Novy mir* were quite daring. The journal *Znamya* shifted considerably toward the liberals. Even the conservative publication *Oktyabr,* edited by V. Kochetov, already worried about circulation, began printing stories and articles aimed at "liberal readers." The extreme orthodox publication *Literatura i Zhizn* announced that it would suspend daily publication on January 1, 1963, because of its "harmful effect on art," as it confessed. An interesting phenomenon, best described as "editorial polycentrism," had come into being by fall of 1962; writers whose work was rejected by one editor because of political implications, could take them to another who might accept it. Yevtushenko, Aksyonov, and the critic Maryamov were appointed to the editorial board of *Yunost,* which further illustrates the growing strength of the liberal camp.

Pravda, on October 21, 1962, published Yevtushenko's poem "Stalin's Heirs," which attacked not only the dead dictator but also his successors:

> We rooted him out of the Mausoleum.
> But how to root out Stalin's heirs?!
> Some of the heirs cut roses in retirement
> And secretly consider it temporary.
> Others even condemn Stalin from the platform,
> But themselves at night languish for the old days . . .
> As long as Stalin's heirs exist on earth
> It will seem to me that Stalin is still in the Mausoleum.[42]

The November issue of *Novy mir* published Alexander Solzhenitsyn's novel *One Day in the Life of Ivan Denisovich,* which for the

[42] *Pravda,* October 21, 1962.

first time revealed to the Russian reader the atrocities of the Siberian concentration camps of the Stalin era. By November 23, 1962, when Khrushchev addressed the Central Committee on de-Stalinization in literature,[43] the liberals had reached a new milestone. Khrushchev announced that he had personally ordered the publication of the Yevtushenko poem in *Pravda*. He also disclosed his endorsement of Solzhenitsyn's manuscript stating that the concentration-camp facts could no longer be concealed.

Khrushchev's speech could have been the most important single victory for the liberals, had it not been for the two circumstances: first, the speech was not published in the Soviet press, although reports did appear in the West; second, when Khrushchev and other high-ranking officials visited the Moscow Art Exhibit, in the Manège Gallery, on December 1, 1962, he attacked vehemently the entire creative intelligentsia.

A new tightening of cultural control was ushered in by this event, and for a time the liberal writers were forced to return to their most effective weapon, "conspiracy of silence," in which they were joined by their brethren throughout the creative community, including a most illustrious group of unofficial artists, whose strength was felt at the Manège exhibition — the Belyutin circle, to be discussed in the next chapter.

[43] For the unpublished Khrushchev speech delivered to a plenum of the Central Committe of the CPSU on November 23, 1962, see *The New York Times*, November 29, 1962. See also Yevgeny Yevtushenko, *A Precocious Autobiography* (New York, 1964), p. 122.

The Manège Affair

WITH the first limited exchange of specialists, cultural delega-
tions, and tourists after Stalin's death, bits of information on de-
velopments in Western European and American art began to reach
the U.S.S.R. Postcards, articles, and occasional reproductions of con-
temporary works were found in the homes of collectors and artists.
Some reproductions even reached the black market which handled
such sensitive commodities as Western art books and magazines.
With the opening of the East-West cultural exchange in 1959 and the
general influx of tourists that followed, the availability of art books,
magazines, and reproductions increased. Black marketeers were able
to supply the market so efficiently that only the latest information on
such post-abstract Expressionist movements as pop and op art
aroused major interest. Such foreign influences came to be called
"varvarisms" (barbarisms). One Soviet critic has alluded to the Bely-
utin school of abstract expressionism as the "varvarsity" — the imi-
tators of Western bourgeois art.

Many among the younger generation were interested in abstract
expressionism, particularly a group influenced by the artist Ilya Bely-
utin. As early as 1954, Belyutin, riding on the liberal crest of the first
post-Stalin relaxation of government control, had begun his unofficial,
although officially sanctioned, creative activities. Gathering around
him a group of young artists, he first started teaching art in his home.
He then acquired a large barn-like studio in the old Arbat Street in
Moscow. Space, everywhere in the Soviet Union and especially in
Moscow, remains at a premium to this day, but Belyutin had well-
placed friends in the cultural hierarchy. At first, most students worked
realistically in the traditional art-school manner. However, as time

progressed, experimentation was encouraged along the lines of the masters of contemporary Western art. Before long the Arbat studio became so popular that even official guests "with a taste for formalism" were occasionally received for informal exhibits. Quietly the works were viewed, sold, and bought there. The list of patrons included "enlightened" officials from the top of the Party hierarchy. On occasion Belyutin and his students were able to make officially financed "inspirational" sojourns into the provinces. Some of Belyutin's former students, in conversations with us, joked as they spoke of

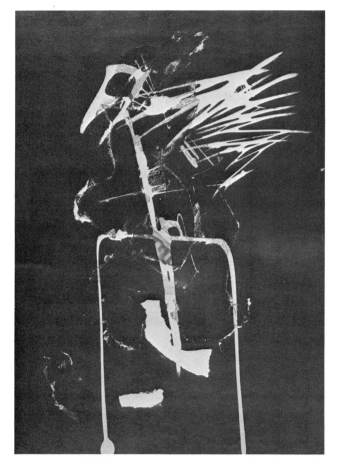

Figure 14. Artist anonymous. (1962). Collage, 16 x 22½".

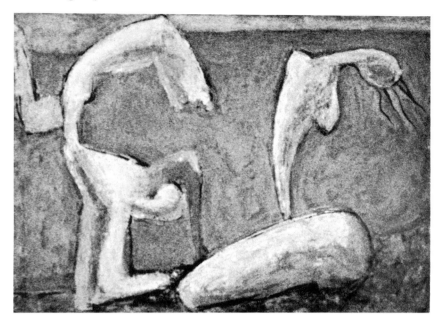

Figure 15. Artist anonymous.

the art depicting "natural beauties of the Volga," with which the so-
cial realism artists usually rewarded their benefactors (the Artists
Union, creative clubs, and so on) after such sponsored trips; while
the artists' works "hardly resembled the bends in the river, let alone
the detailed shoreline, smokestacks of factories and collective farms
in the distance." However, a few members of the Belyutin group, stu-
dents conceded, "are still fond of the nineteenth-century school of
naturalism and French academism."

The Belyutin group can be classified as abstract expressionists
identifying themselves with the artists who participated in the Ma-
nège exhibition. Several artists illustrated in Figures 14–24 formed a
part of the now famous show. For reasons of discretion their names
are not given here. These artists are most imaginative in their applica-
tion of such unusual techniques for present-day Russia as palette
knife, collage, and mixed media. The imagery in these works is strong
and personal. It is surprising that the group was able to function, in

87

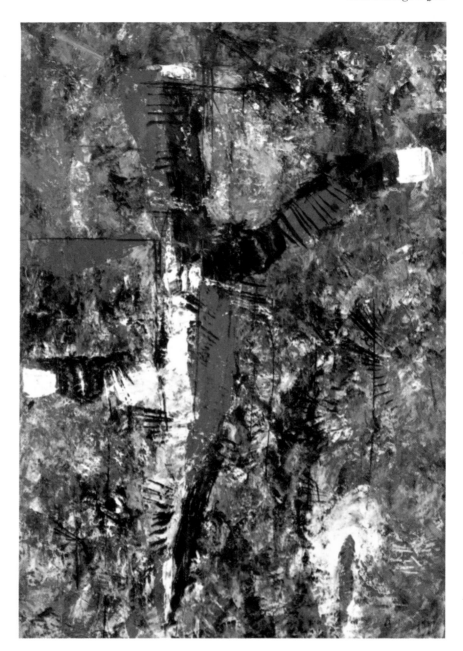

Figure 16. Turmoil (1964). Oil on cardboard, 16 x 22½".
Courtesy of Mr. and Mrs. Jack F. Smith, Dallas, Texas.

spite of its highly placed patrons, for the official press continued the propaganda against "formalism" in editorials in Party and art journals.

Other artists of this period (1958–1963) associated themselves with various forms of surrealism. Books on Salvador Dali, Eugene Berman, Georgio De Chirico, Roberto Matta, Yves Tanguy, and later René Magritte and Delvaux were esteemed highly in some quarters and so were postcards showing their work. Soviet aestheticians are most antagonistic towards this school of painting because it is pre-occupied with the subconscious and the soul and, hence, contradicts the Soviet concept of reality. When the subjective, the unconscious, is freed, they claim, it inhibits reality, and where it should re-create reality, it actually perverts and reforms it.[1] The relentless exploitation of the unconscious by artists in the bourgeois societies is precisely the reason for the increasing decay of Western art, in the view of the Soviets. In a rigid attack on surrealism, which exploits the human

[1] For an elaboration of this discussion, see John Fizer, "Art and the Unconscious," *Survey* (January 1963), No. 46, pp. 125–133.

Figure 17. Artist anonymous.

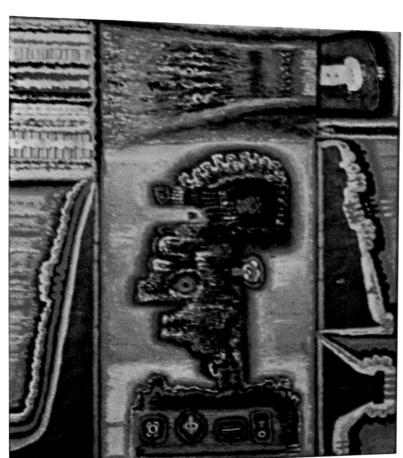

psyche, "forcing out of art everything rational," one critic declared:

Surrealism is the enemy of democracy, people's art, realism, and great artistic traditions. It exceeds the boundaries of art. If everything living and rational in the human society is striving toward knowledge, development, light, health, happiness, and joy, then surrealism cultivates madness, sickening hallucinations, forcing out of art everything rational; everything, except that which reminds one of nightmares. It strives to break down a man with a healthy psyche and to make him sick. . . . Can that kind of art answer to the people's needs, aid social development, and elevate man to perform lofty deeds? Of course not! On the contrary, surrealism is the enemy of life, reason, and happiness.[2]

The unconscious "unrealities of life" disturb the balance of socialist realism. Soviet art must reflect the positive humane side of man; in a word, like other forms of intellectual exercise, it is a purely rational undertaking. Art, as has been indicated, has become an applied ideology, and, like most ideologies, must perform "a controlling function"[3] over every segment of society. To permit an artist exercise of his free will, to let him engage in unhampered exploration of the realities and subrealities of life might result in a pluralism of realities challenging the concept of the sole Communist reality.

By the mid-sixties, available information on contemporary Western art had become widespread. Independence and individualism among the younger, more enterprising artists grew stronger. As abstract expressionism in the West declined, it became as ridiculous to make a hodge-podge Russian version of De Kooning, Motherwell, or Kline, as it was in the West for many followers of the same trend.

Beset by crucial political problems abroad and facing the agricultural crisis at home, the Kremlin leadership came to the realization that it had lost its absolute control over the cultural life of the country. By the sixties it was not a question of isolated deviants: a whole new movement was in progress. Artists had begun openly to exhibit abstract paintings and sculptures that deviated radically from socialist realism. Poets and writers were making wide use of styles and subject matter unrelated to socialist realism. The creative intelligentsia

[2] A. K. Lebedev, *Iskusstvo v okovakh* (Moscow, 1962), pp. 58–59.

[3] L. I. Timofeyev, *O teorii literatury* [On Theory of Literature], p. 96.

interpreted Khrushchev's encouragement of the anti-Stalinist line in the arts to be a new gift of freedom. This trend alarmed the leadership, especially the conservative elements, because the liberals included the most talented and influential members of the creative community: Ilya Ehrenburg, Konstantin Paustovsky, Kornei Chukovsky, Dmitry Shostakovich, Alexander Tvardovsky, Mikhail Romm, and many other noted figures.

An exhibit given over entirely to modern and abstract art was scheduled to open in the Hotel Yunost in Moscow on November 29, 1962. In addition, a one-man show of Yevgeny Kropivnitsky, was organized and due to open shortly. Most of the works scheduled for the exhibition at the Yunost Hotel were given a private showing on the evening of November 26, 1962, in the studio of Ilya Belyutin. The showing was attended by several Soviet cultural officials and some 150 specially invited guests including a few Western correspondents.[4] About 75 canvases were shown — the work of Belyutin's students in abstract and semi-abstract styles. Exhibited also were the works of the sculptor Ernst Neizvestny. The exhibit lasted only a few hours, on November 26, and was then closed, although a large crowd of Muscovites — mostly students and intellectuals — waited outside hoping to gain admission.

Shortly before the opening of the Yunost exhibit, on the afternoon of November 29, 1962, some liberal officials from the Ministry of Culture approached leaders of the artists and instead proposed to show the works in the large retrospective exhibition of Moscow art, which had been in progress for a month at the Manège Gallery off Red Square. The Manège exhibition was to be visited by the top Party leadership in an official review of the works on display. Evidently acting without the blessings of the organs of the more conservative Art-

[4] For Leonid Ilyichev's reference to the November exhibit and criticism of the ignominious attendance of Western correspondents, see his major ideological speech at the first meeting of creative artists and Party leaders, December 17, 1962, in the brochure *Iskusstvo pridnalezhit narodu* [Art Belongs to the People], (Moscow, Gospolitizdat, January 8, 1963), p. 7. The brochure also includes his speech delivered at a meeting with young artists on December 22, 1962. Hereafter cited as Ilyichev.

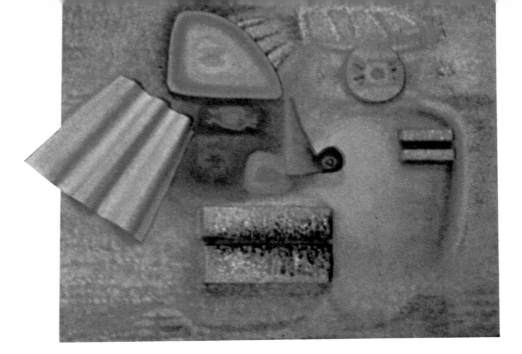

Figure 18. Artist anonymous.

ists Union, the cultural officials felt that the hitherto condemned "deviationist" art had a chance of gaining at least passive acceptance in the review by officialdom, considering the increasing process of liberalization of the arts started by Khrushchev. The next day, at the insistent urging of the cultural officials, the artists hurriedly brought their paintings and pieces of sculpture — some of which had been

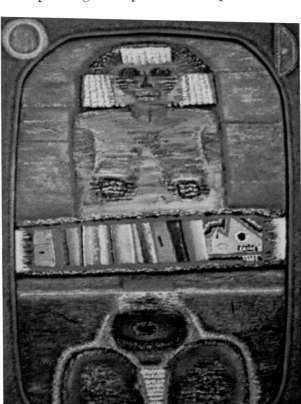

Figure 19. Artist anonymous.

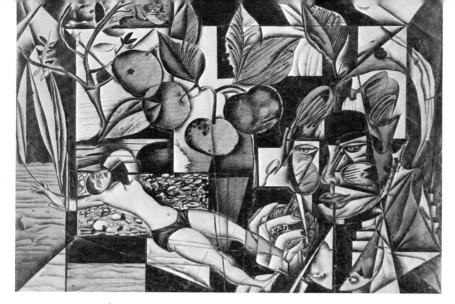

Figure 20. Artist anonymous. Caucasus **(1963). Pencil, 12 x 16½".**
Courtesy of Mr. and Mrs. William L. Rose, Des Moines, Iowa.

slated for the Yunost exhibit and some not — to the three split-level
rooms of the Manège Gallery.

On December 1, 1962, Nikita Khrushchev, accompanied by four
presidium members and several members of the Party secretariat, vis-
ited the Manège Gallery where the exhibit, "Thirty Years of Moscow
Art," consisting of 2,000 canvases and sculptures, was in progress. The
group of avant-garde artists, headed by Belyutin, had worked their
way into the three private rooms of the gallery with 75 paintings in-
cluding the work of the sculptor Ernst Neizvestny, perhaps the most
esteemed among Soviet artists, but whom, regrettably, we were not
able to meet or acquire information about. Khrushchev's reaction to
the public exhibit was restrained, although he was annoyed by sev-
eral of the paintings — R. Falk's "Nude" and "Still Life," D. Shtern-

Figure 21. Neizvestny,
The Head **(1963).**
Bas-relief casting
in plaster of Paris.

berg's "Aniska" and "Still Life: Herring," P. Nikonov's "Geologists," A. Vasentsov's "Breakfast," and some others.

When he entered the private rooms with the more modern abstract works, however, he is said to have lost control of himself, creating a scandalous scene with an outburst of barnyard Russian. The comments of Neizvestny, who had been designated to explain the works, only infuriated Khrushchev, particularly when Neizvestny referred to the artists' right of self-expression. Noticing an abstract bronze by the sculptor, Khrushchev asked: "And where did you get such material when there is a shortage?" "I stole it, like everybody else," answered the sculptor. "Then I'll cut off your channels," said Khrushchev. After a quick glimpse at a few more paintings, he turned to his comrades-in-arms, D. Polyansky and others, and for the benefit of those most concerned, shouted:

What is this anyway? You think we old fellows don't understand you. And we think we are just wasting money on you. Are you pederasts or normal people? I'll be perfectly straightforward with you: we won't spend a kopek on your art. Just give me a list of those of you who want to go abroad, to the so-called "free world." We'll give you foreign passports tomorrow, and you can get out. Your prospects here are nil. What is hung here is simply anti-Soviet. It's amoral. Art should ennoble the individual and arouse him to action. And what have you set out here? Who painted this picture? I want to talk to him. What's the good of a picture like this? To cover urinals with?[5]

At that point, his son-in-law and editor in chief of *Izvestia*, Aleksei

[5] See *Encounter* (London), April, 1963, pp. 102–103. The preceding and the following dialogue (the Neizvestny-Khrushchev-Adzhubei exchanges), were reported to the authors on good authority, and are additions to the *Encounter* version presented here.

Figure 22. Neizvestny, Fallen Soldier **(1957). Bronze on plexiglass base, 3' ³⁄₄" high. At base 13⅞ x 1⅝". University of California Art Museum, Berkeley. Gift of Sidney E. Cohn, New York.**

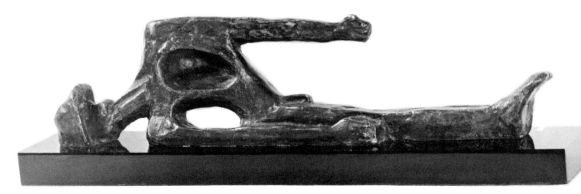

Adzhubei tried to break in to explain. "Be quiet, young man!" was Khrushchev's curt reaction. Then the painter Zheltovsky, who had painted the picture in question, came forward. Khrushchev addressed him: "You are a nice-looking lad, but how could you paint something like this? We should take down your pants and set you down in a clump of nettles until you understand your mistakes. . . . We have the right to send you out to cut trees until you've paid back the money the state has spent on you."[6] Then, after a quick glance at a painting by the artist Gribkov, Khrushchev called out to the head of the Central Committee's Ideological Commission, Leonid Ilyichev: "Comrade Ilyichev, I am even more upset by the way your section is doing its work. And how about the Ministry of Culture? Do you accept this? Are you afraid to criticize?. . . . One cannot tell whether these have been painted by a man's hand or daubed by the tail of an ass." And he ended by saying: "Gentlemen, we are declaring war on you!"

This outburst by the chief of state of a civilized nation, one artist observed, surprised the cultural officials even more than the invited artists. It was evident now that the cultural officials had taken "independent action" in inviting the artists for it was clear, too, that Khrushchev had been as much surprised by the defiant display of "formalist" works, which caused the impromptu reaction. Nothing like this had occurred before, at least not in such "enlightened" company, even though Khrushchev's diction had always left much to be desired.

Both Vladimir Serov and Alexander Gerasimov, the exponents of socialist realism, were present at the exhibition. Eyewitnesses said that there was a "sheepish" look about them when they entered the premises with the official entourage. However, if they had arranged the fiasco, they could not have been too comfortable, going over the head of the Ministry of Culture. On the other hand, if they were just along for the official review, which seems to be the likeliest assumption, and learned about the "special" show, the thought must have passed their heads: "What if the party leadership reviews the show with no more than light comment?"

[6] *Ibid.*

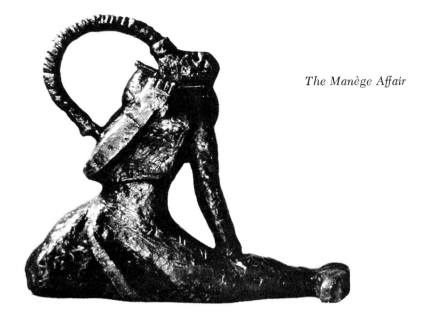

Figure 23. Neizvestny, Gas Attack **(1959). Brass, 10″ high.**

That Khrushchev had no previous knowledge of the existence of the Belyutin-group show in the exhibition hall is supported by the fact that he was led to the upstairs rooms on the insistence of Neizvestny, with whom (and with whose work) the Party leader was personally acquainted through his son-in-law, Adzhubei. Clearly, the open exhibition of abstract works was merely the last straw which broke the camel's back — the liberalization in the arts had gone too far for Khrushchev and the Party leadership.

On December 3, 1962, *Pravda* published an editorial entitled "Art Belongs to the People" reaffirming "the Leninist policy of Party-mindedness and Communist ideology" in the arts. It made clear that little sympathy would be shown to "those artists who, under the pretext of ostensibly bold quests and ostensibly bold innovations have departed from and betrayed the glorious traditions of our realistic art."[7]

On the same day, December 3, 1962, a Moscow University senior professor opened his lecture by reading the *Pravda* editorial of the day. When he finished reading, he laid the paper aside and stated: "In

[7] *Pravda,* December 3, 1962. *Pravda's* attack included all arts. Commenting on music it stated: "Socialist art . . . resolutely and firmly rejects the absolutely unjustified imitation by a few of our musicians of inferior bourgeois traits in music — those who are ready to adapt all Soviet music to cantankerous jazz."

my opinion this editorial points 180 degrees in the wrong direction,"[8] and proceeded to explain his reasons.

Also on December 3, the leading film director Mikhail Romm delivered a passionate speech against conservative officials in the cultural field before a meeting of the R.S.F.S.R. Writers Union. He opened by saying that he had been through much in life, and at his age it did not matter to him whether he was permitted to continue directing films or not. Therefore, he could speak his mind about the weekend's despicable "provocation" by the enemies of true art. "The

[8] Related to one of the authors by a Moscow University student who had attended the lecture.

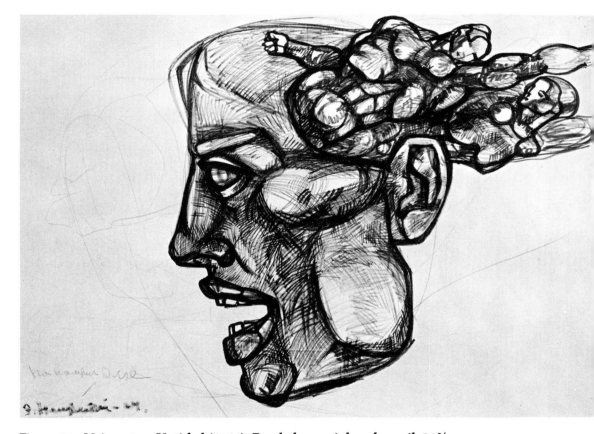

Figure 24. Neizvestny, Untitled (1964). Brush, brown ink and pencil, 24⅜ x 36¼". The Museum of Modern Art, New York. Gift of Olga A. Carlisle.

incident showed," he continued, "that Soviet creative artists can make no real progress unless they succeed in removing hacks and syco- phants like Vseveolod Kochetov, Anatoly Sofronov, and Nikolai Gri- bachev, from influential positions in the arts."[9]

A day later, Vladimir Serov, the new head of the U.S.S.R. Acad- emy of Arts, spoke out in *Pravda* against "those renegades who betray the principles of popular art and grovel before modern, decadent bourgeois abstract art." He called upon the Party and the academy to help the erring colleagues "to acquire purity of artistic thought."[10] Alexander Gerasimov was finally afforded an opportunity to avenge himself. Writing in *Trud* he attacked individuals and publications for promoting "formalist art."[11] The two protagonists of social realism launched the attack from the conservative camp, setting the stage and tone of the imminent cultural "freeze."

Meanwhile, the visit of Khrushchev and other leaders enor- mously increased public interest in the Manège exhibit. Gallery at- tendance was at peak level; visitors crowded about the criticized works of Falk, Shternberg, Nikonov, Pologova, and Vasnetsov. On December 4 and 5 the criticized works were removed from view, but by December 7 they had been rehung.[12] Why they were belatedly removed, and then quickly brought back, is a matter of speculation, but the liberal intellectuals were encouraged by what they inter- preted as the inability of the cultural and Party leadership to remove the paintings from the exhibit permanently in the face of public interest.

At the Central Committee meeting of the Party held on Decem- ber 17, 1962, with 400 artists, composers, and writers in attendance,

[9] This was disclosed to one of the authors by a young Moscow composer who attended the special R.S.F.S.R. Writers Union meeting. Romm was removed from his office in August 1964. See *New York Times,* August 20, 1965.

[10] *Pravda,* December 4, 1962. Serov had made his own reputation with large poster-like canvases of Lenin in various revolutionary settings.

[11] See *Pravda,* January 9, 1963.

[12] The works by the artists from the Belyutin group, exhibited in the three split-level semiprivate rooms, were removed from view along with the criticized paintings, however; they were not rehung with the latter, which remained on public view for an additional month.

the Party spokesman, Leonid Ilyichev, made it clear that the Party was reassessing its policy of liberalization in the arts and expected the creative community to adhere to the principle of socialist realism. In literature, the anti-Stalinist line would be pursued but the writers must recognize the Party's "guidance" in literature, as well as in the other arts. A letter of protest personally addressed to Khrushchev was read at the meeting by Ilyichev, signed by such prominent figures in the arts as the writers Simonov, Ehrenburg, Chukovsky, and Kaverin; the sculptor Konenkov (dean of Russian sculptors) and the elderly artist Favorsky (father of Soviet graphic art); the composer Shostakovich; the film director Romm; and many others.[13] The signers included two Nobel Prize-winning scientists, Igor Tamm and Nikolai Semyonov. The letter asked "Nikita" to end the persecution of "formalism" and to give assurances that Stalinist methods would not be restored:

Without the possibility of the existence of different artistic trends, art is doomed. We now see how artists who have followed a single trend which flourished under Stalin, and which did not permit others to work or even to live, are beginning to interpret what you [Khrushchev] said at the exhibition. . . . We appeal to you to stop this return to past methods which are contrary to the whole spirit of our times.[14]

Khrushchev did not reply. But appropriately, the arch-conservative, Vsevolod Kochetov, editor-in-chief of the journal *Oktyabr*, declared: "Certain realist artists, instead of taking the offensive have been forced to go on the defensive, and instead, it is the formalists and abstractionists who have gone over to the attack."[15]

At least two more groups of intellectuals sent letters of protest to the Central Committee. One group of young abstract artists declared that they were seeking their own way in "Socialist art," and that without such searches there could be no progress.[16] Apparently one letter

[13] *Le Monde* (Paris), December 28, 1962.

[14] Ilyichev, p. 16. For the full text in English and general documentation of the 1962–1964 conflict, see Priscilla Johnson and Leopold Labedz, *Khrushchev and the Arts: The Politics of Soviet Culture, 1962–1964* (Cambridge, 1965), pp. 105–120.

[15] *Pravda*, January 1, 1963.

[16] Ilyichev, p. 18.

made a plea for " 'peaceful coexistence' of *all* trends in art," which Il-yichev denounced as "an appeal for peaceful coexistence in the sphere of ideology," upbraiding the comrades (who later retracted the letter) for having sent it "presumably not as a document but as a draft."[17] The situation seems to have gone out of hand. In his major speech of December 17, 1962, Ilyichev said:

It is said that sometimes at meetings, in discussions of creative questions, it is now considered indecent and old-fashioned to defend the correct Party positions; to do so is to appear to be a reactionary, a conservative, to lay oneself open to the accusation of dogmatism, sectarianism, narrow-mindedness, backwardness, Stalinism, etc. . . . It is one thing to combat the consequences of the cult of personality in order to assert the Leninist standards of life . . . and another to deal blows, under the guise of the struggle against these consequences, to our society and our ideology. . . . The question of creative freedom must be fully clarified. . . . We have full freedom to fight for communism. We do not have and cannot have freedom to fight against communism.[18]

If this speech and other official statements are accepted as proof of unrest in the arts after the Manège exhibition, they clearly point to confusion within the ranks of the Party hierarchy.[19]

The confusion can be further illustrated. While the Manège affair was unfolding, an exhibition of several Yugoslav modern painters was in progress at the Hermitage in Leningrad. The showing included the noted primitivist Ivan Generalich, whose fantasy-sparked peasant scenes are the antithesis of social realism. In the beginning of the new year (January 1963) an exhibition of 300 canvases by the French modernist Fernand Leger opened in the Pushkin Museum in Moscow, where it continued to run unimpeded for three months. The young avant-garde poets Bulat Okudzhava and Andrei Voznessensky continued to give public readings. The writer Valentin Katayev and the playwright Viktor Rozov departed for the United States on schedule, while Yevgeny Yevtushenko left for a quick visit to France and

[17] *Ibid.*, p. 16.
[18] *Ibid.*, pp. 20, 21 and 25–26.
[19] The Khrushchev leadership was probably too preoccupied at the time with the apparent unrest in the military establishment over the Cuban missile crisis.

West Germany. Soon the Western press was to take note of him in the headlines and carry front-page photographs showing him sitting on a train reading Pasternak's *Doctor Zhivago,* with a bottle of "Jim Beam" bourbon and a "Zippo" cigarette lighter on the table before him.

While the literary intelligentsia seemed to have put up a firm opposition front, the artists who had exhibited in the Manège remained silent and stubborn, refusing to recant. Their road to recognition had been long and slow, and so silent, in fact, that their strength and number at the Manège exhibit came as a complete surprise to officials and the general public.

Without the opportunity to exhibit and communicate with his audience, the avant-garde Russian artist has remained in virtual isolation — painting for a small, select group with little hope of recognition. Thus, without open support from the audience (yet to be cultivated), the moment the show came under attack, the painters retired to their studios in silence. Now, with almost no reaction from the visual artist, the Party turned to the consolidation of its forces on the literary front and began a campaign against the literary intelligentsia.[20]

[20] While confusion reigned in the immediate aftermath of the exhibition, considerable consolidation was in progress on the part of the government and conservative elements in the creative community. Unfortunately, the aftermath of Ilychev's earlier and Khrushchev's later speeches, restored some prominent Stalinists to positions of influence. Vladimir Serov had been named as the new president of the Academy of Arts, replacing the more moderate conservative Boris Johanson, on December 4, 1963. Shortly thereafter Alexander Gerasimov was elected as the new head of the Union of Artists. Another extreme conservative, Alexander Laktyonov, was named director of the Surikov Art Institute in Moscow. Alexander Chakovsky was named chief editor of the once liberal *Literaturnaya Gazeta* replacing the less orthodox V. A. Kosolapov; six other editors were also dropped: V. N. Volkovitinov (editor of *Science and Life*), Yury Bondarev, G. M. Korablenikov, Boris Lenotiev, Vladimir Soloukhin, and Yevgeny Surkov. On March 15, 1963, Stepan Shipachyov, the head of the Moscow branch of the Writers Union, was removed, allegedly at his own request, and replaced by Georgy Markov, an old conservative. Alexei D. Romanov, former journalist and ideological expert with no experience in film-making, was placed at the head of the country's motion-picture industry; other changes of lesser importance were also made.

Retiring to their studios did not mean complete defeat for the unofficial artists, for often open criticism in a closed society serves to increase interest in the subject under review. In retrospect, the Manège incident clearly served to rally the advocates of modern art around the criticized painters, increasing public interest. In fact, the incident was the starting point which gave the modern-art movement such an initial impetus and desire for legitimacy that, by the summer of 1964, the unofficial community boasted of having gained a significant following from the general public — particularly from the young intelligentsia which suddenly began to acquire works of art in accordance with their intellectual taste.

The Framework of Unofficial Art

THE formal organizational ties of the official artists' community, embodied in the powerful Artists Union, have been discussed earlier. The cohesive forces which unite the community of unofficial artists, however, are relatively weak, even among individual groups, although they represent real and influential trends, barely tolerated by the authorities.[1] However, the organizational weakness has a survival value. During past cultural crackdowns formally recognized writers' clubs and other creative organizations challenging orthodoxy were quickly dissolved.[2] The creative trends existing among the unofficial circles, however, have somehow managed to prevail and indeed to come to the surface during the cultural thaws, only to retreat again when pressure for conformity was exerted.

The strength of the unofficial art community is not in organization (most artists move in small circles of friends) but in numbers. A conservative estimate made by an important Soviet modern art collector in May of 1964, estimated the community of unofficial artists at

[1] "Cliquishness," as defined by the orthodox critics, is the tendency of artistic groups whose members are linked by personal relations and common interests not shared by the Party-controlled organizations such as the Artists Union.

[2] In the wake of Khrushchev's anti-Stalin speech the editorial board of *Literaturnaya Moskva* took advantage of the so-called "second thaw" and launched a radical social-critical campaign for a few months at the end of 1956, thus becoming a center of literary opposition. With publication of its almanac, which contained a novel, a play, and several short stories, poems, and articles, the group of writers (including Granin, Dudintsev, Kirsanov, Yashin, Nagibin) and the editorial board (Kazakievich, Aliger, and Bek), who contributed to this collective effort, openly called for autonomous writers' groups centered in journals and publishing houses independent of any centralized control. See *Literaturnaya Moskva*, No. 2 (Moscow, 1956).

500 in Moscow, 300 in Leningrad, and from 50 to 100 in Kiev[3] for a total of about 1,000 artists throughout the Soviet Union.

Ironically, it is in the two metropolitan centers, where official cultural policy originates, that the unofficial artist enjoys the greatest freedom. However, in the provinces, away from the watchful eye of the cultural officials where one might expect unofficial groups to flourish, local political control is so restrictive that the artist can do little more than echo the approved official sentiments emanating from Moscow. In the cities of Alma-Ata, Yerevan, and Tbilisi,[4] for example, the provincial artist works in the earnest style of academician A. Gerasimov, whose official portraits of Stalin adorned public halls for a quarter of a century. It is indeed in the provinces, the hinterlands of Russia, where the force of communism is most strongly felt — where the propaganda value of art is most insisted upon and the aesthetic least heeded, where the artist is directed to glorify the agricultural drive in the virgin lands of Central Asia, the bridging of the Yenisei River, or the introduction of a chemical fertilizer. There, in the provinces, the official creative theory and control of art are most successful.

However, metropolitan artists are interested in improving the lot of their provincial brethren. We were told, for example, how word would come to Moscow about a gifted young provincial artist working in an "unusual abstract" style. The news would reach an influential person interested in new talent: in some way arrangements would be made to bring the young artist to the city. Recruiting is not a standard practice; however, talented artists are sponsored and brought to Moscow, where numbers and proximity create the atmosphere needed for further development of their talents — although often, to the chagrin of the sponsors, the genius from the provinces proves of uncertain ability. Ilya Ehrenburg has commented: "I know young Soviet artists who were 'discovering America' in 1960. They

[3] We were told that there is a small creative community in Kiev supporting a group of talented avant-garde artists. The few samples of works from Kiev which we saw in Moscow and Leningrad were unfortunately rather routine examples.

[4] With the notable exception of the Baltic cities of Riga and Tallin, where comparable but much smaller groups of unofficial artists exist.

were doing (or to be more precise, trying to do) what Malevich, Tatlin, Popova, and Rozanova had already done in their time."[5]

Enforcement of socialist-realism standards has never been completely successful in the metropolitan centers. "Formalism's" endurance under fire was noted by the Stalinist art critic B. M. Nikiforov, writing at the peak of the postwar Zhdanov period Nikiforov complained in 1948: "For many years it was a formidable task to overcome the survivals of formalism in the development of Soviet painting. *The struggle continues to this day.*"[6] A curious statement, coming in the Zhdanov era, by the end of which Soviet society was supposedly rid of all "undesirable" elements in art and literature.

In Moscow and Leningrad, however, a part of the "great experiment" tradition continued to survive. It lingered on with such masters of the "formalistic brush" as Pavel Filonov, who painted throughout the 1930's and early 1940's before his death in the famine accompanying the wartime siege of Leningrad;[7] Robert Falk, an influential university professor, who continued to pursue his art until his death in 1958; Alexander Tyshler, who has worked since the Revolution in a rather delicate surrealistic style; Leningrad artist Nathan Altman, who has persisted in his experimental searches through the years; and the "official" Leningrad artist and noted lithographer Anatoly Kaplan, in whose magnificent illustrations of Jewish folk themes the Chagallian touch vividly survives. Masters such as these — who have maintained their ties with the past, thereby supplying a link with the pre-Stalinist artistic tradition — have been most important for beginning artists.

The young artists are proud of their heritage, and voices have been raised against the deliberate isolation of these and other masters

[5] Ilya Ehrenburg, *Lyudi, gody, zhizn* (Moscow, 1961), p. 429.

[6] B. M. Nikiforov, *Zhivopis* (Moscow-Leningrad, 1948), p. 21. Italics supplied. For more recent attacks on formalism, that is, abstractionism, published at the height of the 1962–1964 campaign, see V. Kemenov, *Protiv abstraktsionisma* (Leningrad, 1963) and Atanas Stoikov, *Kritika abstraktnovo iskusstva i evo teory* (Moscow, 1964).

[7] Filonov's works, turned over to the museum after the artist's death by his two living sisters, are kept under lock and key in the Russian Museum reserve of Leningrad.

from the public. Many important members of the past are not alien elements to be feared, but exert a free, creative influence to be welcomed. In his memoirs, Ehrenburg again complained: "Our museums possess superb collections of the 'left art' of the early postrevolutionary years. It is a pity that these collections are not open to the public. You can't throw out a link from the chain."[8]

It was not until the Manège manifestation, however, which re-

[8] Ehrenburg, *op. cit.*

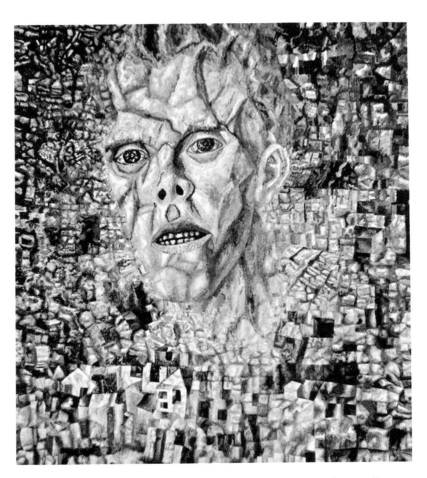

**Figure 25. Filonov, The Youngest (1930's). Oil, 29½ x 33".
Photograph by Alexander Marshack.**

vealed the strength of the unofficial artist and his open public sup-
port, especially from the young intelligentsia — students, engineers,
scientists, teachers, lawyers and other members of the rising profes-
sional elites in the new Soviet society, for whom the old formulas of
culture and aesthetics have become banal — that the cultural author-
ities of the government became generally concerned.

After Khrushchev's speech in 1956 denouncing Stalin's cultural
policies, literary and artistic circles formed in institutes and universi-
ties, youth cafes began to open, handwritten or typewritten volumes
of prose and poetry appeared, and even a few unofficial journals.[9] The
young artists began to visit homes of unofficial artists who had before
moved only in closed circles; their kitchens and bedrooms were now
turned into studios, and genuine teaching of modern art began. Cau-
tiously some of the early postrevolutionary creative spirit was revived.
The young artists began to influence their friends, these their own
colleagues, and soon modern art once again became a reality on the
Russian creative scene.

The unofficial artist is supported by the young intelligentsia, and
also by the members of the "new class"[10] — the "Red" petty bourgeois,
the bureaucrats, the professionals, and managers. Yevtushenko, the
poet, for example, has a collection of abstract paintings in his home.
Khrushchev's son-in-law, the former editor of *Izvestia,* Aleksei Adz-
hubei, is said to have owned twenty abstract paintings and modern
sculptures at the time of the Manège incident. Of the professional
classes, the scientists particularly lean toward modern art. Several
unofficial artists have high-ranking patrons in the institutes and re-
search centers clustered around Moscow and Leningrad. Some works
have even reached the scientific communities of Siberia. "You don't
really expect an astrophysicist — with his thoughts in outer space —

[9] This practice has now become a thriving enterprise and occasionally costs the
entrepreneurs a few years of hard labor and exile in Siberia. For a more recent
case and letter of recantation by the former editor of the short-lived unofficial
Moscow publication *Sintaksis,* see A. Ginzburg, "Otvet gospodinu Hyugesu,"
Vechernyaya Moskva, June 3, 1965, p. 3. Ironically, after Ginzburg's letter,
Grani (No. 58) published all three volumes of *Sintaksis.*

[10] For the Communist society's "new class," see Milovan Djilas, *The New Class*
(New York, 1957).

to be satisfied with a Gerasimov in his living room," commented one artist, adding: "On second thought, maybe in his living room, but not in his study or his *dacha*." The relationship between modern science and contemporary art has been keenly recognized by the scientists and the artists, and a genuine understanding and compassion has developed between them, particularly by the former who enjoy much personal and economic freedom.

As elsewhere, abstract art is often bought for its status value and as an investment.[11] Yekaterina Furtseva, the Soviet Minister of Culture, at the June 1963 Ideological Plenum, drily mentioned a critic who had attacked the controversial sculptor Ernst Neizvestny, only to pay him 12,000 (old) rubles ($1,200) for a statue.[12] Several art collectors and art dealers have become prominent and affluent in Moscow and Leningrad. The going rate of an average oil painting by a recognized unofficial artist is about 150 rubles ($165 by the official exchange; 1 ruble = $1.10). Prints and sketches go for about 25 rubles, sculptures can go as high as 2,000 rubles. This, translated into the earning power of an average Soviet worker (75 rubles per month, compared to the American average of $400) means that an average canvas costs the equivalent of $800, or two monthly salaries. Only the monied Soviet ruling and professional classes have the means to buy original works.

In general, the Soviet upper classes are overpaid, in American terms, by contrast with the average worker. In some respects, social stratification in the U.S.S.R. is far more extreme than in the West. The Soviet poet and playwright Sergei Mikhalkov was not joking when he stated, while visiting the United States in 1959, that he was a millionaire from the Soviet Union.[13] For example, a captain in the Red

[11] Our visit to the home of a young unofficial-art dealer in Leningrad was interrupted by that of an "important personage" (director of a Siberian industrial complex), who paid 860 rubles ($946) for three oils and several sketches.

[12] For a discussion of the June plenum and translation of speeches presented, see Johnson and Labedz, pp. 54–60, 216–240.

[13] Norman Cousins, "On Rubles and Royalties," *Saturday Review* (September 5, 1959), p. 28. The system of incentives for Soviet professional groups, particularly writers and scientists, is on a par with that of many Western societies. Indeed, the rewards given to Soviet writers are unique in the Socialist world. Pro-

Army earns seven to eight times more than an average worker.[14] But there is little upon which the wealthy Russian can spend his riches. In a communist state it is difficult to purchase collective property for personal use, such as a private home, because all property is owned by the state; cars are scarce (more than five years of waiting); and the quality of most Soviet goods is such that the upper classes refuse to buy them and either import or go without them. Since only a few can travel abroad, some spend their money on modern art because they like it, some simply for investment, and some because of the social lustre acquired with the purchase. Ironically, then, persons most closely associated with the establishment — and hence, with controls over creative freedom — are also those often responsible for underwriting many of the more important unofficial artists. The Manège exhibition illustrates the point. The fact that it is possible to exhibit in public galleries means that abstract art has some influential patrons high up in the cultural policy-making hierarchy.

This, then, explains the toleration of art collectors such as George D. Costakis, one of the largest individual collectors of pre-Soviet and Soviet modern art in the U.S.S.R. Costakis is a son of a wealthy Greek plantation owner who lost his large holdings in the Tashkent region after the Revolution and the nationalization of land. Costakis (now in his fifties) has lived in the Soviet Union since he was eight; he retained his Greek citizenship, and continues to associate with the foreign community and the outside world. These associations would once have been detrimental to the career, but times have changed and now such contacts add social status to those who travel abroad, a pattern similar to that of prerevolutionary days.

ceeds from one book alone can run into millions of rubles. No other professional group enjoys such a privileged position. Significantly, the advantages made available to the professional elites and the manner in which rewards are distributed have produced a sense of professionalism and social stratification. This phenomenon has aided the rise of de facto "interest" groups in the Soviet society whose demands for functional autonomy have been heard for some time. Indeed, professional pluralism may not be as far away as some Sovietologists predict.

[14] A Red Army captain, with field assignments in the North, told one of the authors in April of 1964 that he was earning 560 rubles ($616) per month.

Costakis is more fortunate than many of his compatriots; he works for the Canadian embassy in Moscow, which provides him with direct access to the outside world — a privilege denied some of the most important people in the country. Costakis' position remains undefined, for only he knows how far he can extend this highly speculative venture into the acquisition of works of art in an atmosphere which is not conducive to the development of modern art. In the past few years Costakis has acquired a valuable collection of modern Russian art — including works by Kandinsky, Malevich, Lissitsky, and Popova from earlier times to Rabin, Zveryov, Plavinsky, and Yakovlev from the present generation. It is probably the most representative collection now in existence.

Costakis began with a collection of small icons, now considered one of the finest private collections in the Russian Orthodox style. He then proceeded to acquire oils, prints, and sketches, and has managed to obtain diaries, letters, photographs, and personal effects of many artists whose pictures are in his collection. It was obvious during our visit with him that he cares deeply about Russian art and immerses himself in its many curious byways. Mrs. Costakis pleasantly commented, with an air of patient pride, that "George is more in love with Popova than with me."

We asked Costakis if he planned to make use of the wealth of information he has collected, by writing a book. "Yes," he replied. "One of these days when I am not so busy collecting I will write a book which will give the critics enough food for a decade." The book would cover the entire pre-Soviet and Soviet modern-art movement. In the meantime he seems to be more interested in individual monographs on such little-known people as Lyubov Popova.

In a country where open exhibits of modern art do not exist, with criticism from both viewers and critics freely stated, Costakis performs a unique function: he is the public, the critic, and the collector wrapped into one. The path to recognition for an unofficial artist is to have his work acquired by George Costakis, who is for many Moscow and Leningrad circles the final arbiter in Soviet modern art.

Costakis does not confine his activity to the home front. He manages to make occasional trips abroad to find or search for early mod-

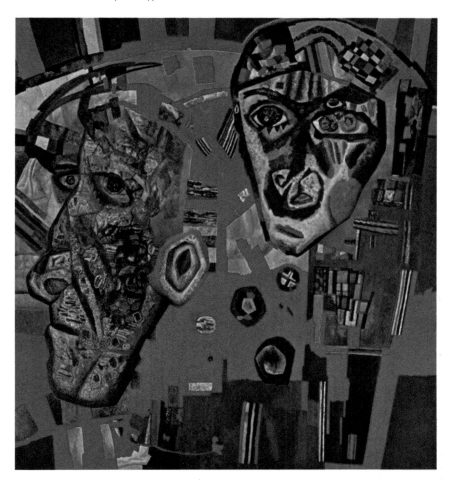

Figure 26. Filonov, Two Heads **(1925). Oil, 25 x 26".**
Photograph by Alexander Marshack.

ern masterpieces, and to enter works from his collection in foreign
exhibitions. In 1956 he went to Paris to acquire works of Kandinsky,
Chagall, and others. His correspondence with Marc Chagall, who has
lived in France since the thirties, continues to the present time. In a
Kandinsky show, held in Tokyo in June 1964, Costakis entered twenty
works from his collection. More recently he has established contacts
with some Western European art dealers and seems to have become

instrumental in arranging sales agreements covering large quantities of oils, prints, and even icons which are exported to the West by official Soviet agencies.

Costakis, then, commands a degree of authority and respectability in Soviet official circles, in part because of his contacts in the unofficial circles.[15] Cultural officialdom evidently recognizes that there is a nucleus of creative activity in unofficial art which deserves attention and permits people such as Costakis to represent it, albeit sparingly. Costakis' acquisition and preservation of many fine works of modern art are no longer looked upon as a dangerous challenge to orthodoxy.

Costakis is but one of many large collectors of the older generation who enjoy a kind of semi-official status, while the younger collectors, less experienced and with fewer and less influential contacts, remain underground. But they too serve an important function, for they provide a market for the new rising talents who are not fortunate enough to reach the collections of the "giants." They keep the young artists in money for the few art supplies that can be had and provide them with latest information on the art developments in the West; they give small exhibits in their homes, studio apartments, and youth cafes, quietly selling their works to other collectors and art lovers.

To be able to exhibit openly in a public gallery was a formidable

[15] Ironically, while official circles seem to have recognized his role in Soviet creative life, and hence do give him social status, the foreign community in Moscow, for which he has done a great deal, does not always realize his importance. The cultural section of the American embassy in Moscow pulled a faux pas in not inviting Costakis to attend the Moscow opening of the American Graphic Arts Exhibit, held in the Uzbek Pavillion at the Exhibit of the Achievements of the People's Economy on December 6, 1963. Hurt by the oversight (which was a result of ignorance rather than malice), he refused to receive the exhibit's staff — or for that matter any American — and it took some persuasion on our part to explain the incident away. With a promise to correct the error in the future, we were invited to his home and studio collection, where he displayed a wide variety of works ranging from the earliest to the current period. He was a gracious host, with a charming Russian wife, a Soviet citizen. For the closing of the Graphic Arts Exhibit the American ambassador in Moscow, Foy Kohler, gave a reception on May 11, 1964, in the Astoria Hotel in Leningrad; it was attended by several hundred guests, among them Costakis, by the personal invitation of the ambassador.

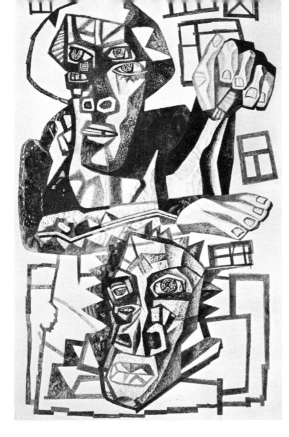

**Figure 27. Filonov,
Two Heads (1925).
Oil, 19¼ x 31½".
Photograph by
Alexander
Marshack.**

feat in itself and a milestone in the short history of the Soviet modern-art movement. "With the first step having been taken at the Manège," as one artist pointed out, "others will be easier." Indeed, both the doctrine and authority seem to be fading before the forces of complex social change.

Shortly after our arrival in Moscow during one of our first walks down Gorky Street, one of us was tapped on the back with an "excuse me" in English. As we turned around, there stood before us a teenager, a tall young man wearing a worn G.I. parka and blue jeans. He inquired whether we were Americans, again in English, in the usual fashion of the *stelyagi*,[16] which made us immediately apprehensive, as it is open season on foreigners in Russia these days for Western goods. His English was limited, and our conversation switched to Russian. After explaining that we were connected with the American art exhibit he told us, to our surprise, that he was an artist in the latest

[16] Soviet equivalent of beatniks, distinguished by their unconventional Western clothes, who work the "Gorky beat" scavenging foreign goods from visitors.

Western mode — pop art. He said: "It is dangerous for us to be seen together on the street," and invited us to follow him to a place where we could become acquainted without being observed. We continued for several blocks through back streets and alleys, finally reaching an old building. After climbing several flights of stairs, he rang a bell and talked in a whisper to a young woman, trying to convince her to let us in. After minutes of quick and heated argument, when we were about to leave, he beckoned to us.

We entered a communal corridor, passed through a poorly lit and narrow hall, and then walked into a six-by-ten-foot room. The plaster on the walls of the room had crumbled away, exposing bricks with occasional scraps of wallpaper stuck to them. There was one bed on

Figure 28. Falk, Negro Entertainer **(1917).**

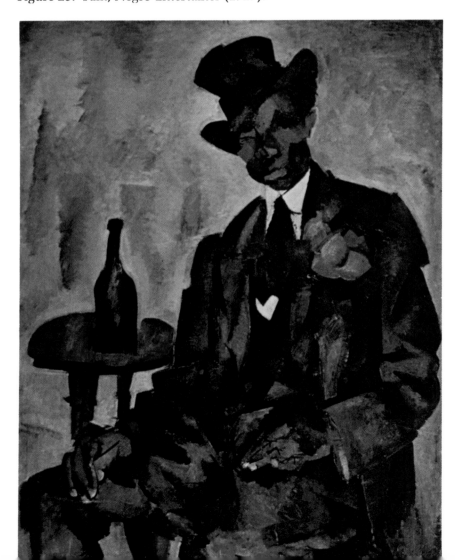

Figure 29. Pop Artist, Untitled (1963). Tempera, 11¼ x 11¼".

the right side, a child's bed on the left. Squeezing between them, we sat on low, crate-like seats by the window. Our acquaintance introduced us to the hostess, a frightened delicate woman, and her small daughter. Later he told us that she had this child by a foreign student whom she married, but that she was unable to obtain a passport to leave the country with him.[17]

As we began to discuss art, we were amazed at the scope of the

[17] The association with a foreigner, and later attempt to leave the country with him, resulted in her dismissal from her job. Although idleness is illegal and work guaranteed by the constitution, she was unable to find employment in the months

young man's knowledge. The last person we expected to encounter in Moscow was an eighteen-year-old who knew more about the New York artistic scene of the moment than either of us, although we had been intensively briefed on the latest developments in the New York art world in preparation for the trip to the Soviet Union. Our young friend was not only well aware of the numerous subtleties of abstract expressionism, but knew fully as much about pop and op art. He spoke of Anuszkiewicz, Oldenburg, Lichtenstein, Jones, Indiana, Rauschenberg, and many others, as if he knew them personally. We asked him how he learned about these people in the Soviet Union, without Western press and news media. He told us that when he was fifteen, during what he called the "great thaw" (1959–1962), he attended several semi-official abstract-art exhibits around Moscow. On occasion he expressed his enthusiasm so openly that the authorities removed him from the premises. Now "with age," as he put it, he was more careful, especially since he was coming into his own and was concerned for his future. Besides, at the time of our talk, less than a year after the Manège incident, official vigilance was strict.

He was the first to tell us how abstract expressionism gained its foothold in the Soviet Union in the early sixties, how news filtered in through tourists, cultural exchanges, the limited number of subscriptions allowed to institutions (institutes, libraries, editorial offices of journals, and the like), trustworthy individuals, and foreign diplomatic missions. One of his sources of information, for example, was the Lenin Library in Moscow where, upon knowledgeable request, it was possible to obtain *Art News, American Artist, Amerika, Artforum, Du, Gebrauchsgrafik, Réalités,* and so on. Since such publications are limited to library use only, it happens that interested parties rip out

after her husband left. The months soon turned into a year, and she had to support herself and her daughter somehow, for there is no unemployment insurance in the Soviet Union. Eventually, she turned to prostitution. She was not a streetwalker (as prostitution is severely punished in the U.S.S.R., although it exists openly, particularly in Odessa and Leningrad), but received selected clients. Obviously, our young artist was once a customer. Now it was evident that she cared for him deeply, or she would not have received him in her apartment with foreigners who could have been under surveillance.

an occasional page with a painting by de Kooning or Motherwell, for example, to sell them on the black market. Our young hero was extremely informative, told us what exists in this shadow world of Soviet art and how, and gave us a comprehensive list of unofficial artists, critics, and art collectors. Long after this memorable meeting, through months of contact, conversing with unofficial artists and acquiring their works, we reflected with even more surprise on the young man's insight.

The Artists

I N THE mid-1960's the Soviet Union did not have any specific schools of contemporary art. Instead, several loose trends existed headed by influential artists and teachers who subscribed to one or several schools of modern art. Generally artists were grouped in small circles ranging in size anywhere from three to about a dozen people. In no sense could the trends be defined as art movements; rather there was a conglomeration of artists' groups who did not subscribe to the official dogma of socialist realism.

Communication between the groups is casual and limited. They have no publications, since duplication of written material is the sole privilege of the state. If they show their work, it is within their homes, since galleries are not open to them. They meet at these private showings (if word of mouth has carried news to them) and at the homes of private collectors like George Costakis (if they have risen that high in the unofficial echelons). But it is not unusual for two artists working in the same style, living in the same neighborhood, to know nothing of each other. There are no "artists' bars" or restaurants where groups meet to trade shop talk. The groups have in common: severe limits upon the style and content of their work, difficulties in learning of art movements outside the Soviet Union, and often an impoverished life, which is reflected in much of their work.

An observer, entering the unofficial community for the first time, is struck by the political overtones which permeate the scene. The intensity of the artist's resistance to socialist realism determines the imaginative quality of his work. But, in having to fight for his individuality, the unofficial artist remains, ironically, entangled with his opponent, the state. And even when his work takes on a withdrawn fan-

tastical quality one senses the power which has forced the retreat. Therefore, comment on unofficial art is inextricably political in nature. The tentative efforts, particularly of the younger unofficial artists, are hard to categorize since their experimental nature tends to shift them from camp to camp.

The Soviet unofficial artist's attempt to keep one eye on the state and the other on his painting has largely resulted in cautiously experimental work; besides, it obviously suffers from lack of contact with the mainstream of international art. His scope has been narrowed by the state's removal of his heritage, the works of the modern Russian masters of the early twentieth century. His knowledge of current developments in international art is generally limited to reproductions and hearsay. The unofficial artist's work, therefore, is often a strange amalgam of trends which is hard for the Westerner to envisage. Various major movements of the international art scene — abstract expressionism, collage, pop art, op art, and so on — take on a different character in Russian unofficial art, and often seem ill-suited. Thus, finding it difficult to assign proper aesthetic categories, we have grouped the artists primarily on a scale of decreasing adherence to official dogma.

We have introduced the following three categories of artists: (1) *Borderline* artists, whose creative output in style and subject matter borders on the official and unofficial; some of them belong to the Artists Union and others remain on the periphery of acceptability. To this group belong such artists as Yefimov, Yershov, and Kaplan, who are official artists but whose work is more interesting than that of most; its quality and subject treatment surpasses the work of other union members. Brusilov's work is aesthetically acceptable to the union but he cannot obtain membership because of the union's discriminating admission policy; this alienation drives him toward unofficial art. Rabin and Glazunov fall into the category of borderline artists because of the official sanctions they receive, though they also create unofficial art; their works have wide appeal at home and abroad, which is in their favor. (2) *Unofficial* artists such as Kropivnitsky, Zveryov, and Plavinsky fall into this category because their creative output and social standing is clearly unacceptable. They are in the forefront of the avant-garde, experimenting with various forms

and styles. (3) *Social outcasts* (for lack of a better term), who represent an interesting segment of the unofficial community — socially ostracized and supported by the state. Their art is of a very personal nature, reflecting the atmosphere in which the artist lives; fantasy is important in their work. This category includes Yakovlev, Kharitonov, and Sitnikov, whose work we found the most interesting of any we encountered in the U.S.S.R.

Irrespective of classification, all artists discussed in this chapter are representative of the Soviet modern art community, which we have called the "unofficial community," carrying on artistic activity outside of the Artists Union.

The Borderline Artists

The official media — from simple pencil sketches to large oil canvases — hardly show any signs of individuality. In the monumental arts, for example, adorning entrances to factories, collective farms, dams, pub-

lic squares and streets, it is difficult to distinguish styles among the enormous placards, murals, and frescoes. Stylistically and ideologically they are kept consistent and up to date with the political changes; the images of downgraded leaders fallen in disfavor are simply replaced or painted over, as in the case of Stalin and, more recently, Khrushchev.

The Tretyakov Gallery in Moscow and other state galleries in Soviet cities and towns are well stocked with easel paintings, the fine art of socialist realism. There again, the Western observer finds remarkable uniformity, subjugation of form to the subject and stifling academic sterility. There are no galleries in the Soviet Union exhibiting paintings by artists who work outside the accepted creative mode of socialist realism, which is not the case in other socialist countries

Figure 30. Favorsky, Illustration to the "Lay of Igor" tale (1962). Wood engraving, 5½ x 12".

such as Poland and Yugoslavia.[1] Moreover, the general public may purchase state-approved art in state art salons, usually situated on main streets. In Moscow they can be found on Gorky Street and in Leningrad on Nevsky Prospect. The salons are the only open and legal places for the public to acquire contemporary art.[2] The salons are run by the local Artists Union with all proceeds going to the Artists Fund from which the artists receive rewards and bonuses. One-man and group shows are organized and advertised by announcements and posters.

Occasionally more daring artists of an impressionistic direction are shown, but generally the content of the exhibited art is kept on a safe and conservative level. The variety is usually limited to landscapes, still life, revolutionary lore, and the unavoidable portraits of

[1] The recently opened Modern Art Gallery on the River Sava in Belgrade is not only an architectural model but a vivid monument to what Socialist culture can achieve if left to develop on its own. See Aleksa Chelebonovich, *Savremeno Slikarstvo u Jugoslaviji* [Contemporary Painting in Yugoslavia], (Belgrade, Izd. zavod Jugoslavija, 1965) — 252 pages of well documented and illustrated text with a penetrating analysis of this officially recognized and highly motivated artistic movement in Yugoslavia.

[2] There is one kind of enterprise, the komisionny magazin (second-hand store), which is the only example of limited free enterprise in the Soviet Union; there a citizen can sell goods, according to the demand, for a profit. One can see displayed in the store windows prerevolutionary sets of books, prints, etchings and lithographs, china, crystal, and other items of antiquarian and speculative interest. Occasionally the authorities crack down on enterprising entrepreneurs, who then move from Leningrad to Moscow, or Kiev, where the pressure may be less at that time. Leningrad is particularly attractive to the black marketeer because it is more visited by tourists. Then too, the aristocracy lived there, and their descendants are less attached to the family treasures, such as books and art objects, and sell them.

Figure 32. Zakharov, Untitled (1963). Woodcut, 11 x 15½".

Figure 31. Favorsky, Untitled. Wood engraving, 3⅛ x 5⅞".
Favorsky (d.1965) is regarded by many as the father of pre-Soviet and Soviet graphics with a long standing in the Artists Union. Important to a whole generation of graphic artists, he was conservative in his technique and nationalistic in the treatment of the subject. He worked primarily in wood engraving and was often called the Dürer of Russia.

Lenin bought by directors, executives, and party members.[3] The graphic salons offer a much higher standard of quality and individuality, perhaps because here the line between craft and art is vague, and one can allowably admire for their excellent technical execution etchings and engravings by such masters as Favorsky, Kravchenko, Khizhinsky, Vereysky, and others. The younger graphic artists, such as Zakharov and Galitsyn, work in a much more relaxed manner. The editions of these artists run high for Western standards, from 300 to 500 prints being struck, and prices on the average are as low as $3.50 to $5.00 for signed but not numbered prints. The character of this merchandise in the salons is periodically revised and reevaluated by a committee from the Artists Union, and the works found ideologically weak or technically unsound are weeded out. Some approved subjects, particularly representations of Lenin, are still prerequisite for the artists' personal advancement.

Vasily Yefimov. — One of the talented graphic artists we met was Vasily Yefimov, a vibrant and energetic man of great physical strength,

[3] One wonders how Lenin, the architect of proletarian art, would like to see his portraits so eulogized and sold at such exorbitant prices — from 300 to 6,000 rubles ($330-6,600).

Figure 33. Korovin, Untitled (1963). Water color lithograph, 12 x 15".

in his early forties. He was a decorated Hero of the R.S.F.S.R., a brave soldier, and one of the few NCO's invited to Stalin's victory banquet in the Kremlin in 1945. The Soviet regime has rewarded him handsomely with education, training, and responsibilities. He holds a position of authority and respect in the Leningrad Artists Union, trying in his work to integrate quality with the necessary ideological content. His latest portraits of Lenin and the controversial Mexican painter David Alfaro Siqueiros (whom he met and befriended) are examples of his style. Presently he makes primarily linoleum cuts, the so-called "linographs," like many other Soviet graphic artists.

Yefimov is well versed in developments in the Western art world. He is successful financially and socially and is quite content with his way of life — pursuing the established status quo of his artistic and, consequently, social existence. Like many other successful members

of the Soviet society, he cannot afford to modify his artistic direction regardless of his doubts, thoughts, and opinions. His style is in the feeling of the 1920 graphics with reliance on strong silhouette and contrast, the drama achieved by simplicity, and stylization of form. There is a general trend in this direction among other artists, but his work seems to stand out as the best.

The subject matter of the graphics in the salons is limited and carefully chosen: pictorial scenes pertinent to the geographical location, be it Moscow, Leningrad, or Kiev, executed in various media from etching to silk screens, mostly mediocre in quality and taste; subjects of the Revolution and the Second World War; and folklore, fairy tales, and children's book illustrations. In this last category one can find occasionally a charming and worthwhile print.

Figure 34. Yefimov, Siqueiros in Prison (1964). Linocut, 16 x 24″. Portrait of the Mexican painter David Alfaro Siqueiros in prison.

Figure 35. Yefimov, Lenin (1964). Linocut, 16 x 24″.

Igor Yershov. — Igor Yershov is among the best artists — certainly one of the most popular artists in the folklore genre. He is a handsome man, who sports a goatee — unusual in Soviet society. Few people in the U.S.S.R. show signs of individuality. They include, as in the West, members of the Bohemian community in the art and academic world.

Yershov lives in Leningrad in a two-story building, occupying the second-floor apartment. We were introduced to him by one of his young protegés. He received us cordially in the room he uses as a studio. There was a low couch and a working table with a huge built-in radio above it. He told us that he likes to work late at night listening and reminiscing to music which induces a flow of fantasy for his charming illustrations of Russian fairy-tale lore.

He works mostly in the linoleum-cut technique, though he showed us his more ambitious work in water colors — stylizations of the Russian icon and a series of studies of a bottle. Some of these water colors were exhibited in the first major foreign show of Soviet painters, organized by Eric Estoric of the Grosvenor Gallery in Lon-

Figure 36. Yershov, Sivka-Burka **[A fairy tale], (1963). Linocut, 18 x 22″.**

Figure 37. Rabin, Vida, Volokolamsky Monastery **(1964). Pencil, 17 x 23".**

don in June, 1964. Yershov makes a conscious distinction between his two levels of work, which we found interesting; many official artists we met did some experimentation on so-called "personal things" but we never ran across an official artist who made (for example) non-objective studies "for the drawer" — which is where these personal works go. Speculation may be aroused by this dual personality of the Soviet artist, but we never saw anything from the "drawer" which did, in fact, radically differ from the artist's daily work. The "personal things" were conservative studies, hardly alarming in nature.

Yershov's fairy-tale illustrations are well known in the Soviet Union. He is published extensively in children's books, and his prints

are sold separately in 300–500 edition albums in the official salons. He uses a familiar and accepted stylization of the Russian "skazka,"[4] emphasizing bright colors with a moderate stylistic exaggeration of form. His imagery is familiar to practically every child in Russia, and his treatment of subject is certainly accepted by the ethical code of the official socialist realism.

On the other hand, an artist such as Vida Rabin, who developed an unusually original and charming stylization of the "skazka," inventing a new set of animal characters and often placing them in a magic fauna setting with the traditional onion-domed Russian churches in the background, was rejected by various publishers on the grounds that her work was too stylized and formalistic. These examples illustrate the enormous resistance of the bureaucratic apparatus to unfamiliar and new forms of expression, no matter how innocent.

[4] "Skazka" is a Russian folk tale in verse, akin to fairy tales in prose, treating generally the World of the Wonderful. The folk form, the origin of which is lost, has had numerous literary imitations; for example, Alexander Pushkin in *Tsar Sultan* and *Le Coq d'Or*.

Figure 38. Kaplan, Rachel **(1964). Lithograph, 17 x 24″.**

Figure 39. Kaplan, The Merchant's Family **(1963).**
Lithograph, 12½ x 17".

Anatoly Kaplan. — The greatest contemporary Soviet graphic artist is
undoubtedly Anatoly Lvovich Kaplan. Although his works are in the
major Soviet museums he is hardly known to the general public.[5] He
became known in the West in 1961, for which credit should be ac-
corded to Eric Estoric of the London Grosvenor Gallery; it was his

[5] Kaplan is best known in the Soviet Union for his graphic series "Views of
Leningrad During the Days of the Blockade," printed in 1946 and acquired by
eighteen Soviet museums.

persistence, perseverence, and patience that persuaded "Mezhduna-rodnaya kniga" (International Book — the trust which handles foreign book, art purchasing and commercial affairs) to organize the Soviet Graphic Arts exhibit in London in 1961, the first of that kind in the West. For this commercial exhibit, Estoric had to make repeated trips to the Soviet Union to negotiate the transaction, for it was regarded as highly irregular by Soviet cultural officialdom.[6] For the exhibit Kaplan was commissioned to create an album titled "Tevia the Milkman," based on his interpretation of the Jewish story of that name by Sholom Aleichem. This album, in a limited edition of 125 copies, together with other lithographs by Kaplan, was bought by Estoric from the Soviet government. Since Kaplan is a member of the Artists Union, he received his usual salary (no commissions were paid) and permission to keep five albums gratis. Several illustrations on these pages are from those five albums. However, Kaplan is not allowed to sell them on his own, even if he wanted to; such sales would be regarded as black-marketeering. That same year, as a result of the London exhibit, his works were acquired by the major museums in the United States, Canada, Europe, and Israel.

Kaplan was born in 1902 in the small provincial town of Rogatchev in Belorussia. This is the same region from which two of his famous contrymen, Chagall and Soutine, came. Shortly after the revolution Kaplan settled in Leningrad and in 1927 graduated from the

[6] Estoric has been mainly responsible for bringing Soviet official contemporary art to Western viewers and buyers. In the preface to the prospectus of the June 1964 exhibit, "Aspects of Contemporary Soviet Art," he comments: "The exhibition consists of works which have been purchased by the Grosvenor Gallery and which are available to the public. Various lengthy formalities, rather different from those surrounding the purchase of art in the Western world, have been operative. This is not intended as criticism, but rather as an explanation. But were it not for the cooperation which I enjoyed from many authorities in various Soviet ministries, this exhibition would not now be taking place. For this is a commercial exhibition for which there were no established precedents Coexistence means working and living together on all levels — this is not an idealist's objective but a stern reality which depends upon realistic means of achieving this coexistence. There are no fixed ways, there are no fixed channels, there are no established habit patterns. We must find a way, and the arts are one of the ready means in this task. If this exhibition helps in any way to 'build bridges across the gulf,' then every problem has been justified."

Leningrad Academy of Arts. When the Artists Union was established in 1939, he became a full member.

Anatoly Kaplan, like Igor Yershov, is also a folklorist, and consequently his subject gives him more latitude in personal expression than would have been possible in any other occupation. The main theme of his work is Russian Jewish folklore, for which he has a deep feeling.

A few years before the war he started his fine series of illustrations and interpretations of the stories of Sholom Aleichem and Jewish folksongs. This major project continues to the present with such memorable editions as Early Kasrilovka (1937–1939), Kasrilovka (1937–1941), Enchanted Tailor, Vols. I and II (1953–1957), The Little Goat (1958), Shir Hashirin: Song of Songs (1958–1960), Yid-

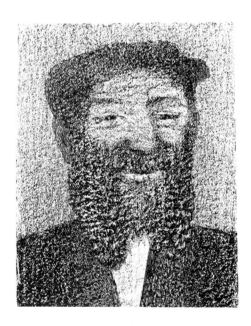

Figure 40. Kaplan, Tavy the Milkman **(1961). Lithograph, 12½ x 17".**

dish Folk Songs (1959–1960), and Tevia the Milkman (1057–1961); his latest work in progress is for an album based on Sholom Aleichem's novel "Stampenue."

The subject matter of his work is the "shtetl," that is, the provincial Hassidic community. He endearingly and gently depicts the

pathos, humor, and soul of the Yiddish folk, dwelling on the joys of youth and sad finality of old age against the background of fear and poverty of the Jewish village. His characters include a wide range of sentiment — wit and earthiness, fatalistic resignation and stiff dignity. Kaplan is a poet and a master of the atmosphere; his creations are permeated with the flavor of provincial Russia.

Folk art and the life of the provincial Russian Jewish ghetto were also a basis for the work of Marc Chagall, with whom Kaplan is often compared. Chagall also repeatedly returned to his native Vitebsk for imagery and inspiration. But as time went by, Chagall's memories were transmuted into a dreamy universe where the village figures assumed a mythical importance. It is difficult to say whether Kaplan's imagery would have reached Chagall's intensity if Kaplan had had his commissions and acclaim. It would indeed be challenging to see what Kaplan could have done with the ceiling of the Bolshoy if he were commissioned by the Soviet government to decorate it.[7]

Limited to the medium of lithography, Kaplan is an ingenious and superb craftsman. Using transference techniques from textured paper, wood, and various grained surfaces, he achieves remarkably subtle and rich effects. He has a strong sense of form, utilizing it effectively in "The Little Goat" series, but especially beautiful in the vignettes of "The Bewitched Tailor" and "Tevia the Milkman" where form and light interact, recalling Georges Seurat's silhouettes against the pointillistic background, melting and shimmering in the silvery grays of his lithographs.

But Kaplan is more than a superb craftsman. Preoccupied with Jewish folklore, illustrating volumes which are sold publicly, for the Jewish citizens of the Soviet Union he is a recorder of history, a unique poet-historian, whose imagination has recaptured the life of their forefathers. Indeed, to the three million Jews living within the borders of the Soviet Union, many of whom still speak Yiddish, to be able to read Sholom Aleichem in their mother tongue in such luminous renditions of the past, touching upon the pathos, the fiber of

[7] One of the most important public works completed by Chagall was the redecoration of the Paris Opera ceiling, commissioned by France's Minister of Culture, André Malraux, and upon its completion presented by Chagall as a gift to France.

Jewish remembrance, Kaplan is more than an artist or even a "link with the tradition," as some have said; he is a symbol of the eternal Jewish "exodus" which has yet to cease. In this and other ways, Kaplan has reached the Soviet Union's Jewish intelligentsia, who once would not have been eager to identify themselves with anything Jewish. Today such eminent Soviet Jews as the writer Ilya Ehrenburg display in their homes and studios lithographs by Kaplan. In a comment on Kaplan's work, Ehrenburg says:

Anatoly Kaplan is an artist. He does not explain, he creates his images arisen both from the poetry of his favorite books and from the visual sensation of the world. I know his lithographs created from the stories by Sholom Aleichem. They are sad and poetic. The love of youth and the wisdom of old age, the tales of old villages like Kasrilovka, which disappeared long ago, are seen in these lithographs. They may indeed be born from stories of a great writer, but they live their own independent life. It is not a supplement to a book, it is a wonderful work of fine art, where black and white are used so vividly as to create an impression of a full color scale. . . . There are lithographs by A. Kaplan on the walls of the room where I work, they bring me much joy. I am sure that a similar joy will be experienced by other owners of these lithographs.[8]

However, with the exception of the support of the Jewish population and of the more enlightened members of the intelligentsia, Kaplan enjoys virtually no acclaim, and his position in the Artists Union remains precarious. It was noticeable that he enjoyed little rapport in the offices of the Leningrad Artists Union, for he preferred to receive his visitors there, where such meetings could be supervised. And, indeed, they were. During each of the meetings some conspicuous person would be in the room at all times. Since both his unique talent and the subject matter which he pursues verge on unorthodoxy, we surmise that had Kaplan not joined the union at its inception, its roster would hardly include him today. On the other hand, if the Artists Union realized the value of his talent and the extent to which he has made an impact on the West (albeit selectively), it could do much,

[8] See the catalogue of Kaplan's 1961 show, *Kaplan: The World of Sholom Aleichem and Other Scenes, Tales and Songs of Russian Provincial Life* (London: Grosvenor Gallery, 1961), p. 1.

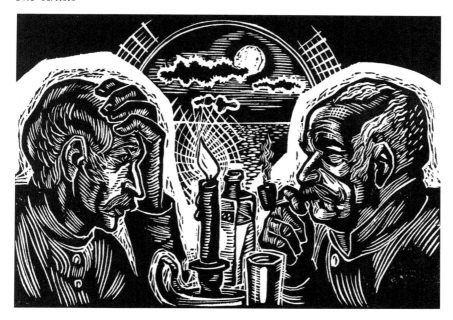

Figure 42. Brusilov, Shkuna Konstantin **(1963). Linocut, 5¾ x 7¾".**

by popularizing him at home and abroad, to improve the stature of
the state in the eyes of the world. Few actions could throw a more
favorable light on the professed or real Soviet Jewish problem.

Anatoly Brusilov. — After the above discussion of at least three mem-
bers of the Artists Union whose creative output places them in the
borderline category, let us now consider a talented younger artist
who is not a member of the Artists Union. Anatoly Brusilov works as
an illustrator for a state publishing house in Moscow. He specializes
in illustrations of American novels, notably J. D. Salinger (one of the
few young and popular American authors published). The *Catcher
in the Rye* was, at that time, his most recent subject. Although Brusi-
lov's work is acceptable to the publishing house, the Admissions'
Commission of the Moscow union repeatedly turned him down,
ostensibly because his work was too stylized. However, he insists that
his linoleum and woodcut illustrations are conservative enough (as
the accompanying illustrations indicate, specifically Fig. 42), and ar-

Figure 41. Kaplan, Jewish National Song
"For Peace and Friendship" **(1962). Color
lithograph, 18 x 24".**

tistically up to the standards of the commission; he thinks that his talent, or for that matter any real young talent in recent years, has become a competitive threat to the older membership of the union.

Firmly rejected by the union and employed by the publishing house on a commission basis, he admitted he had recently turned to experimentation in between jobs. Using collage cutouts from old books on medicine and Victorian machinery, which he integrates into his drawings, he demonstrates promising signs of individuality. Consequently, Brusilov, who probably would have become a prolific artist within the union, is now slowly moving away from conservative art to experimental work and developing his talent along lines incompatible with the goals of the union. The union, then, with its rigid self-protective admissions policies promotes dissension and unorthodoxy in the younger ranks. Either way the union loses, for privileges denied in one are privileges gained in another sphere of activity. But it is of more importance to note that the new talent, inside or outside the union, is increasingly turning more toward experimentation in technique and form.

Like many of his colleagues, Brusilov finds himself in an unsatisfactory position, rejected by the union on the one hand and not firmly rooted in the unofficial community on the other. At least those artists who preoccupy themselves with "deviationary" art, for the most part are members of the unofficial community and reap its benefits, however limited they may be. In their kind of world moral support and peace of mind can go a long way. It is much easier to grow with something than to be transplanted into it, even if an artist had the necessary talent. A case in point is that of the next artist, Oskar Rabin, who "grew" with and even married into the unofficial tradition,[9] but whose fortune has dramatically changed, as he has now moved into a highly desired position in the unofficial community: official toleration.

[9] Rabin married the daughter of his long-time teacher, master, and friend, the painter Ye. Kropivnitsky. For a penetrating analysis of Rabin's work, and Rabin's own biographic sketch, see the illustrated article by Jacques Catteau, "Oskar Rabin, Painter," *Survey* (London, October, 1965), No. 57, pp. 80–85.

Figure 43. Brusilov, Political Background of Labor Day **(1961). Collage.**

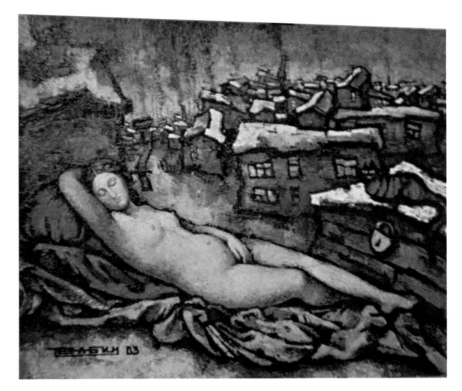

**Figure 44. Rabin, Untitled [nude à la Titian] (1963).
Oil on canvas.**

Oskar Rabin. — In the borderline category we have thus far discussed only graphic artists. We found these artists more versatile and interesting than the easel painters. Since the graphic artists are associated with publishing houses, their work is more available in galleries and less expensive, and therefore more accessible to the general public. It has thus had a greater impact. We shall now turn to a painter, whose work cannot be found in the galleries but is praised and bought by the official community. He is not a member of the Artists Union, although he has been exhibited with about seventy representatives of socialist realism (surely, with the blessings of cultural officialdom) in the 1964 show of contemporary Soviet painters at the Grosvenor Gallery in London — the only unofficial artist in the group.

Oskar Yakovlevich Rabin is a member of the unofficial community, a successful painter who sells widely both at home and abroad. Unlike other unofficial artists, whose suppport is mainly domestic, Rabin has gained a wide recognition abroad. Thanks to the diplomatic community in Moscow, to whom he has been catering for years, he has managed one-man and group exhibits abroad. His art is borderline but certainly not official. His works were exhibited in the first one-man exhibition of an "unofficial" Soviet painter in the United States at the Arleigh Gallery in San Francisco, September–October 1965. Estoric of the Grosvenor Gallery has been also quietly exporting examples of unofficial art, including Rabin's. How he managed to procure enough works (twenty-five in total) for a one-man show in the United States remains mysterious; the likeliest possibility is that Estoric tapped Rabin's high-ranking patrons in the party and cultural policy-making hierarchy. The fact that his unofficial activity has continued unimpeded for years supports this assertion. And, of course, the demand for his work abroad must have helped considerably. Surely, his association with the foreign diplomatic community has been known to the authorities. His studio is a haven for students, artists, art dealers, and collectors. Such activity does not go unnoticed and, hence, must be sanctioned in some quarters.

Rabin now lives in the Moscow suburb of Lianozovo, a hodgepodge of new prefabricated housing units, towering construction cranes, barrack-like one-story dwellings, shacks and log cabins, typical of the changing suburban countryside, where the "nagar vikov" (literally, candle snuff or residue of time) is being replaced by the sterility of the new. Compared with many Soviet citizens, Rabin is fortunate to have a dwelling with several rooms, where he and his wife Valentina-Vida, also an artist, live with their two children. It is a low wooden building, simple and plain, but adequate inside. The living room serves as a studio for both him and his wife. The walls are decorated with sketches of his wife's charming animal characters (see Fig. 37). There is an old-fashioned oval mirror between the two windows, a dining table with several chairs, and a samovar in the corner. At one end of the room stands a large easel, usually with a wet canvas on it, and the remaining wall area is filled with Rabin's paintings and

works of friends, other artists, and students. The room is sparsely furnished but provides a warm and hospitable gathering place for his family and friends.

Rabin is a slender man of middle years, bald, gaunt-featured, who wears a small moustache and glasses. He is friendly but his manner is quiet and one notices a sense of sadness which is also a component of many of his paintings. His art strongly reflects his environment — the sacred and the profane aspects of Russian life, which are not new, of course, but still exist in many ways. Russia is notorious for its staggering contrasts, and Rabin attempts to capture this in his work. For example, he juxtaposes a Da Vinci madonna with the Moscow slums, or floats a sensuous Titian nude on the same background [Fig. 44]; or, again, contrasts onion-domed Moscow churches with the tall Stalinesque official buildings. There are other motifs such as torn "Moskva" vodka labels through which one can see parts of the city [Fig. 45], an empty vodka bottle floating by the Taj Mahal, fish

Figure 45. Rabin, Moskovskaya **(1963). Oil on canvas.**

heads, cats on rooftops, samovars, trains, trucks, crumbling new apartment buildings, and so on. Rabin works mainly with a palette knife, in subdued harmonies, generally in ochre and umber tones.

Rabin is a prolific artist, painting usually in series on his three favorite themes — "window," "railway," and "domestic." His work has changed little during the past few years. The window theme has pre-occupied him throughout his life. It reappears again and again in his work, a source of inspiration explored both for the problem of light and as a frame through which the subject is viewed [Fig. 46]. He has mirrored, for example, window-like reflected images on the samovar. Rabin was working on such a canvas at the time of Kennedy's assassination. Shocked by the incident, as many of his countrymen were, Rabin burned a candle in Kennedy's memory, painting it into the window on the night of that memorable November day. The painting bears the title: "John F. Kennedy, November 22, 1963" [Fig. 47].

For many years Rabin worked on the railroad as a porter and engine driver, painting in his spare time; he has done numerous works with such subjects as electric trains, overhead wires and signal lanterns.

In his domestic theme, Rabin is particularly fond of the low, single-storied building with brightly lit windows, flushed in brown, yellow, or grays, against the evening light — very much like the house he occupies [Fig. 48]. Again, through the windows he shows snow-covered suburbia, smoking chimneys, scrawny cats on the roof tops, and crumbling brown apartment buildings. The recurring scrawny cats are reminiscent of one which the Rabins once owned. Animals are very much a part of the suburban life the Rabins live.

Rabin calls himself "a realist" because he draws his inspiration from the world around him. "My imagery is simple," he says, "because I live a simple life. I go nowhere and I see nothing. My life is spent between the *elektrichka* [electric commuter train], the *kontora* [office] where I work as a commercial illustrator, and my easel. That is the world I know, the world I see out of this window and the *elektrichka*, that is the world I paint." What more could the social realists want of an artist? Yet the revolutionary context, the search for the "lofty," for the "ideal," are missing. But Rabin has been acknowledged

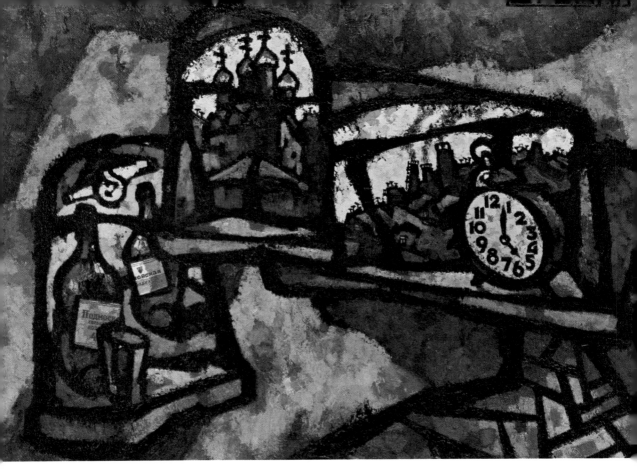

Figure 46. Rabin, Four Windows and Alarm Clock **(1965). Oil on canvas, 31 x 42½". Courtesy of Mr. and Mrs. Robert A. Zimmerman, Cambridge, Mass.**

and given the right to exhibit, at least abroad, which is far more than most of the official artists have yet to gain. It is doubtful that he will soon become a member of the Artists Union, unless he changes his style considerably or the Artists Union abandons the precepts of socialist realism. Neither is likely to happen.

To sum up, Rabin is a prolific painter with a personal style and language. Some domestic critics speak of the "shallowness of his imagery and content," but those are conservative critics.[10] One has to evaluate his work in the light of the conditions and life in the Soviet Union. Only then does his work become meaningful as a reflecting

[10] See *Sovetskaya Kultura*, June 10, 1965. Also, *San Francisco Chronicle*, June 16, 1965, p. 48.

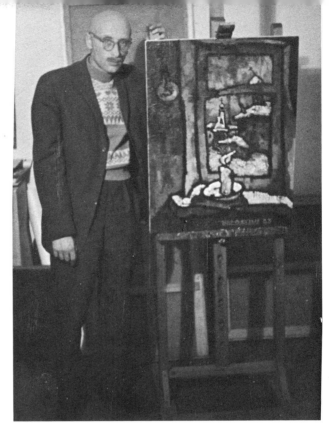

Figure 47. Rabin, John F. Kennedy, November 22, 1963 **(executed on the day of Kennedy's assassination). Oil on canvas.**

factor of one of the facets of the Soviet reality. His evident affection for his country (if he chides, it is a most gentle reprimand) and his poetic, nostalgic depiction of it have found admirers and patrons in the official hierarchy.

Figure 48. Rabin, Home **(one of his earlier works). Oil on canvas.**

Ilya Glazunov. — Ilya Glazunov, a Leningrader who is not a member of the Party or the Artists Union has done well for himself, nevertheless. Glazanov has traveled abroad, even holding an officially sanctioned one-man show. He occupies a large studio on Arbat Street in crowded Moscow where space is at a premium even to official artists. While few citizens can frequent foreign diplomatic missions, Glazunov teaches art to the wives of American Embassy personnel. He has been allowed to make trips to Italy where he painted a portrait of the actress Gina Lollobrigida — a charming but unlikely subject for a Soviet painter.

Glazunov comes from an intellectual family. His father was a professor of history, and his uncle a professor of music at the Leningrad Conservatory. His parents died during the Leningrad blockade, and the boy was taken to the countryside to be tended by a grandmother. It could be said that Glazunov's attachment to the simplicities of Russian life began there. He has said: "My first impression of real life was a piece of blue sky, light, and a touch of foamy clouds — a road, lost in the field of daisies, and, faraway, a wonderfully mysterious forest, seething with summer heat and the chirping of birds. It seems to me that from that moment on I began to 'love' as if someone had said imperatively: 'Love!' "[11]

Glazunov returned to Leningrad in 1944 to begin art studies, painting the usual subjects for a youth of the time. In 1951 he entered the Leningrad Institute of Painting, Sculpture, and Architecture, named after the noted Russian realist, Repin. Between studies, he took time out to travel through Russia, acquainting himself with "the furious waves of the Volga, and the still wooden houses of the North, shrouded in the lights of the Arctic Circle." He worked hard at his studies and undoubtedly turned out a number of works done in the approved manner. But he was soon to become dissatisfied with its limitations. He chafed at the difficulty of showing his "innermost thoughts" in the impersonal framework of socialist realism.

He turned to the theme of love, and did a painting which depicted a man and a woman kissing against the dark background of an

[11] From an unpublished biographical sketch of the artist in the possession of the authors.

apartment house in St. Petersburg. This painting was exhibited at an international competition in Prague, where it won first prize. Fame won it a showing in Moscow but continued disapprobation from the social realists. Glazunov's admiration for Dostoevsky led him to work on a series, "The Canals of Leningrad," inspired by that writer. The Dostoevsky Museum has praised Glazunov's works as being the finest ever done of Dostoevsky's heroes, but the Artists Union adamantly refused him admission.

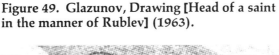

Figure 49. Glazunov, Drawing [Head of a saint in the manner of Rublev] (1963).

Glazunov follows in the footsteps of Bilibin, Steletsky, and Gonchorova, adapting Russian-Byzantine forms in his work. He is a collector of icons, and their technique is strongly apparent in his work [Fig. 49]. Although he is known as a neo-icon painter, there is a sentimental vein in his work, a dwelling on homely simplicities which some have found embarrassing, but which echoes the Russian romanticists of the nineteenth century. He is extremely popular with the average Soviet citizen. Although the Artists Union will not accept him, the Soviet public and many in Soviet officialdom have. His divergence from socialist realism is not, in any way, a veering toward the West, since he is imbued with the spirit of the old Russian traditions, of the sufferings and aspirations of the Russian peoples.

One aspect of Glazunov's recent acclaim should be noted. Less than two years after the Manège Affair, Glazunov was given a one-man show in the Manége Gallery. The opening was honored by the presence of the First Deputy Minister of Culture, Aleksander N. Kuznetsov. The semi-official opening, which had called for only one hundred fifty invited guests from the Ministry of Culture and the Artists Union, was stormed, to everyone's surprise, by an unruly crowd of students, artists, and intellectuals demanding to be admitted. When Kuznetsov appeared, he was pushed around by the crowd which had staged something of a "sit-in" outside the locked doors. When they were finally admitted, more came and hundreds affixed their signatures to a petition to the Minister of Culture, Yekaterina Furtseva, asking that the exhibition be continued. Permission was finally granted for the show to remain open five days from 3 to 5 P.M., but this was hardly enough for the Moscow population of 7.2 million.

In this instance, the Ministry of Culture proved more lenient than the Artists Union, which was completely against the continuation of Glazunov's show.[12] This lends credibility to the position, taken by so many young artists, that the union is jealous and hostile toward

[12] Protesting Glazunov's exhibit, four noted official artists and sculptors wrote in the *Moscow Evening News*: " . . . mystical and religious direction of Glazunov's work departs from the ideology of communism." They expressed dismay at the action of the Ministry of Culture in permitting the exhibit against the protests of the Artists Union. See *Vechernyaya Moskva,* June 19, 1964.

new talent. (Glazunov was born in 1930). The union accused Glazunov of imitating the German expressionists; the unofficial community accused him of being a "poor imitator." In the former instance, lack of patriotism was the bone of contention; in the latter, imitation, and inadequate at that, was the issue.

The Unofficial Artists

Contacts with the West, limited as they still are, have brought a host of exciting new ideas to serious artists of all ages. The abandonment of terror and the grosser forms of coercion in recent years had made it possible for the *real* unofficial artists to exist and in some cases, even to flourish. While artists in the borderline category either belong to the union or have some official recognition, unofficial artists are entirely divorced from the official creative and social community. On those occasions when their existence is acknowledged by the official critics, they are seen as the "other camp." They generally subscribe to the various theories and movements of nonobjective art generating from the West, although some of them do not like to admit it. Zveryov is perhaps most outspoken on this point and refuses to recognize "any such" Western influence in his work. Plavinsky, on the other hand, proudly accepts his colleagues' calling him "our Dubuffet." Originality, of course, is claimed by artists everywhere, including those in the Soviet Union.

A steady stream of information about the latest developments in Western art continues. By mid-1964 the availability of information regarding such post-abstract expressionist movements as pop and op art had reached a high point. It was perhaps one reason for the growing independence and individualism among the younger, more enterprising artists. But such elderly artists as Yevgeny Kropivnitsky also continued to be excited by the new. Experimentation, to be sure, was in vogue.

Yevgeny Kropivnitsky. — Yevgeny Kropivnitsky is one of the leading members of the Soviet unofficial creative community. In spite of his declining years — he is in his seventies — he manages to keep in step with the times and his younger colleagues and protegés. He has been

Figure 50. Kropivnitsky, Three Girls **(1960). Water color, 15½ x 21".**

painting for the last forty years, is regarded by all as the grand old man of the unofficial community, and continues to work with vigor. He is also a poet and has written touchingly of the beauties of nature and family life: he will simply describe a red poppy growing outside the window, the galoshes by the door, the daughter visiting with the grandchildren — the beauty of everyday happenings, the simple facts of life and death.

Kropivnitsky lives outside Moscow in what remains of an old two-story country manor; he and his wife rent a small pantry-like room. Their modest furnishings include two cots in a corner, a square table in the middle of the room, used for eating and working, two chairs, an open closet, and a kerosene stove used for heating and cooking. The room is illuminated by a single bulb and is spotless. Kropivnitsky's wife, Potapova, is also an artist. The warm welcome extended to the authors by the old couple will always be remembered with gratitude.

Kropivnitsky's work is small in numbers. He works in oils, water colors, crayons, and mixed media. A series of water colors and oils on paper and masonite takes as its subject a young girl with braids. The girl is a poetic image of lyrical purity, a memory recaptured in flat colors with Byzantine simplicity. Kropivnitsky occasionally uses "simultaneity" (overlapping pictorial technique). Formal construction, incorporating the arch and angles typical of Petrov-Vodkin, is also used by Kropivnitsky although in a subtler approach.

During the late fifties' mounting awareness of atomic holocaust, Kropivnitsky went through a phase similar to that of many American artists of the time — an instance, perhaps, of the often mentioned silent communication between artists in the world. Kropivnitsky's work during this time was executed in gouache, presenting eerie landscapes lit by red suns descending beyond purple dust plains. Silhou-

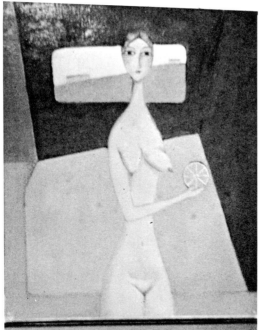

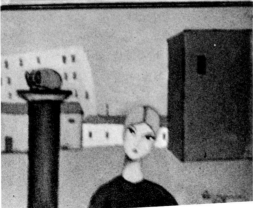

Figure 51. Kropivnitsky, two oil paintings.

149

ettes of dark vent pipes protrude from the ground. Abandoned rocket launching platforms and weird ruins with abandoned machinery represent literally the artist's apprehensions.

His work at the time of our visit was a nonobjective in oil, about 18″ by 24″. He often works in monochromatic pointillism; other works are reminiscent of Paul Klee. He is prolific for his age and continues to experiment and to vary his theme.

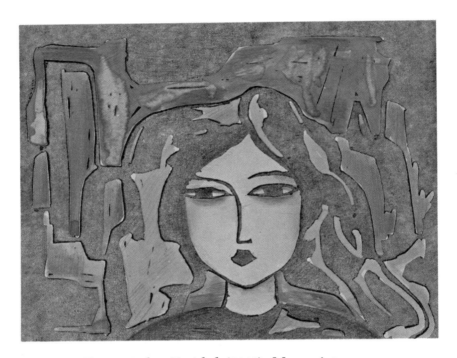

Figure 52. Kropivnitsky, Untitled (1963). Monoprint and crayon, 8 x 10¼″.

Anatoly Zveryov. — Anatoly Zveryov was born in Moscow in 1931. From his early childhood he impressed his teachers with his ability to draw. After graduation from the gymnasium he entered the Painting Academy; however, after six months of attendance he was expelled for having taken off the wall a portrait of Stalin by Gerasimov and

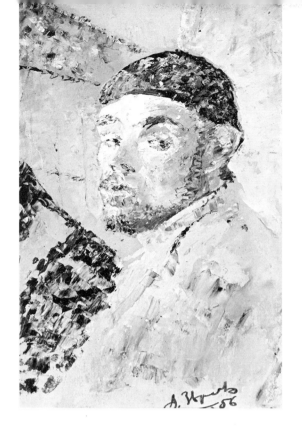

Figure 53. Zveryov, Self-portrait (1956). Oil on canvas, 19¾ x 11½". The Motte Gallery, Geneva, Switzerland.

Figure 54. Zveryov, Crazy Woman (1962). Oil, 23½ x 16¼". Courtesy of Mr. and Mrs. George London, New York.

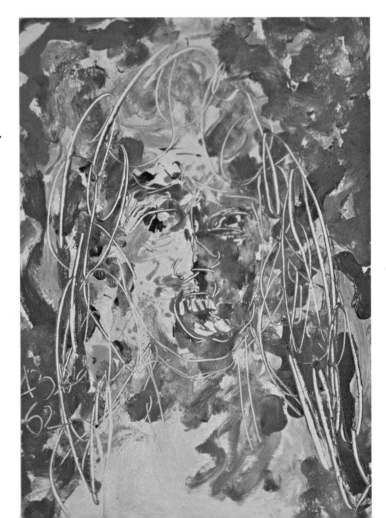

painting a nude on the reverse side. Igor Markevitch, a Swiss conductor, who has acquired the most complete collection of Zveryov's works to date, says in the prospectus to Zveryov's one-man show held in Geneva from May 14 to June 9, 1965: "With Zveryov, we find ourselves in the presence of an artist miraculously gifted who will likely take his place among the most accomplished painters of our time."[31]

Zveryov is an expressionist treating a variety of subjects from portraits to landscapes and animals. He employs a free technique primarily using water colors, oils, gouache, and the mixed media. He applies the palette knife freely, scoring the surface of his paintings, which are often prepared with a background dripped or splashed on. He often mixes gouache with water colors, and paints with oil on cardboard, masonite, or the backs of political posters. He paints with whatever he can lay his hands on: Markevitch notes that he saw him finishing a painting with a lilac branch, retouching this admirably with a piece of white cheese. To an onlooker disturbed by such avantgarde antics he would calmly answer, "How do you know that this wouldn't be better?"

This constant search for new forms of expression makes Zveryov a unique figure in the unofficial community. The painter Robert Falk, who was important for many young modernists, complained that it was "useless" to teach Zveryov anything for he would only be guided by his intuition.

Zveryov's talent is most evident in his portraits, particularly his self-portraits. He is frantic when he works, rapidly transmitting his thoughts into brush strokes on the canvas. It is not a rare occasion for him, according to Markevitch, to produce one hundred drawings or twenty gouaches in one day. He is engaged in constant discovery of new techniques; he may discard within an hour a technique which might preoccupy another artist throughout his entire career.

[13] See Igor Markevitch, in *Zverev: Peintures, Gouaches, Aquarelles* (Geneva: Gallerie Motte, May 1965), to which the following analysis is partly indebted. Mr. Markevitch has also been most kind in assisting us in the acquisition of the reproductions shown here. The exhibit which the Motte Gallery prepared, with Markevitch's help, was the largest one-man show to date of an unofficial Soviet artist in the West. Held in Geneva from May 14 to June 9, 1965, the show displayed one hundred ten paintings, gouaches, and water colors.

Zveryov's versatility is perhaps overpraised but the fact remains that he is the most prolific and imaginative of the unofficial artists. He is still maturing as a painter, and his styles vary. If his work is often inconsistent in quality, it is still, at its best, brilliant and individual.

Figure 55. Zveryov, Greek Head **(1959). Water color.**

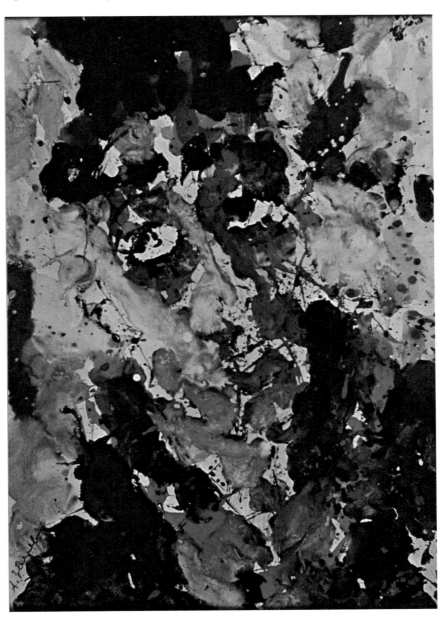

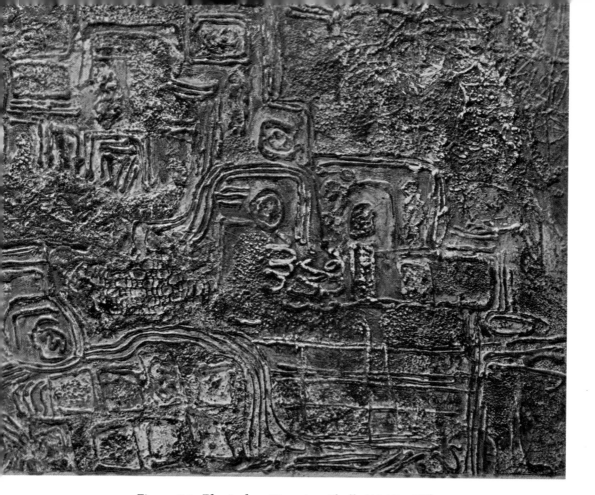

Figure 56. Plavinsky, Tortoise Shell **(1960). Oil on canvas, 17 x 20″. Private collection, New York.**

Dmitry Plavinsky. — Dmitry Plavinsky is highly regarded by the unofficial community as one of the foremost avant-garde painters. Unfortunately, we were not able to meet him. However, his works are in the collection of several important Moscow art collectors and in the private homes and *dachas* of the intelligentsia.[41]

One of the best examples of his work, and one of the largest canvases of the unofficial artists we had an opportunity to see, is in the collection of the American freelance journalist Edmund Stevens, a longtime Moscow resident whose wife Nina is Russian by birth and is

[14] Plavinsky's works have also reached the private collections of New York art collectors. The illustration [Fig. 56] is from the collection of a New York owner who preferred to remain anonymous.

154

particularly active in the collection of modern art. They have one of the largest collections of Soviet unofficial art.[15]

By Soviet standards, Plavinsky's paintings are indeed avant-garde. He works in a three-dimensional collage technique and uses an unusual medium for an unofficial painter: plastics-acrylics and plaster of Paris. Plavinsky has explored three dimensional painting-sculpture.

The painting illustrated here is a good example of Plavinsky's work, with ochre and golden hues dominating the limited collage background. Bits of cloth, coins, and other small objects are imposed on the surface. Finely drawn fish skeletons, feathers, keys, pebbles, and skulls are painted conventionally on the canvas, arranged in harmonious pattern. Plavinsky often uses organic forms creating a surrealistic effect, but most of his work is nonobjective.

[15] Like Costakis, the Stevenses enjoy a status in the Moscow creative world; they own a private home and move freely around the country.

Figure 57. Plavinsky, Leaves **(1965). Water color, 14 x 20″. Collection of Mr. and Mrs. Romaine Fielding, Los Angeles.**

Constructivist Influence. — We saw only one example of constructivist art during our trip. We had been told of a talented young artist, Lev Nusberg, who worked as a laborer but was highly regarded by the unofficial artists as one of the chief spokesmen of the surviving movement in the tradition of Gabo. We visited him on a bitterly cold night in the winter, taking a long subway ride to the outskirts of Moscow where he lived. After walking up four flights in a multi-story apartment building, we rang the communal bell two times as we had been instructed. Our host greeted us and led us through a dark corridor into his pantry-sized room — literally six feet by ten feet.

On the floor there was a small bed covered with a wool blanket. On the walls hung several constructions composed of egg-carton cardboards, painted in symmetrical designs, emphasizing illusionary space. There was a hanging box with several compartments employing mirrors; wires projecting illusionary light and shadow. A construction utilizing the window as a partial source of light reached to the ceiling. It was made with translucent paper and plastic. Electric lights of differing brightness were randomly distributed within the structure. The construction also served as a lighting unit for the room.

The young artist was clearly a follower of Gabo although he felt he had gone beyond the master. Certainly his work did not lack scope

Figure 58. Plavinsky, Voice of Silence **(1960). Oil on canvas, 4 x 6′.**

and imagination. He showed us several pastel sketches of fantastic illumined sculptures, constructions in scale of hundreds of feet, incorporating the movement of variously colored lights. We learned later he had shipped some of his drawings and constructions to an exhibit in Czechoslovakia. This is not an uncommon occurrence in unofficial art. Under the auspices of friendship societies and other agencies of the Soviet Union and the satellite states, unofficial artists can often be shown in the satellites where socialist realism is not so rigidly interpreted.

We could not obtain examples of the constructivist's work. We heard that he had an extensive following among the young artists, who respected his work as well as his aesthetic theories. In fact, due to this following of admirers, he was on the verge of being evicted from his apartment, not for being too noisy, but for the numerous visits from students and visitors. In communal apartments privacy is limited. The majority rules, by means of the apartment "court," and not only decides on the acceptability of the tenant but, at the will of the majority, an individual can be evicted from the premises.

Figure 59. Krasnopevtsev, Still Life: Arch **(1965). Oil, 21 x 28″. Collection of Mr. and Mrs. Romaine Fielding, Los Angeles.**

Dimitry Krasnopevtsev is a 42-year-old Muscovite, employed as a commercial artist. He works in oil, tempera, and crayon depicting still-life with surrealistic overtones. His subjects include drift wood, sea shells, broken pottery. Meticulously executed and carefully arranged, his compositions are usually somber and monotone, transmitting a feeling of a silent and orderly world.

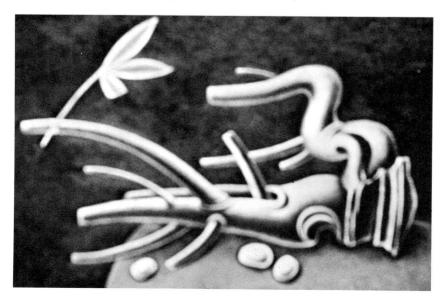

Pop Art. — We met several times with the young pop artist we had first encountered on Gorky Street. He was, incidentally, an acquaintance and friendly rival of the constructivist. The pop artist held a part-time job, as many of his friends did, to support himself and to protect himself from the "antiparasite" laws. The young man's parents were now living in modest retirement. Unlike many of the embittered Soviet youths the young man was not a product of the street. His

Figure 60. Pop Artist, Untitled (1963). Water color, 11¼ x 11¼".

The young artist who did this picture referred to himself as a "pop artist," indicated that he understood what the trend was all about, and demonstrated it in employing as subject the banal and prosaic aspects of his environment. In Fig. 29 he made it clear that he was consciously juxtaposing in his composition the uniformity of the new with the individuality of the old. In Fig. 60 he was anxious to explain the subtle space-color relationship in this almost hard-edge water color between the textural nuances of the circle, the brown houses, red dots (probably suns) and the blue background. In most of his works he was preoccupied with a strong relationship between symbols and signs, and hard-edge principles.

father, a former educator, highly respected and decorated, had to live on "bread alone" because his meager pension was not enough to supply the small family's basic needs. Unquestionably, this hard fact contributed to his son's disenchantment with the system.

We found the pop artist an extraordinary individual. His comprehension of art was remarkable for one so young. He had a superb photographic memory which had obviously been of great assistance to him. His work was the first example we saw in the U.S.S.R. of real comprehension of pop art. The influence of constructivism and cubism was also apparent. He experimented extensively with space-color problems, employing precise geometric forms. A series of little trucks were drawn two-dimensionally on a red background. World War I airplanes were finely executed with occasional collage. Before our meeting, he had several exhibits in private homes of his friends and admirers of unofficial art. News of such private showings is usually passed on by word of mouth; only rarely are written invitations sent to patrons, critics and art collectors.

Our meetings with the pop artist grew further apart as he became apprehensive of being seen with us. Shortly after we met him, he began taking us to meet several "important" artists. One of them, a good friend of his, also worked in the pop art form. His paintings forcefully pictured the monotonous advertising of state grocery stores, the omnipresent browns of the Soviet apartment buildings, dirty tablecloths in cafeterias, tasteless mass-produced furniture and so on. Official imagery — Lenin posters, red banners, hammer and sickle, stars, Party and patriotic slogans — were missing from his work. His paintings were executed in oil, and some were quite large. He worked with bright primary colors, and used the paint thickly. We did not have a chance to photograph his works.

Two Followers. — In any artistic community, of course, some artists are less talented than others. Their work is often interesting only because it throws light on the major trends of the time. The artist of ordinary ability is likely to be a follower rather than an innovator. However, man's need to create is important to society whether the finished work is a masterpiece or not. For this reason, we include two

**Figure 61.
Anonymous
(1963). Oil with
collage.**

Figure 62. Anonymous (1963). Oil on canvas.

examples of artists of lesser talent who are, nonetheless, representative of a segment of unofficial art.

We met a man identifying himself as a "leftist" artist who invited us to see his work. A few days later we were cautiously led by our new acquaintance to an old rundown house dating from prerevolutionary days. He took pains to avoid any encounter with his neighbors. After passing through several poorly lit communal hallways, we reached a

Figure 63. Anonymous (1962). A color crayon on paper, 5½ x 12″.

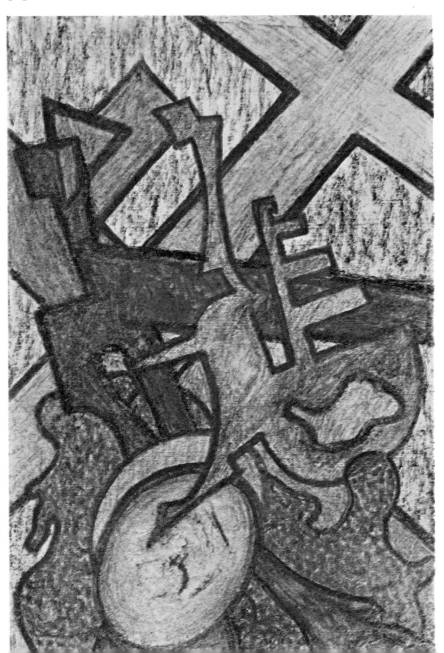

small furnished room. Our host informed us that the room belonged to his mother. He was an engineer, a member of a respected profession, and could not afford the risk of being caught painting in his own home.

His early paintings were decorative and garish, and their likeness to certain illustrations for science fiction was unmistakable. He enjoyed strong contrasts, glossy blacks, oranges, and brilliant reds. We found paintings of a later period interesting, and encouraged him in that direction. He employed the "target" concept, working in collage with tin circles and rectangles symmetrically and centrally arranged. Our approval pleased him — he had not so far received any response from collectors. He felt this was due to a cliqueishness in the unofficial art community — which, if it exists, is also rather a universal tradition wherever artists of different persuasions gather together.

The second artist in this category was a dissident young intellectual of aristocratic background. He lived in a shabby room in a run-down dwelling which he shared with neighbors who had little liking for his intellectual tastes. Introversion is suspect in the workers' communal society. He had been recently interned, by his own design, in a mental institution and was now waiting for the state pension of thirty rubles per month. (This bizarre method of finding creative asylum will be discussed in the section on social outcasts.)

He works in crayon and oil on masonite, juxtaposing textures and colors, sometimes using collage techniques. He is interested in realistic surrealism, which is particularly evident in his crayon sketches that feature astrological symbols.

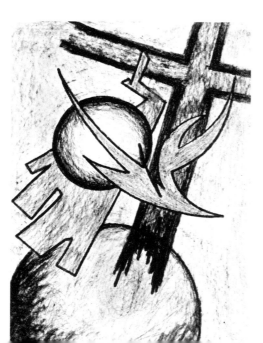

Figure 64. Anonymous, Faith **(1962). Color crayon on paper, 8¾ x 12". Courtesy of Mr. and Mrs. Lawrence F. Costello, Des Moines, Iowa.**

An individual blend of symbolic elements with surrealistic overtones.

The Hermitage Affair. — Art in Russia, in concert with the entire structure of Soviet society, is gradually changing. The struggle between conservative and liberal forces is gathering momentum. Ironically, old institutions of legality are emerging to support the liberals while the conservatives and the Party are increasingly on the defensive. One striking example of this unusual situation is the Hermitage affair, which we witnessed in Leningrad and will present here as it occurred.

During the last days of March, 1964, on the eve of the 200th anniversary of the Hermitage Museum of Leningrad, the museum staff arranged an exhibit in one of several halls set aside for such purposes. This had been done before, but this time five talented young members of the staff were to exhibit their works. Levinson-Lessing, a noted scholar and assistant director of the museum, chose the works to be shown — about twenty oils, five temperas, and thirty-five prints. The exhibit was set up in three small rooms of a large hall. A sign outside the main hall advertised the event, stating that the exhibit was organized by Hermitage staff members. Invitations were sent out and a comment book set up for visitors who wished to register their reaction; this is a common practice in the Soviet Union.

The show opened March 30, 1964, at 11 A.M. The public responded well on the first day. Several professors of aesthetics and other members of the Leningrad intelligentsia attended. On March 31, attendance was even better. On April 1, the paintings were taken down. Mikhail Shemyakin, one of the exhibiting artists, arrived at the museum where he was asked to proceed to a private room. There he was questioned by three persons dressed in civilian clothes, two men and a woman. The questions were about the organization of the exhibit, the person in charge of it, and the like. The primary interest of the questioners was, however, in the "formalistic" nature of the works exhibited. Why did they not have more ideological content? Shemyakin asked to withdraw his work; his request was ignored.

On April 2, 1964, Shemyakin and another member artist were questioned again. The two were accused of formalism. The name of Yosif Brodsky was mentioned; Brodsky had been recently condemned for poetry lacking in ideological content. Shemyakin demanded the

return of his works. Again, he was refused.

Before he left the museum that day, Shemyakin looked through a keyhole in the room where he knew the confiscated works to be stored. To his horror he saw an unidentified man, presumably from the "Bolshoi dom" ("The Big House," known as KGB, Russian initials for Committee for State Security) photographing the works. He immediately called his friends to witness the scene. After a brief discussion, they decided to consult an attorney on their property rights. The attorney told them that if the works were not sexual, abstract, or anti-Soviet, nobody had the legal right to confiscate them. If the works were not returned in two days the attorney promised to protest with an official letter to the *prokuror* (federal judge) in Leningrad.

On April 3 permission was granted for the return of the works. The artists went to the gallery and retrieved their works, but before they reached the exit were stopped and ordered to return them to the same room where they had just recovered them. Word had come from "higher" authorities to keep the artists' works under lock and key for an indefinite period. That same day, between 7 and 8 P.M., an extraordinary meeting of the Hermitage Party Organization was held.

On April 4, around 12 P.M., another extraordinary meeting was held, this time of the City Committee at which the director of the Hermitage Museum, Artamonov, and the assistant director, Levinson-Lessing, were summoned. At this meeting, they were officially fired from their posts, reprimanded, and the former expelled from the Communist Party. The future of the other members of the Hermitage staff involved in the show was turned over to the Party for evaluation. The people who wrote in the comment book also suffered some consequences. One young man, a student, was dropped from the university; another, a biologist, was fired from his teaching post.

On April 6, the works were returned to the artists, and they remained at their jobs. The museum directors remained fired. In the meantime, the letter from the attorney had reached the *prokuror*, including a letter of protest to the Party Central Committee from the Leningrad creative and professional community which was buzzing with discontent; Levinson-Lessing, in particular, was a figure of no small stature. On legal grounds the works were returned to the young

men because their works were neither "sexual" nor "anti-Soviet," nor even "abstract." Shemyakin's contribution to the show was a series of stylized illustrations of *The Tales of Hoffmann.* By the end of April Levinson-Lessing was back at his post, awaiting the arrival of another cultural commissar while Artamonov, a Party appointee, remained fired from his post.

It is clear, however, that open defiance by the artists and the young intelligentsia to the Party's continued surveillance of creativity, the intervening of Soviet legality on behalf of the artists, letters of protest by creative and professional groups, and growing public support, are illustrations of important changes which will have far-reaching effects in Soviet art.

Social Outcasts

Soviet law provides that idle persons and those not working for the state will be duly prosecuted by law for social parasitism.[16] Exceptions to this rule of law are invalids, pensioners, the mentally ill, and married women. Violators are reported to the authorities by the socially conscious citizen and the members of the *Narodnaya druzhina.*[17] The offenders are warned, persuaded to find work, and then periodically checked by the volunteer corps and the police. If an offender disregards the warning, he is then arrested, brought to court, and sentenced to from two to five years of exile with forced labor in special regions where correction colonies are set up.

The antiparasite law is used against the dissident creative intelligentsia, the young poets, writers, and painters who refuse to sub-

[16] See the Decree of the Praesidium of the Supreme Soviet of the R.S.F.S.R. on the strengthening of the struggle with persons who shirk socially useful labor and lead a parasitic life, *Sovetskaya Yustitsiya*, May 1961, No. 10, p. 25. For an authoritative treatment of the Soviet parasite laws, see Leon Lipson, "Hosts and Pests: The Fight Against Parasites," *Problems of Communism*, March–April, 1965, pp. 72–81; and more recently, Harold J. Berman, "The Writer and Soviet Law," *The New Leader*, February 14, 1966, pp. 13–16.

[17] *Narodnaya druzhina*, literally "people's fraternity," is a volunteer people's guard, a public vigilante corps, numbering millions, whose function, among other things, is to report to the local authorities and security organs what they term "unusual" activities of the Soviet citizen, keep public order in meeting places, etc.

scribe to the official dogma of socialist realism. We were told that some of the more talented prolific painters can earn sufficient income from sales to survive on their own without state employment. As soon as their unemployment is reported to the authorities, however, they are apprehended, and charged with *tuneyadstvo* (parasitism).

It is convenient to describe here the arrest of the young Leningrad poet Yosif Brodsky which had some significance in the Russian cultural world.[18] In the two or three years before his arrest, Brodsky had become popular in Leningrad, presenting his work at widely publicized poetry readings and in youth cafes. At twenty-two, he had an unofficial manuscript circulating in the Leningrad creative community, which earned him some influential admirers.

For subsistence Brodsky worked at odd jobs from time to time but his primary means of support came from translating English, Polish, and Yugoslav prose and poetry. However sporadic his earnings may have been he earned more than the thirty rubles a month required by the parasite laws during a twelve-month period. Although he was arrested on a charge of parasitism, the real nature of the case was soon revealed in the charges levied against his creative activity — the writing of unorthodox poetry not in tune with the precepts of socialist realism. In spite of protest and open indignation by members of even official creative community, the young poet was nevertheless sentenced by the Dzerzhinsky District Court to five years of exile and forced labor in the Arkhangelsk region.

As the affair unfolded and became public knowledge, a small document, called "Spravka" (Inquiry) was sent by disturbed Leningrad and Moscow creative circles to the offices of the Central Committee of the party and the Writers Union in protest against the arrest and imprisonment of Brodsky. The document was signed by six laureates of the Lenin Prize, including such eminent figures in Soviet arts as Kornei Chukovsky, Samuil Marshak, Anna Akhmatova, and

[18] Brodsky was sentenced under the "anti-parasite law." (In the Soviet Union, persons who refuse to do "socially useful work," live on nonlabor income, and lead a "parasitic" way of life, are subject to "resettlement" in another locality for two to five years.) See, "The Trial of Iosif Brodsky: A Transcript," *The New Leader*, August 31, 1964.

Dmitry Shostakovich. It was said that Ilya Ehrenburg, in a personal letter to Khrushchev, wrote: "Dear Nikita Sergeyevich. . . . The time of twenty years ago, when we sent talented young people like Brodsky to cut trees in Siberia, is past."

While repercussions of this letter of protest and the whole Brodsky Affair were under review by the mentioned agencies, a copy of "Spravka" found its way to the editorial offices of the émigré Russian publication *Ruskaya Mysl* (Paris), which published the full text.[19] With "Spravka" came a collection of Brodsky's poems (Leningrad, 1962, manuscript edition, circulated through unofficial channels), which later appeared in Russian in the United States.[20]

Shortly after the publication of "Spravka" in Paris, a transcript of the trial proceedings in the Dzerzhinsky District Court, where Brodsky was tried and convicted, also reached the West and was published in West Germany. The American publication *The New Leader* published a translation of the transcript shortly thereafter (August 31, 1964).[21] Susceptible as the Soviet authorities seemed to have become in recent years to pressures from the creative community and sensationalization in the West, it was thought by some people that the popularization of the case abroad would bring enough pressure on the authorities to release the young poet. Indeed, it seemed for a moment that the pressure had worked, for rumor had it that Brodsky was back in Leningrad for re-trial to be held in June 1964. As it turned out, Brodsky had been brought back to the city for medical treatment, then returned again to the Arhangelsk Konoshky District to serve out the rest of his five-year sentence. However, in the end Brodsky was released on probation early in 1966 and was visiting Chukovsky at Peredelkino near Moscow, reportedly indignant about his professed friends abroad.

The Brodsky case shows how individualism is still treated in the U.S.S.R., even though the methods of coercion have changed in the

[19] "Delo 'okololiteraturnovo' trutnya" [Affair About a Literary Drone], *Russkaya Mysl* (Paris), May 5, 1964, pp. 3–4.

[20] Yosif Brodsky, *Stikhotvoreniya i poemy* [Poems and Lyrics] (Washington-New York: Inter-Language Literary Associates, 1965).

[21] "The Trial of Iosif Brodsky," *op. cit.*

post-Stalin period. In the words of the signatories of the "Spravka" referring to the trial: "People have interpreted the trial as a regression to devices peculiar to the Stalinist personality cult, which are totally alien to the principles of Socialist legality." Even though advances have been made in recent years in Soviet legal procedures, they are still under heavy control of political organs.[22] Thus, people like Brodsky continue to be exiled by the state, allegedly for breach of the parasite laws, but in fact, for their resistance to conformity.

This practice is not new in the Soviet Union. If not for parasitism, the more outspoken members of the society are exiled for other reasons. Another institution of official control begun in the post-Stalin period is an innovation worth noting, for it has affected the world of unofficial art. After Stalin's death many of his policies were reappraised by the new leadership. Even before the secret Khrushchev speech and denunciation of Stalin, Siberian labor-camp gates began to open. Some released prisoners returned to the major cities, seeking approval or disapproval of their former milieu. Instead of being accepted into the former life, many gained a new status — that of officially ostracized members of society with a little card issued by the state proclaiming them "schizophrenic" with the right to draw thirty rubles per month subsistence. The returned prisoner was often unable to reintegrate into society because of the stigma attached to labor-camp servitude. Besides, the labor camp often hardened his former attitudes. Many former prisoners openly turned to idleness, refusing to take any part in the active life about them. However, others clearly sought and continued to seek extreme forms of individualism in their personal or creative lives. Only rarely was such an individual reprimanded for his unorthodoxy and uncitizen-like conduct, presumably in recognition of the fact that he had served his term and had passed beyond social recall.[23]

[22] See George Feifer, *Justice in Moscow* (New York: Dell Publishing Co., 1964).

[23] The unorthodox Soviet writer Valery Tarsis, who published a vehement attack on Soviet society in his story "Ward No. 7," published in the Russian émigré literary journal *Grani* (No. 57, 1965, also in English translation at Collins and Harvill Press, 1965), was left at liberty in Moscow, and received foreign

Surely, officials reasoned, any person who would openly challenge conformity and authority *is* "mentally unfit" and should be treated accordingly. A few older artists soon realized the advantages of this social status and, as we shall see, began to use it in obtaining more creative freedom. They were in time joined by members of the younger generation, who found in the mental institutions unique economic and creative sanctuaries. These are the artists who openly challenge authority not only with their unorthodox creative endeavors, but also with their adamant refusal to participate in the "construction of socialist labor" or to take any interest in the collective life. Their inactivity is "parasitic" and therefore punishable by law.[24]

In the Stalinist era such open defiance of socialist morality would have been punished by years of forced labor in Siberia. In the Khrushchev era, for the most part, such defiance came to be defined as a mental deficiency. Granting this status to the "social misfit" means discarding the old maxim "he who does not work does not eat" and providing him — the "refuse of socialist progress" — with a minimum monthly subsistence. Little did the Soviet officials foresee that their benevolence would create a new institution, a haven for numerous dissident intellectuals. Spending a couple of months in a mental institution is small sacrifice indeed for a lifelong pension.

A number of angry young men defy the system by choosing such personal withdrawal from society. One talented young poet from Moscow, feigning mental illness, inveigled his way out of the Soviet Navy, after a year's service on a submarine, and retired to a friend's *dacha* where, he says, "I can think and write in peace without Party slogans." A young journalist, fired from an editorial post of a Moscow journal for harmful editorial criticism of the Soviet reality, retired to the south of Russia on thirty rubles a month "for life," as he put it.

correspondents and even royalties from abroad on his unorthodox and slanderous publications. See Laszlo M. Tikos, "In Russian Insane Asylums," *Problems of Communism*, September–October, 1965, pp. 66–71.

[24] Soviet authorities spirited Valery Tarsis out of the country in February 1966 and denied him citizenship, surely as a countermove to offset the sensational Senyavsky-Tertz and Daniel-Arzhak trial. Tarsis gave an interview after his arrival in London to the *Sunday Telegraph*, February 27, 1966.

Still another young intellectual, a Leningrader who likes the Russian winter, retired to the north, not to write or paint but simply to "watch the reindeer."

This self-imposed alienation has some merit, to be sure. It provides the artist with the freedom of action he needs to create more freely. "What can you do with abnormal people?" argued one doctor of aesthetics. "So we let them seek the form of expression they desire, provided their work does not reach official salons to lead the masses astray." This means that the Soviet government is actually subsidizing unofficial artists and, consequently, abstract art itself — the anathema of socialist realism. It is ironic that the social outcasts have greater freedom of expression than any other creative groups in the Soviet Union. Thirty rubles a month meets minimum subsistence needs and gives the artist that piece of economic freedom craved by artists in all lands. He does not have to report to work or to justify his income as must other Soviet citizens. If he can manage to live on thirty rubles per month, his activity remains unhampered.

One of the major problems still present in the Soviet Union is the construction and allocation of living space. Literally hundreds of thousands of prefabricated communal apartment dwellings are being hastily built. The construction is done at such speed that quality is often overlooked for the sake of quantity. In that regard, the Soviet builder has much in common with the "fast buck" American developer. But space is still a precious thing. In the old communal apartments an entire family may live in one room, sharing the same kitchen, toilet, and bath with several other families. To have all these conveniences in one single independent family unit is indeed a major dream of every Soviet family. First on the list to receive the new *zhil-phoschad* (living space), are the privileged members of the community: the Party members, the managerial and professional elites — scientists, engineers, writers, official artists, and actors. In the next category fall the families whose members died in the war, the widows and children of the fallen heroes.

There are many other categories, but by the time the allocations reach the ostracized there is little chance they will get a decent place to live. As a result, many artists occupy outrageous, pantry-like quar-

ters in nineteenth-century relics with primitive facilities. However, millions of ordinary citizens, of course, live no better. Obviously a certain kind of art tends to be produced in this atmosphere. This is not an invariable rule, though; Kropivnitsky, for example, lives in similar surroundings and is preoccupied with entirely different imagery.

Vladimir Yakovlev. — Perhaps the most eccentric of the outcast artists belonging to this group is Vladimir Yakovlev. He is nearly blind in one eye: the other is covered with a grayish film which forces him to bring objects in close proximity to see well enough to work. At a distance of six inches, he twists and turns his head grotesquely, searching for a hole in his clouded vision through which to perceive. A

Figure 65. Yakovlev, Jewish Face **(1963). Pastel over watercolor, 11¼ x 16″**

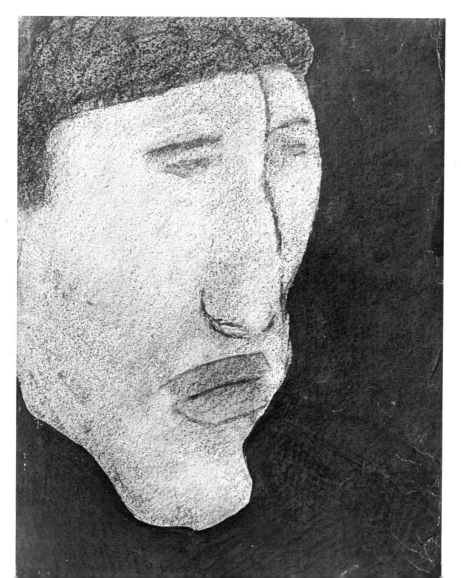

Figure 66. Yakovlev, The Head **(1962). Pastel over water color, 11¼ x 16".**

leather strap around his waist holds up a pair of baggy trousers. He wears high-topped, heavy-soled work shoes with strings laced loose and long, the tips flopping about. He is a morose, ill-kempt man whose appearance signals dejection. From a distance, Yakovlev appears to be in his sixties; he is thirty years old.

Yakovlev was born in the small provincial town of Balakhna. At twelve he became actively interested in art. He received the regular introduction to art from the high-school art teacher. He was later encouraged with some direction from painter friends who saw his work and recognized his talent. It is evident, however, that he has not had any formal training. Like many contemporary artists, he is a self-taught painter which perhaps accounts for a certain immaturity in his work. Influences of such artists as Modigliani, Soutine, and Klee are discernible in his paintings.[25]

Until the age of eighteen Yakovlev was physically agile (at six-

[25] The face of one head is copied from Mantegna; Yakovlev used a reproduction of a detail from his frescoes.

172

teen he was a champion in a regional competition in boxing). "It was in 1957," he writes, "that I started to paint abstract paintings, lyrical abstractionism. By 1958, flowers and portraits appeared, painted not from nature — in which I talk about intimacy, coziness, and magic lyricism, and the images one carries with oneself like a first glance of love — but from imagination."[26]

At eighteen, Yakovlev was stricken with an eye disease. He lost 50 per cent of his normal vision. Evidently this was one of the major causes for the mental breakdown which followed and his consequent confinement to mental institutions, to which his parents still periodically commit him. "From 1959 to 1963," he adds, "I was in and out of insane asylums and if they don't 'railroad' me again to the *sumashedshy dom* [crazy house], I hope to develop abstract painting in the feeling of the 15th–16th century."

It is difficult to judge Yakovlev's mental state. One wonders whether his maladjustment is due to his physical condition or induced by the environment. In another individual perhaps Yakovlev's environment would not have produced the same mental result, at least not to such an extreme degree. There were rumors in the community

[26] From a biographical sketch written by the artist for the authors.

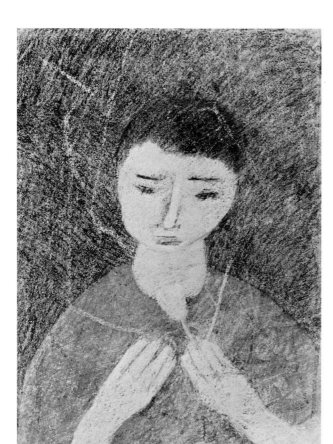

Figure 67.
Yakovlev, Self-
portrait **(1962).**
Pastel, 11¼ x 16".

173

about the readiness of his parents to commit him permanently to a mental institution, so that they could have some peace and privacy in the one room they share. Whether the rumors were true or not, some conclusions might be drawn from portraits he made of his parents, which are far from flattering.

Judging from the works we saw, in his possession and those owned by Soviet collectors,[27] his output so far can be divided into three categories: flowers, portraits, and abstractions. These categories are all permeated with his personal expression of nature. He is prolific and works often in bursts of energy on a series of subjects, combining the representational and the abstract. Lately he seems to be more interested in nonobjective chromatic painting.

Yakovlev's working area is a round table in a small room. He sleeps on a sofa. A few feet away there is a bed where his parents sleep. A bureau, buffet, and a few chairs are clustered around the table. The room where the Yakovlevs live is part of a communal apartment in a log-cabin-like two-story house built before the revolution. Once it probably belonged to a single merchant family. Now there is a family in every room. In the communal kitchen where several housewives, including Yakovlev's mother, cook their family meals, space is at a premium. The communal telephone is in the communal corridor, and at the end of the corridor is the communal chain-pulling toilet. With the absence of privacy, it is no wonder that Yakovlev's paintings so poignantly reflect the anguish he feels in his cramped quarters. He dreams of the day when he will have his own room.

Meanwhile, Yakovlev continues to paint his sad portraits with crossed-out eyes, his lonely flowers. Several portraits he calls Jewish heads. The most intriguing are two striking three-quarter portraits [Fig. 65] executed in water-color underpainting and pastels. In them, as in most of his work, there are elements of pointillism with a modulating softness which he achieves by loosely applying pastel over the water-color underpainting. In the portrait with lines [Fig. 66] he ac-

[27] In the West, one of his oils and two pastels are in the possession of Natalie Babel (Sorbonne, Paris); one painting is owned by movie director De Santos in Paris; six paintings are in the possession of Mr. Kraisky in Sweden; the authors own thirty-five pastels.

174

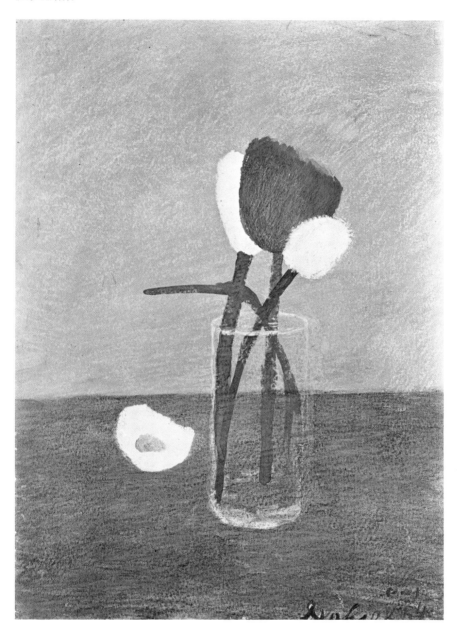

Figure 68. Yakovlev, Tulips **(1964). Pastel and tempera, 11¼ x 16".**

tully uses a dot pattern in paint application.

In several portraits, he depicts himself: a boy with a flower or a boy with empty blue eyes, with a church and a house in the background. In all we find a touching sadness, naiveté of style and simplification of form, reminiscent of Modigliani whom he greatly admires.

The most successful boy portrait is one done in subtle brown and greenish tones [Fig. 67], a strange and tender picture. A portrait of a young man in a black tunic could perhaps be attributed to what he called "abstract painting in the fifteenth to sixteenth century." It is a handsome portrait, subtle in its color harmony, unique in its imagery. In it one can trace some influences of the fifteenth-century Italian tradition.

The flower paintings are symbolic of one aspect of his emotional state. They are tender, fragile, contained and restricted by the sides of a cylindrical vase, or huddled and hunched up in the lower left corner of the painting. Regardless of placement, the flower itself always remains a focal point in the composition. Like the rest of his work, these paintings are also executed in water-color and tempera underpainting with pastel over it. They are reminiscent of the mystical flower bouquets by Odilon Redon. Images of an extremely private world, nevertheless, they directly communicate to the senses.

Undoubtedly, the strongest of his portraits are those of his mother [Fig. 69] and his father [Fig. 70]. The portrait of the mother is a bitter personal statement. He crosses out her eyes, perhaps in protest against his near-blindness for which he may blame her. The rest of the face is as if chiseled from granite. The shape and outline is clear; the features, stony and expressionless. It is not like the twisted and tormented face of the other portrait of his mother [Fig. 71] with red hair, which brings to mind some of the faces by Francis Bacon. The latter portrait is anguished and grotesque; yet it does not compare to the piercing, expressionless mask of the woman in the black dress.

The currents in Yakovlev's work are numerous. He is a young and growing artist. The validity of a work of art, however, is determined by the expression of the inner life — and this Yakovlev achieves with great intuitive force in the haunting silence of his flowers and in the

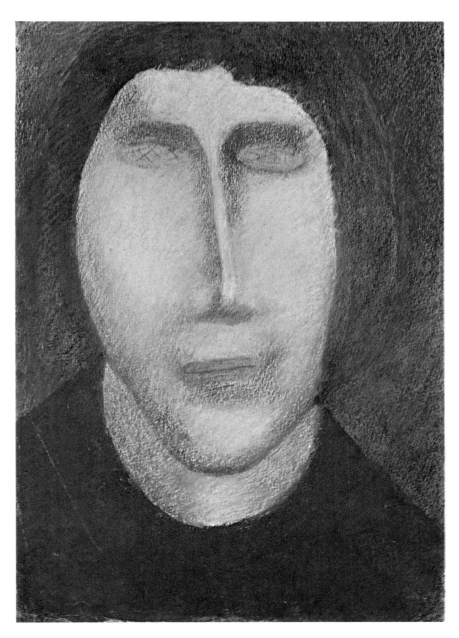

Figure 69. Yakovlev, Mother (1964). Pastel, 11¼ x 16″.

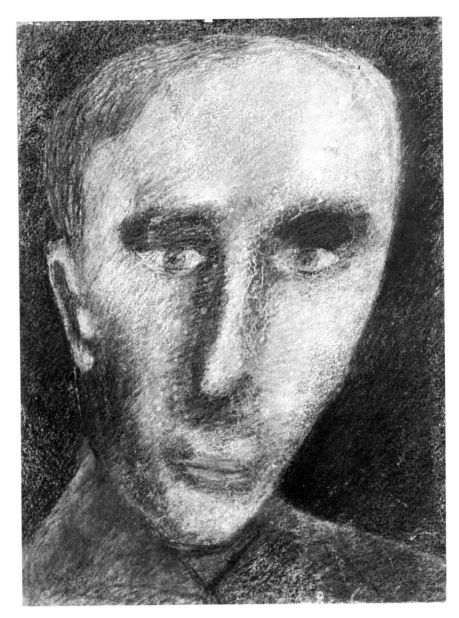

Figure 70. Yakovlev, Father **(1964). Pastel and tempera, 11¼ x 16″.**

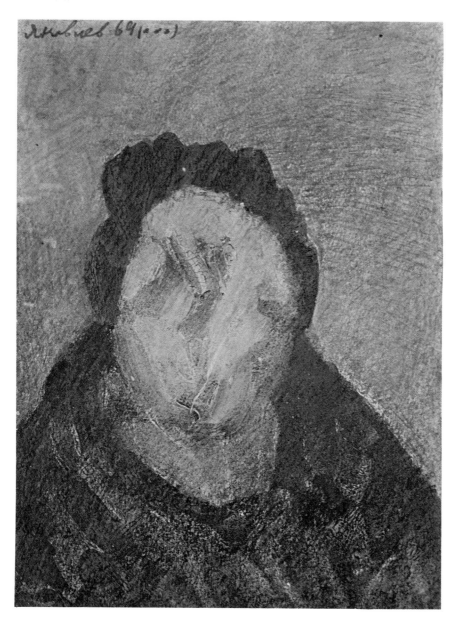

Figure 71. Yakovlev, Mother **(1963). Pastel, 11¼ x 16″.**

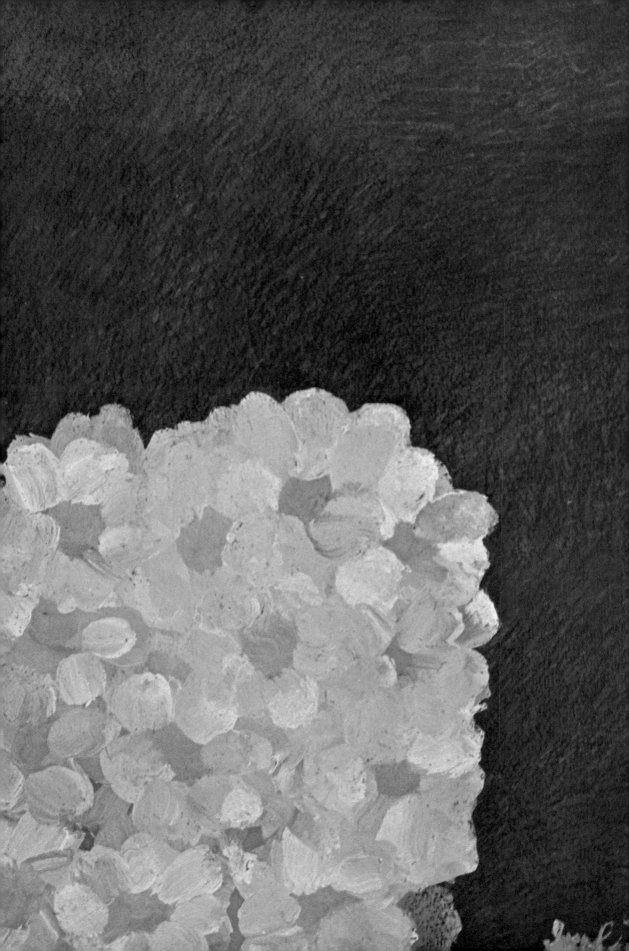

human intensity of his portraits. Here we see creative genius in this most unusual of the Soviet artists, who crosses every boundary of socialist realism.

Alexander Kharitonov. — Kharitonov is a young artist of about thirty-five years who also lives in Moscow. We were introduced to his work by various collectors. This was an indication that he was highly regarded by the unofficial community, some people placing his work in a class by itself. Kharitonov is a painter who invents a fairytale all his own. He is more of a fantastist than his colleagues Sitnikov or Yakovlev for he paints fantasies, beautiful dreams of the *skazka* with castles, and enchanting princesses chasing rainbows. This is the enigmatic domain of his reality [Fig. 73].

Kharitonov paintings are filled with playful mystery. He escapes into the fairy tale world of the Russian heritage, where one can find traces of folklore, mystery, and legend, so well treated before him by such great Russian mystic folklorists as Mikhail Vrubel, Bilibin, and Nikolay Roerich. He bears no stylistic resemblance to these masters, but in the kind of mystical lyricism he pays homage to Rublev and the great Russian icon-painters.

In his work he is concerned with the chromatic vibration and prevailing rhythm produced by merging color and form. He works in calm, sumptuous colors, executing his canvases in minute short strokes, carefully blending pearly greys, earth greens and blues with an occasional accentuation of pure cadmium yellow, for a light in the window, or a flower on the hillside [Frontis.].

"The Crucifix" is a sensitive rendition of a traditional subject. Articulate in his composition, he carefully balances the cross, the figure, and the trees on the hill, achieving an excellent interrelation of these elements. The painting is in smoky greys applied with minute brush strokes. The figure of Christ is simplified to the point of the primitive wood carvings. Kharitonov creates a very flat picture space, using uniform brush strokes and well-balanced composition in monochromatic harmonies. There is a fluid, rhythmic motion in his space, depicted in rainbow colors [Fig. 74].

Kharitonov is a prolific draftsman and has done interesting series

Figure 72. Yakovlev, Untitled (1962). Pastel, 11¼ x 16".

of drawings, closely related to his oils in subject and technique of rendering. Most drawings are finely executed in a hard pencil, with occasional accentuation of details in color crayon. His figures are elongated and graceful, reminiscent of Andrei Rublev.

The "Four Figures" drawing shows his graphic style to advantage. The figures are gracefully drawn, clad in medieval or Renaissance costumes, characteristic for Kharitonov. The exaggerated curves and necks, the ethereal facial expressions, the gestures, the mannerism, and the subject — all these poignantly signify Kharitonov's fantastical poetic temperament.

Figure 73. Kharitonov, Untitled (1962). Oil on canvas, 16½ x 22″.

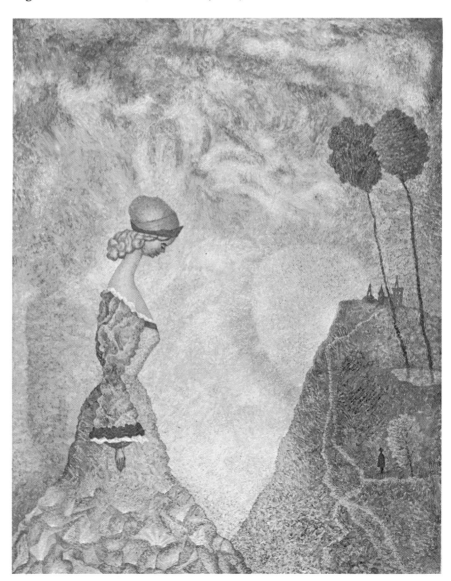

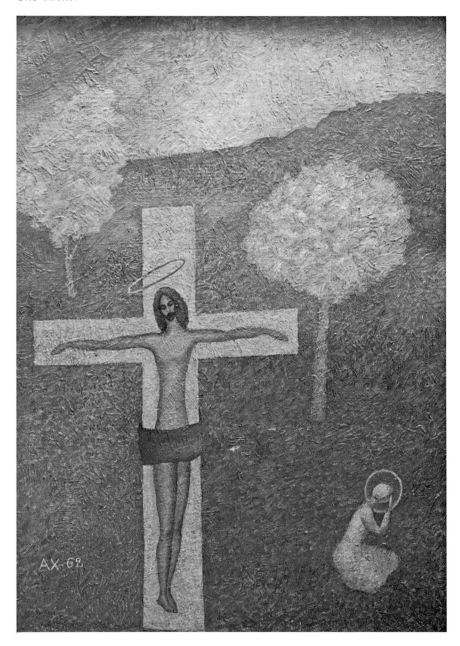

Figure 74. Kharitonov, Crucifix **(1962). Oil on canvas, 15½ x 22″.**

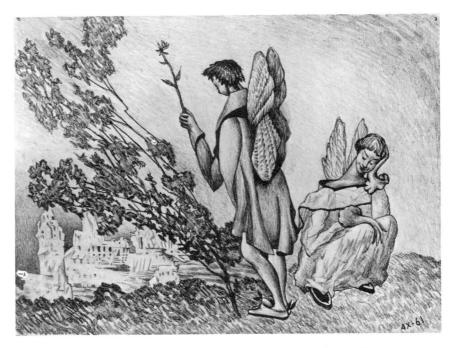

Figure 75. Kharitonov, Untitled (1961). Drawing, 8¼ x 11″.

Figure 76. Kharitonov, Untitled (1961). Drawing, 10 x 14″.

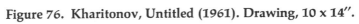

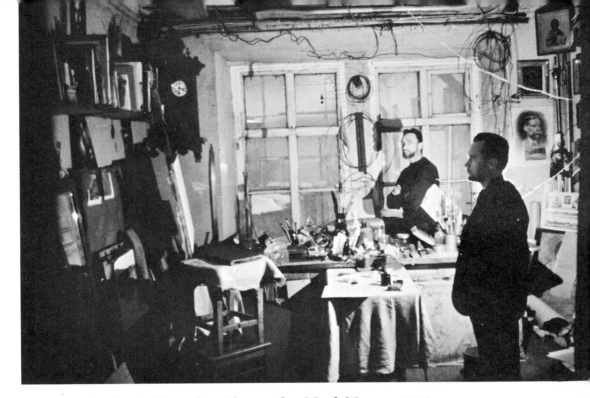

Figure 77. Sitnikov in his studio with co-author Mead, Moscow, 1964.

Vasily Sitnikov. — Vasily Sitnikov lives in an old two-story house across the street from the Lubyanka State Prison in Moscow. He is in his late forties and is a wiry slim man with dark intelligent eyes and a penetrating glance. Often when he receives guests he wears American bluejeans, knee-high Russian leather boots, a black broad-brimmed hat rakishly squashed on the sides, with an ostrich feather stuck in the rim.

Little is known about Sitnikov's past. Nevertheless, from the few comments he made, we deduced that shortly before World War II, in the wake of the Yezhov purges, he was arrested under strange circumstances. He spent the war in an insane asylum in or around Moscow. The memory of the abandoned ward with windows blown out by shell flak, without heat, food, and only one blanket for each person, is deeply imbedded in his mind.

He spoke of forty-below-zero weather and the fantastic effort it took to crawl from his bed, shuffling to a neighbor who had just died, in order to steal the dead man's remaining crumbs of frozen bread. He still wonders at the miracle of his own survival. The next stage of his

rehabilitation was spent in the Kazan forests. The choice was to die or find food. Every evening Sitnikov prepared himself a stew of frogs and herbs, in which the Kazan forest abounds, and in a matter of months regained his physical strength (to the point that his work would have merited Stakhanov distinction, he joked, had he been in a shock brigade). A photograph of this period shows him tanned, muscular, and apparently in top physical condition.

Figure 78. Sitnikov, Fantastic Monastery **(1966).
Tempera on masonite, 22 x 33″. Courtesy of Mr. and
Mrs. Robert A. Zimmermann, Cambridge, Mass.**

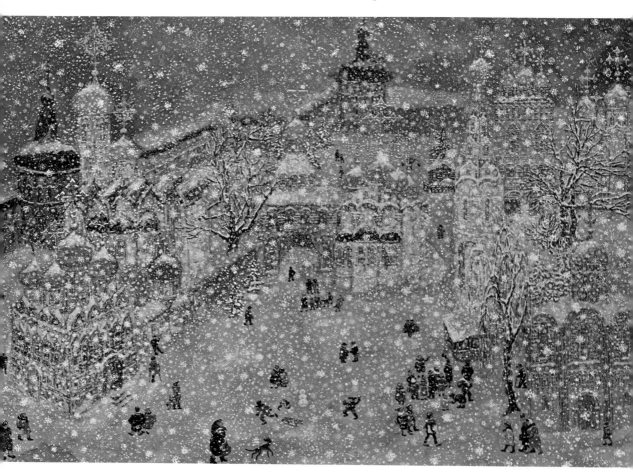

At one point during his imprisonment in Moscow, he was held in a back building of the Lubyanka Prison, where he was interrogated and severely beaten. Once back in Moscow, unable to find satisfactory employment and generally refusing to participate in the construction of socialism, he was pensioned and billeted in a dismal cellar where he lived for several years. Reaching the point of utter desperation, he went to the housing office and, in his own words, demanded: "Look, I am a painter and a lot of foreign visitors are coming to my place, and my surroundings create a very bad impression on them. I am sure you do not want these foreigners to leave with the idea that Soviet painters are living like this." His plea worked; he was given better quarters, but, ironically enough, they were across the street from Lubyanka Prison.

A Moscow visitor could probably pass by Lubyanka without recognizing it. It is situated in an official-looking building in the heart of the city. It could indeed be mistaken for just another office building. No guards stand near it as they once did. It was in the thirties that a large annex was constructed across the street from the main building; there political prisoners were held and executed. The two buildings were joined by an underpass beneath the street. One side of the annex overlooked a thoroughfare, the other bordered on a little alley, called Malya (small) Lubyanka.

We had been in Moscow for several weeks when, one night, an acquaintance led us to this forgotten alley between the two prison buildings. It is in an old part of Moscow; like many other buildings in this area, Sitnikov's residence is a typical two-story prerevolutionary structure of bleached ochre. To enter the building, one goes through a small door which is a part of a large arched gate, once used for carriages. One flight up one reaches a platform in front of the door to Sitnikov's apartment. Beside the door there is a pull-chain with a sign behind it which reads "Vasily Yakovlevich Sitnikov, the painter, lives here!" The chain is attached to a bell in his studio and also serves to hold notes meant for visitors. Such openness is most unusual in the U.S.S.R.

Sitnikov has two rooms in a communal apartment. The front room is a cluttered studio-workshop; a kayak is attached to the rafters

of the ceiling. There is a makeshift easel constructed from rough planks lying across one corner of the room, painting materials on the floor, a shelf of books on Western art, and other objects. Propped against the wall, yet dominating the whole scene, is a seventeenth-century icon. He repeatedly offered us the icon as if he hoped to insure its survival.

The second room faces Lubyanka; it has a huge window which is always covered by a white curtain to block the prison from view. On a little writing table stands a baroque silver writing set. To the left is

Figure 79. Sitnikov, Eros (1947). Pencil drawing, 9 x 9½″

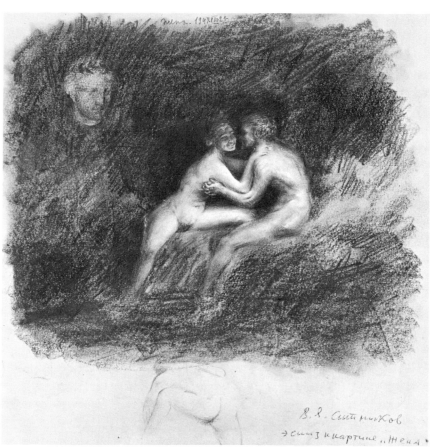

Figure 80. Sitnikov, Untitled (1959). Shoe polish, 20 x 30".

an ancient sofa covered with a bear skin. Several worn rugs are scattered around the floor. The wall holds a collection of icons, some of exceptionally good quality from the fifteenth and sixteenth centuries. They are arranged, not as religious symbols to be used for worship, but as works of art. In a corner above the couch hangs a plaster cast of the face of Eros, benevolently smiling down on the couch. From a

large lampshade shaded with a huge gypsy shawl emanates a warm glow, which conceals the shabbiness of this intimate and cozy little room.

To understand fully his work, one must look at Sitnikov's past. He suffered much during his imprisonment, and was, of course, celibate during that time. A feeling of tenderness predominates in the work of the 1950's. There are many sketches of this period executed in pencil and in his inventive adaptation of shoe brush and shoe polish.

Obtaining art supplies and equipment is a serious problem for all unofficial artists. Since they cannot requisition materials from the government as the official artists do, they have much difficulty in obtaining even the most common supplies, such as ink and paper. They are obliged to acquire whatever materials they can from the local stores, which carry some art supplies for general public consumption, usually as low in quality as in quantity. Hence the frequent use of pencil, felt-pen, crayon, rubber cement, and other more readily available media.

Nor have the unofficial artists any printing presses. To own a private press in the U.S.S.R. is against the law, as it also is to own a mimeograph or duplicating machine. (Presses in the studios of official artists are properly registered and owned by the state.) Moreover, etching and carving tools, zinc plates, and wood blocks are difficult to obtain since these items are at a premium even for the official artist. (Linoleum, however, is more readily available.) In spite of these difficulties, the unofficial artist somehow manages to work with common substitutes. He may use shoe polish for ink or the back of a political poster for paper.

Sitnikov achieves a very private and often extremely elegant sensuality in his paintings. The work of the fifties, although it occasionally pictures sexual acts, is not vulgar, but a tender accolade, honestly set down, to physical love. Sitnikov often dedicates and inscribes these drawings to a mythical "wife."

There are also studies of female anatomy, executed on paper with shoe polish and shoe brush, an interesting technique. Sitnikov developed this technique when he was unable to buy art supplies. His

Figure 81. Sitnikov, Wife. Pencil, 10½″ x 15″.

Figure 82. Sitnikov, Plowed Field. Unfinished. Oil on canvas.

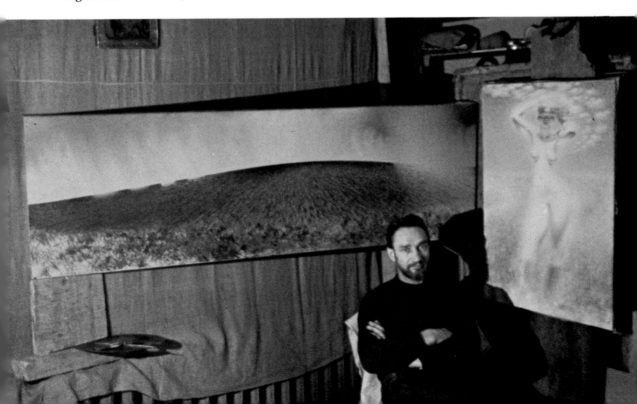

ingenuity has led to an interesting stylistic treatment of his later works in oil as well as in other media. In 1964 he had a large oil painting on the easel in his studio depicting an unplowed field with a sheet of rain sweeping over it. This painting reflects some of the softness of his shoe-polish technique of subtle integration of form and color executed much in the same manner as his crayon drawing of the unplowed field and rain, now in the collection of the Museum of Modern Art in New York. In the painting we viewed he superimposed four ghostly peasant draw wagons on the background of a plowed hilltop field outlined heavily, using four basic colors. The painting has a hallucinatory effect which is extremely gripping.[28] Sitnikov gave several other paintings in the same genre to the American painter James Ernst in 1962. Ernst presented two to the Museum of Modern Art in New York.

[28] Sitnikov was commissioned to do this painting for Nina Stevens, wife of the American freelance journalist, Edmund Stevens, who resides in Moscow.

Figure 83. Sitnikov, Plowed Field **(1962). Crayon, 23½ x 32¾″. The Museum of Modern Art, New York.**

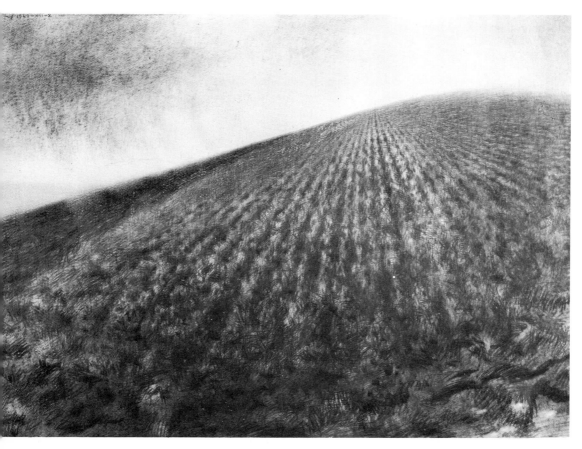

Sitnikov regards his portraits as his most serious works. One early example dates back to his days in the asylum [Fig. 85]. The most striking one is the portrait of an inmate, deeply felt and very touching, stylistically reminiscent of Kollwitz and Munch [Fig. 86].

In the late fifties and early sixties his work took him occasionally into abstraction. Sitnikov seeks and explores new ways and methods, but like most of his colleagues lives in the creative vacuum of the outcast. The difference between him and his colleagues is that he most painfully realizes the limitations of his environment. As a result, his attitude toward life is without optimism, though not completely despondent. "Come to me openly," Sitnikov said to us, "in the most luxurious car; I have nothing to hide; I do nothing harmful. Besides, I'm getting old. How can I hope to create something meaningful without some point of reference, a note of inspiration, and communication?"

It is hard to summarize his work. In some of his sketches from

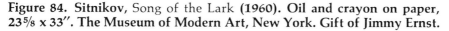

Figure 84. Sitnikov, Song of the Lark **(1960). Oil and crayon on paper, 23⅝ x 33″. The Museum of Modern Art, New York. Gift of Jimmy Ernst.**

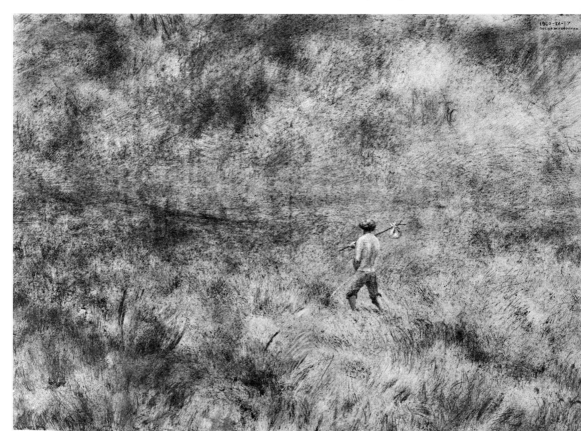

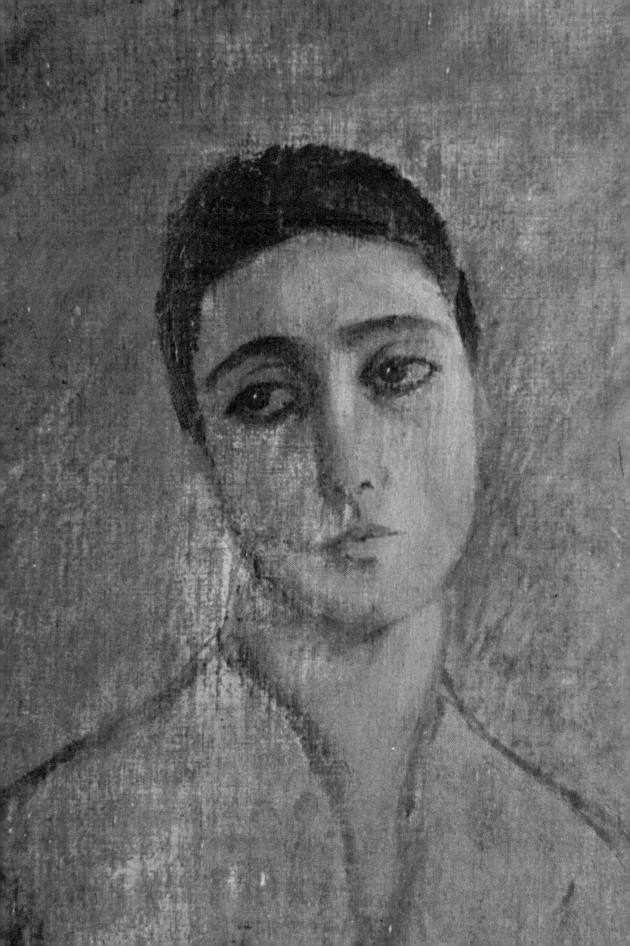

early periods the lack of formal artistic training and solid technical background is discernible. However, all his work possesses an emotional and personal touch and a pantheistic appreciation of life. His genius stands out particularly because he reflects an existing side of the contemporary Soviet *Zeitgeist* which was also a part of the Soviet reality of thirty years ago — the Tiffany lamp, the commode with an oval mirror, and the *muzhik* (peasant) with the cart. Despite the sputniks, subway, and atomic plants, all these images are as valid in the Soviet Union today, especially in the old parts of the cities and provinces, as they were then.

Figure 86. Sitnikov, Inmate. Pencil.

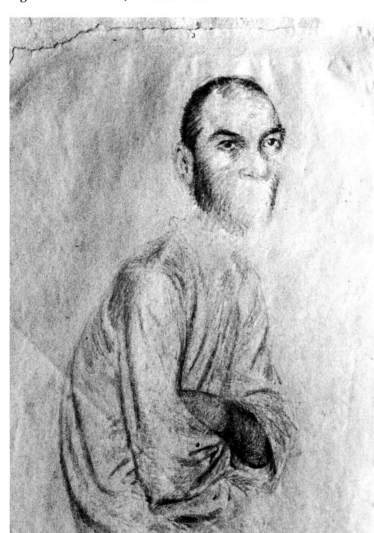

**Figure 85.
Sitnikov, Untitled.
Oil on canvas.**

It is difficult to place the work of the social outcasts in any one category; not all are "fantasts" but the bond between them is a harsh environment which produces their differing routes of fantasy. In the case of Kharitonov, it is a direct escape into the fairy-tale world of the *skazka*; in Vladimir Yakovlev, we see in the portrayal of a realistic flower a symbol of his flight; while in Vasily Sitnikov, there is wry humor and earthiness.

In our view, these painters lead their unofficial colleagues in style and originality and cannot easily be pigeonholed. It is the melancholy feeling and a personal, introverted vision which makes them similar. It is neither the technique nor the subject, but the feeling of flight into another world which one finds different in their works. They are not surrealists in the accepted sense, but a sense of displacement haunts their canvases; there is an absence of any mention of the society in which they live. The savage wit of surrealism is completely lacking, although wry humor is not. The fascination with dream images, that is, the view of the surrealist who stands outside the dream arena and chooses those elements which suit his imaginative purpose, is not that of the social outcast. He paints from within the arena of dreams and is a participant in it.

Conclusion

I N RECENT years significant changes have taken place in Soviet art. Unofficial art is slowly altering the organizational structure of official art. The change is sought mainly by the young intelligentsia — students, and young teachers, engineers, lawyers, managers, and other members of the rising professional groups. The old formulas of culture and aesthetics have become empty and useless for them. The young intellectuals have begun acquiring and enjoying works of art and literature which satisfy and nourish their perceptions. Works of unofficial writers are circulated in manuscript form, in addition to the palatable officially published works. It is not unusual to find a library with works in manuscript.

By bringing art down to the level of the masses, the Party has seriously alienated the intelligentsia. Ehrenburg declared succinctly that while "every artist strives to be understood by as many of his contemporaries as possible, this does not mean that all works of art must be perfectly comprehensible to all readers, viewers, or listeners. . . . "[1] Many intellectuals have become indifferent to the hackneyed Party goals, seeking their own forms of expression, setting their own norms and values — including artistic tastes. Why the Party has allowed the intelligentsia this freedom, limited as it is, can perhaps best be explained by the fact that the intelligentsia has limited its influence to its own ranks and for the Party, limited freedom is preferable to open ferment. In this way the Party has thus far kept the intelligentsia from the open dissent which could affect the masses. As long as this can be maintained, the official goals in art will continue to be pursued.

[1] *Sovetskaya Kultura,* March 27, 1956, p. 4.

The functional side of life, however, has begun to play an increasing role in the acceptance of modern art. An important breakthrough, for example, has been made by Soviet architecture — that most visible but worst off of Soviet arts — which has had suddenly to adapt itself to contemporary methods of mass construction, assimilating many new techniques such as pre-cast concrete and standardization of prefabricated materials. The *Moskovsky rayon* (Moscow Region) of Leningrad — a modern housing development — is a case in point. Modern decorative art combines with functional lines of the new buildings and the space-age nomenclature of the streets. Visiting the new apartments on *Prospekt Gagarina* (Gagarin Street, named after the first Soviet cosmonaut), one finds modernistic touches in interior decor, ranging from lampshades to semi-abstract prints, some of which, the tenants claimed, came with the apartments.

The positive role played in the past, for example, by the journal *Dekorativnoe Iskusstvo* (Decorative Art), in its campaign against "bad taste," is commendable and revealing, considering the influence it has exerted in introducing decorative art, and criticizing style and taste in public buildings, and the successes it has had in influencing industrial design in the past few years. Associating technical progress with modernistic forms, *Decorative Art* has taken valiant steps in introducing modern art for public use and acceptance.

A relationship between modern science and contemporary art has been keenly recognized by some members of that most respected profession in the Soviet Union today — the scientists. Several artists whose works are illustrated in these pages claim patronage in the scientific institutes and research centers around Moscow and Leningrad, some works even reaching the scientific communities in Siberia. One price the Party must pay for modern science and technology is the realization that the scientist is a man whose intellect and taste cannot be satisfied with the art of the masses. His reality, the one in which he lives and works, is no longer identical with that of the masses. For his talents he is rewarded with a lucrative life which places him in a separate social and economic class.

It is difficult to describe the unofficial artistic development in present-day Russia and place it in the proper historical perspective.

198

Its origin proceeded from the modern-art movement of the prerevolutionary days but was stifled in the thirty years of the Stalin era which followed. We are now witnessing a sharp curve in the sequence of political events in Russian history. Ironically, the dialectic has given birth to a new class phenomenon with the rise of the intelligentsia, and the professional and technocratic elites. The dictatorship in the name of the proletariat is weakening. With the rise of classes, a reassertion of the individual is gradually emerging in Soviet society. With this has come a new identity and security in life. The contrived "reality" imposed by coercion is disintegrating under the pressure of time. The absolutism of old standards has already been challenged successfully in major streams of Soviet life by new principles and ideas. The rate with which this has taken place in recent years indicates the growing sophistication and maturity of the individual and the nation.

Unofficial art in the Soviet Union is a creative expression with no definite direction, following no single school or specific style. It is a manifestation of individualism versus collective socialist realism. There are certain groupings along socioeconomic and aesthetic lines. However, the only common denominator uniting this movement is its search for individual expression outside the official creative doctrine. There are a few successful unofficial artists partly recognized by officialdom, such as Rabin and Glazunov. The artists of the Belyutin circle are employed by the state and are socially acceptable, but produce unofficial art in their free time. The third group, exemplified by Yakovlev, is ostracized by the state. Their work expresses personal isolation.

Aesthetically, few are continuing in the steps of Goncharova, Malevich, Larionov, and other masters of that great artistic vitality of forty years ago. Yakovlev's and Sitnikov's portraits show influences of German expressionism. Yershov's and Kharitonov's fairy-tale pictures are reminiscent of the pretty paintings and book illustrations of the World of Art circle of painters. The Belyutin group is influenced by various contemporary Western movements, predominantly by abstract expressionism. Finally, Glazunov and others are reaching back into the national heritage for traditional elements.

199

But few traces are left in Russia today of the opulent tradition of the World of Art painters — people like Golovin, Korovin, Bakst, Benois, Dobuzhinsky — who worked in the rich tradition of Russian theater. The over-all impression the unofficial artists impart is that of artistic naiveté, lack of sound training, and limited knowledge of contemporary art abroad. Unofficial art should be seen as a platform which may support a renaissance in Russian art. It is not a modern art movement as we understand the meaning of the phrase — rather, it is a part of the new mood which is gripping the entire society of the U.S.S.R.

Soviet totalitarianism has changed in recent years. It has become less coercive, more tolerant, and at times even disposed to sweeping changes. The difference between the poets of Stalinism and of the post-Stalin period was summed up by Yevtushenko who told a French journalist: "They ended up in Siberia, and I started there."[2] Since Stalin's death, liberalization of Soviet life in general, and the arts in particular, has vacillated, yet over-all freedoms have been gained and kept. Meanwhile, a qualitative change in the creative sphere has gradually taken place. Contacts with the West have brought exciting new ideas to intellectuals. The abandonment of terror tactics and the grosser forms of coercion by the government has made it possible for officially disapproved forms of expression in art, literature, music, and even ideas, to exist, and, in some cases, to flourish. When Soviet officials now attempt to control the arts, they face a more mature, sophisticated, and powerful creative intelligentsia than at any time in at least three decades.

Now the creative intelligentsia has a powerful following, whether Yevtushenko's poetry readings or Glazunov's official one-man shows are offered. It becomes harder for the Party to reverse the trend of liberalization and reinstitute the political coercion of the past. Of course, it can always enforce its will, but only at a price — the price of reverting to cruder forms of repression which might well rend the whole fabric of the Soviet society.

In recent years, the liberalization in the arts has continued at a

[2] Yevtushenko lived in Siberia during the war. For this comment, see *Politika,* Belgrade, August 26, 1965, p. 10.

rate determined by two factors: first, the plan to ease controls through the familiar process of careful decisions taken by the top of the power hierarchy; second, increasing pressures exerted on the Party from below by the artists' natural tendency to seek more functional autonomy. It is difficult to estimate exactly how much the slower rate of the former is compromised by the more rapid rate desired by the latter.

However, there has been an increasing tendency on the part of some impatient members of the creative community, particularly among the young intelligentsia, to gain their freedom directly. They would bypass the usual methods -- measures taken by the top Party hierarchy to ease control over the totalitarian society. The professed cultural setback after the Twenty-third Congress, initiated with the sensational pre-Congress Sinyavsky-Daniel trial,[3] served as a check on those who seek freedom beyond the limits of official liberalization. Sholokhov declared at the Congress: "The gaining of Soviet authority came to us at a price too expensive to let smear and slander go unpunished."[4] The ruling elite cannot abruptly and easily abandon what it calls "correct Party positions." The Twenty-third Congress reaffirmed the accepted mode of liberalization and denounced the anonymous publication of anti-Soviet works abroad as giving "ammunition to reactionary propaganda." Indeed, the publication of "illegal" literature smuggled abroad has become of great consequence to the regime in recent years, as it is used effectively by Western propagandists in the ideological confrontation with the Soviet Union. Soviet propagandists have found it difficult to cope with the increasing volume of these works. The ever more daring publication of borderline works at home has increased also. Admitting the growing alienation of the in-

[3] Soviet literary critic Andrey Sinyavsky was sentenced to seven years and writer Yuli Daniel to five years for smuggling "slanderous" unofficial manuscripts abroad. Sinyavsky and Daniel pleaded not guilty pointing out that characters created by an author are independent of the author's morality. A letter sent to the *London Times* on January 31, 1966, signed by forty-nine men of letters from the West (among them many Nobel Prize winners) protested the trial. The letter supported the defendants and pleaded that their work be judged "solely on its literary and artistic merits," acclaiming their books as "notable contributions to contemporary writing." See Leopold Labedz, "The Trial in Moscow," *Encounter,* April, 1966, pp. 82–91.

[4] *Pravda*, April 2, 1966, p. 5.

telligentsia, several speakers at the Party Congress showed concern over the harmful influence of Western propaganda. Minister of Culture Yekaterina Furtseva complained:

Reactionary propaganda is making savage attacks on socialist culture, on the principles of *narodnost* and *partynost* in art, attempting to defame the productions of socialist realism. These are not isolated attacks but a part of a general ideological offensive, which is being undertaken by the forces of imperialism, in the first place by the United States of America, against our country, against all great countries of the Socialist concord. Under such conditions we need not defend our positions, limiting ourselves to the different attacks. Sometimes, unfortunately, there is a place for that. We must go forward. And we have something to go forward with. Soviet culture is rich and diverse! We are not afraid of open confrontation with the ideological enemy.[5]

Such commentary at the Congress seemed to signal a return to a tougher policy on the cultural front. However, one familiar point was raised: "If this or that artist makes a mistake, our task is to air it out in time and help to correct it. It is also very important that criticism be convincing, principled, and necessarily good-willed."[6] And while Sholokhov reminded the Congress audience that if the accused had been tried in the twenties, when the "revolutionary code of law" prevailed, their fate would have been otherwise, this does not mean a "return to Stalinism." Rather, it demonstrates how tolerant the Soviet system has become of such manifestations in the post-Stalin period. Interestingly, Sholokhov showed more concern for the strength of those supporting the "slanderers of the Motherland" than the slanderers themselves whom he called "amoral." By now there are many documented cases of intervention in the form of personal and collective letters of protest by the official creative community interceding in behalf of the more outspoken members of their community. No doubt these people came to the defense of Sinyavsky and Daniel, this time with overwhelming support from the Communist parties abroad.[7]

[5] *Ibid.*, April 7, 1966, p. 4.

[6] *Ibid.*

[7] After ignoring the protests of the Western Communist parties for several months, a *Pravda* editorial of February 22, 1966, mildly reacted: "The campaign

Conclusion

Cultural developments in the post-Stalin period permit one broad assumption: as the pressures have developed toward gradualism, with the easing of political control over the totalitarian society, Party dogma has increasingly been carrying lighter weight in policy-making decisions. Clearly, both the Party doctrines and authority must change or lose their power. It is to be hoped that the Russian creative genius, so evident in the technological sciences, will one day flourish in the arts as well. As Andrei Voznessensky has said of the artists:

> You were immured in walls, burned on stakes,
> Monks, like ants, danced on your bones.
>
> But art has always been reborn
> From execution and torture and has been sparked anew.[8]

organized on an unprecedented scale in the West in the defense of the two subversive agents in literature has misled some honest people. . . . Some progressive representatives in the West got alarmed" — needlessly, the editorial stressed, because the handling of the whole affair only affirms the "democratization of Soviet development. . . . We believe that we will be understood by all those to whom the work of democracy and socialism is dear." See Kevin Devlin, "Echoes of the Tertz Affair," *The New Leader,* March 28, 1966, pp. 17–18.

[8] Andrei Voznessensky, *Mozaika* (Vladimir, 1960), p. 62.

Bibliography

This bibliography lists primarily sources used in the preparation of the text, but some additional reading is included. It is not a comprehensive list of sources relevant to the study of Soviet art. Most articles, pamphlets, and exhibition catalogs mentioned in the text are not listed in the bibliography, but appear in the footnotes fully documented.

In Russian

Alpatov, M. *Andrei Rublev.* Moscow, Iskusstvo, 1959.

Anatonova, V. I. and N. E. Mneva. *Katalog drevnerusskoi zhivopisi* [Catalog of Old Russian Painting]. Moscow, Iskusstvo, 1963, 2 vols.

Baskin, M. P. (ed.). *Protiv sovremennovo abstraktsionisma i formalizma* [Against Contemporary Abstractionism and Formalism]. Moscow, 1964.

Benua, A. *Istoria russkoi zhivopisi 1917–1933* [History of Russian Painting, 1917–1933]. Moscow, 1933.

————. *Vozniknovenie "Mira Iskusstva"* [Rise of "World Art]. Leningrad, 1938.

Bulgakov, M. *Istoria russkoi tserkvi* [History of the Russian Church]. Ann Arbor, Michigan, 1963, 12 vols.

Demosfenova, G. and A. Nurok and N. Schatyko. *Sovetsky politichesky plakat* [The Soviet Political Poster]. Iskusstvo, Moscow, 1962.

Dneprov, V. *Problemy realizma* [Problems of Realism]. Leningrad, Sovetsky Pisatel, 1960.

Ehrenburg, Ilya. *Lyudi, gody, zhizn* [People, Years, Life]. Moscow, Sovetsky Pisatel, 1961.

Florovsky, G. *Puti russkovo bogoslovia* [The Roads of Russian Theology]. Paris, 1937.

Futurizm: Marinetti. [Futurism: Marinetti]. St. Petersburg, 1914.

Gerasimov, A. M. *Za sotsialistichesky realizm: Sbornik statei i dokladov* [For Socialist Realism: Collection of Articles and Speeches]. Moscow, Academia Khudozhestv SSSR, 1952.

Gosudarstvenny Russky Muzei: Zhivopisi [State Russian Museum]: Painting]. Moscow-Leningrad,Iskusstvo,1963.

Grafika XVIII–XX vekov [Eighteenth–Nineteenth Century Graphics]. Moscow, Iskusstvo, 1958.

Istoria kultury drevnei Rusi [Cultural History of Old Russia]. Moscow-Leningrad, Akademia Nauk SSSR, 1951–1952, 2 vols.

Istoria russkovo iskusstva [History of Russian Art]. Moscow, Akademia Khudozhestv SSSR, 1957, 12 vols.

Istoria russkovo ikusstva [History of Russian Art]. Moscow, Akademia Khudozhestv SSSR, 1960, 3 vols.

Izmailova, T. and M. Aivazyan. *Iskusstvo Armenii* [Art of Armenia]. Moscow, Iskusstvo, 1962.

Kemenov, V. *Protiv abstraktsionisma: V sporakh o realizme* [Against Abstractionism: In Debates on Realism]. Leningrad, Khudozhnik RSFSR, 1963.

Kratky slovar po estetike [Concise Dictionary of Aesthetics]. Moscow, Izdatpolitlit, 1963.

Kratky slovar terminov izobrazitelnovo iskusstva [Concise Dictionary of Fine Art Terms]. Moscow, Akademia Khudozhestv SSSR, 1959.

Khrushchev, N. *Otchetny doklad Tsentralnogo Komiteta Kommunisticheskoi partii Sovetskovo Soyuza XX syezdu partii 14 fevralya 1956 goda* [Opening Address to the Central Committee of the Communist Party of the Soviet Union at the Twentieth Session of February 14, 1956]. Moscow, 1956.

————. *Za tesnuyu svyaz literatury i iskusstva s zhiznyu naroda* [For a Close Tie of Literature and Art with the Life of the People]. Leningrad, 1957.

Lazarev, V. *Iskusstvo Novgoroda* [The Art of Novgorod]. Moscow, 1947. 2 vols.

————. *Andrei Rublev*. Moscow, 1960. Summary and legends also given in English, French, and German.

Lebedev, A. K. *Iskusstvo v okovakh: Kritika noveishikh techeny v sovremennom burzhuaznom izobrazitelnom iskusstve* [Art in Bondage: Criticism of the New Movements in Contemporary Bourgeois Fine Art]. Moscow, Akademia Khudozhestv SSSR, 1962.

Lenin, V. I. *Polnoe Sobranie Sochinenii* [Collected Works]. Moscow, Gospolitizdat, 1959, 5th ed.

Lifshits, Mikhail (ed.). *Lenin o kulture i iskusstve* [Lenin on Culture and

Art]. Moscow, Izogiz, 1938.

—————. *K. Marks-F. Engels ob iskusstve* [K. Marx-F. Engels on Art]. Moscow-Leningrad, Iskusstvo, 1938.

Manifesty italianskovo futurizma [Manifestos of Italian Futurism]. Moscow, 1914.

Materialy pervovo vsesoyuznovo sezda sovetskikh khudozhnikov [Materials of the First All-Union Congress of Soviet Artists]. Moscow, Sovetsky Khudozhnik, 1958.

Mochalov, L. V. *Khudozhnik, kartina, zritel: Besedy o zhivopisi* [Artist, Picture, Viewer: Conversations on Painting]. Leningrad, Khudozhnik RSFSR, 1963.

Naumov, V. P. *Za ideinost literatury i iskusstva* [For Ideological Content in Literature and Art]. Moscow, 1963.

Nikoforov, B. M. *Zhivopis* [Painting]. Moscow-Leningrad, Iskusstvo, 1948.

O partiinoi i sovetskoi pechati. Sbornik dokumentov [On Party and Soviet Press: Collection of Documents]. Moscow, 1954.

Paustovsky, Konstantin. *Tarusskie stranitsy* [Pages From Tarusa]. Kaluga, 1961.

Pavlov, Todor. *Pytanya teorii ta istorii literatury* [Questions of Theory in History of Literature]. Kiev, 1959.

Pervy vseseoyuzny syezd sovetskikh pisatelei: Stenograﬁchesky otcyot [First Congress of Soviet Writers; Stenographic Report]. Moscow, 1934.

Plekhanov, G. V. *Sochinenia* [Collected Works]. Ryazanov, D. (ed). Moscow, 1923–1927.

Polonsky, V. *Russky revolyutsionny plakat* [Russian Revolutionary Poster]. Moscow, 1925.

Problemy sotsialisticheskovo realizma [Problems of Socialist Realism]. Moscow, Sovetsky Pisatel, 1961.

Razumny, V. *Problemy sotsialisticheskovo realizma* [Problems of Socialist Realism]. Moscow, Sovetsky Khudozhnik, 1963.

Russkaya peisazhnaya zhivopis [Russian Landscape Painting]. Moscow, Iskusstvo, 1962.

Sidorov, A. A., *Russkaya graﬁka za gody revolyutsii, 1917–1922* [Russian Graphics During the Revolutionary Days, 1917–1922]. Moscow, 1923.

Stalin, Yosif V. *Sochinenia* [Collected Works]. Moscow, Gospolitizdat, 1951, 13 vols.

Stoikov, Atanas. *Kritika abstraktnovo iskusstva i evo teory* [Criticism of Abstract Art and Its Theories]. Moscow, Iskusstvo, 1964.

Sutyagin, A. (ed). *Osnovy marksistko-leninskoi estetiki* [Basis of Marxist-Leninist Aesthetics]. Moscow, 1960.

Tolstoi, V. *Sovetskaya monumentalnaya zhivopis* [Soviet Monumental Painting]. Moscow, Iskusstvo, 1958.

Trety vsesoyuzny syezd sovetskikh pisatelei: Stenografichesky otcyot [Third All-Union Congress of Soviet Writers: Stenographic Report]. Moscow, 1959.

Trifonova, T. K. *Istoria sovetskoi literatury* [History of Russian Literature]. Moscow, Akademia Nauk SSSR, 1961, 3 vols.

Trofimov, P. S. *Estetika marksizma-leninizma* [Aesthetics of Marxism-Leninism]. Moscow, Sovetsky Khudozhnik, 1964.

Voprosy kultury po diktature proletariata [Questions of Culture During the Dictatorship of the Proletariat]. Moscow-Leningrad, 1925.

Voznessensky, Andrei. *Mozaika* [Mosaics]. Vladimir, 1960.

Vtoroi vsesoyunzy syezd sovetskikh pisatelei: Stenografichesky otcyot [Second All-Union Congress of Soviet Writers: Stenographic Report]. Moscow, 1956.

Yudin, P. F. (ed.). *Literaturnoe nasledie G. V. Plekhanova* [Literary Heritage of G. V. Plekhanov]. Moscow, 1934–1939, III.

Zimenko, V. M. *Sovetskaya portretnaya zhivopis* [Soviet Portrait Painting]. Moscow, Iskusstvo, 1951.

Zotov, A. I. and O. I. Sopotsinsky. *Russkoe iskusstvo: Istorichesky ocherk* [Russian Art: A Historical Sketch]. Moscow, Akademia Khudozhestv SSSR, 1963.

Soviet Newspapers and Journals
(published in Moscow or Leningrad)

Bolshevik

Dekorativnoe Iskusstvo [Decorative Art]

Iskusstvo [Art]

Izvestia

Kommunist

Komsomolskaya Pravda [Komsomol (youth organization) Truth]

Leningrad

Literaturnaya Gazeta [Literary Gazette]

Literaturnaya Moskva [Literary Moscow]

Literatura i Zhizn [Literature and Life]

Novy Mir [New World]

Oktyabr [October]

Pravda

Sovetskaya Kultura [Soviet Culture]

Sovetskaya Yustitsia [Soviet Justice]

Teatr [Theater]

Tvorchestvo [Creativity]

Vechernyaya Moskva [Evening Moscow]

Voprosi Filosofii [Questions of Philosophy]

Yunost [Youth]

Znamya [Banner]

Zvezda [Star]

In English

Alpatov, M. *Russian Impact on Art.* New York, 1950.

Bauer, Raymond A. *The New Man in Soviet Psychology.* Cambridge, Mass., 1952.

Billington, James H. *The Icon and the Axe: An Interpretive History of Russian Culture.* New York, Knopf, 1966.

Black, Cyril E. (ed.). *The Transformation of the Soviet Society.* Cambridge, Harvard University Press, 1960.

Blake, Patricia and Max Hayward. *Dissonant Voices in Soviet Literature.* New York, Pantheon Books, 1962.

Borland, H. *Soviet Literary Theory and Practice During the First Five-Year Plan.* New York, King's Crown Press, 1950.

Brinton, Crane. *The Anatomy of Revolution.* New York, Vintage Books, 1965.

Brown, Edward J. *The Proletarian Episode in Russian Literature, 1928–1932.* New York, Columbia University Press, 1953.

Brzezinski, Zbigniew K. *The Permanent Purge.* Cambridge, Harvard University Press, 1956.

Bunt, C. G. E. *Russian Art from Scyths to Soviets.* London, 1946.

Carter, Huntley. *The New Spirit in the Russian Theatre, 1917–1928.* London, New York, Paris, 1929.

Chen, Jack. *Soviet Art and Artists.* London, Pilot Press, 1944.

Chernyshevsky, N. G. *Selected Philosophical Essays.* Moscow, Foreign Language Publishing House, 1953.

Crankshaw, Edward. *Khrushchev's Russia.* Baltimore, Penguin, 1959.

Deutscher, Isaac. *Stalin: A Political Biography.* New York, Oxford University Press, 1963.

Djilas, Milovan. *The New Class: An Analysis of the Communist System.* New York, Praeger, 1957.

Dudintsev, Vladimir. *Not by Bread Alone.* New York, Dutton, 1956.

Dumbarton Oaks Papers. Cambridge, Harvard University Press, 1953–54, Nos. 7 and 8.

Erlich, Vitor. *Russian Formalism: History, Doctrine.* S'Gravenhage, Mouton, 1955.

Ermolaev, Herman. *Soviet Literary Theories 1917–1934: The Genesis of Socialist Realism.* Berkeley and Los Angeles, University of California Press, 1963.

Fainsod, Merle. *How Russia is Ruled.* Cambridge, Mass., Harvard University Press, 1963.

Fedotov, G. P. *The Russian Religious Mind.* Cambridge, Harvard University Press, 1966, 2 vol.

Fischer, George. *Russian Liberalism.* Cambridge, Harvard University Press, 1958.

Fischer, Louis. *The Life of Lenin.* New York, Evanston, and London, Harper and Row, 1964.

Gabo: Constructions, Sculpture, Paintings, Drawings, Engravings. Cambridge, Mass., Harvard University Press, 1957.

Gabo, Naum, J. L. Martin, *et al. Circle: International Survey of Constructive Art.* London, Faber and Faber, 1937.

Garthoff, Raymond. *Soviet Military Policy: A Historical Analysis.* New York, Praeger, 1966.

Gibian, George. *Interval of Freedom — Soviet Literature During the Thaw.* Minneapolis, University of Minnesota Press, 1960.

Gorky, Maxim. *Mother.* New York, Collier Books, 1962.

Gray, Camilla. *The Great Experiment: Russian Art 1863–1922.* New York, Harry N. Abrams, 1962.

Guerney, Bernard (ed. and trans.). *An Anthology of Russian Literature from Gorky to Pasternak.* New York, Vintage Books, 1960.

Hamilton, G. H. *The Art and Architecture of Russia.* London, 1945.

Hauser, Arnold. *The Social History of Art.* New York, Vintage Books, 1951, 4 vol.

Johnson, Priscilla and Leopold Labedz. *Khrushchev and the Arts: The Politics of Soviet Culture, 1962–1964.* Cambridge, The M.I.T. Press, 1965.

Kassof, Allen. *The Soviet Youth Program: Regimentation and Rebellion.* Cambridge, Harvard University Press, 1965.

Katayev, Valentin. *Time Forward.* New York, Farrar and Rinehart, 1933.

Kirk, Russell. *The Death of Art: Ehrenburg's Thaw.* Chicago, Regnery, 1955.

Kloomok, I. *Marc Chagall: His Life and Work.* New York, 1951.

Kohn, H. *The Mind of Modern Russia.* New York, 1962.

Kondakov, N. *The Russian Icon.* Oxford, 1927.

Lehmann-Haupt, Hellmut. *Art Under a Dictatorship.* New York, Oxford University Press, 1954.

London, Kurt. *The Seven Soviet Arts.* New Haven, Yale University Press, 1938.

Ludwig Feuerbach and the Outcome of Classical Philosophy. New York, International Publishers, 1935.

Lukomsky, G. K. *History of Modern Russian Painting, 1840–1940.* London, Hutchinson, 1945.

Magarshack, D. (ed.). *Stanislavsky on the Art of the Stage.* London, 1950.

Malevich, Kasimir. Exhibition catalogue. Whitechapel Art Gallery, London, 1959. Introd. by Camilla Gray.

Marx, Karl and Frederick Engels. *The German Ideology.* R. Pascal, (ed). New York, International Publishers, 1947.

Marx and Engels. Literature and Art: Selections From Their Writings. New York, International Publishers, 1947.

Merton, Robert K. *Social Theory and Social Structure.* Glencoe, The Free Press, 1949.

Miliukov, Paul. *Outlines of Russian Culture.* New York, Barnes, (Perpetua Ed.), 1960, 3 vols.

Miłosz, Czesław. *The Captive Mind.* New York, Vintage Books, 1953.

Mirsky, D. S. *A History of Russian Literature.* New York, Knopf, 1960.

Olson, Ruth and Abraham Chanin. *Naum Gabo; Antoine Pevsner.* New York, Museum of Modern Art, 1948.

Panova, Vera. *Span of the Year.* London, Harvill Press, 1957. Referred to in the text as *The Seasons.*

Piper, Richard (ed.). *The Russian Intelligentsia.* New York, Columbia University Press, 1961.

Pasternak, Boris. *Doctor Zhivago.* New York, Pantheon, 1958.

Read, Herbert. *The Philosophy of Modern Art.* Horizon Press, New York, 1953.

Riasanovsky, Nicholas V. *A History of Russia.* New York, Oxford University Press, 1963.

Rice, Tamara Talbot. *A Concise History of Russian Art*. New York, Praeger, 1963.

Rosenberg, Harold. *The Tradition of the New*. New York, McGraw Hill, 1960.

Simmons, Ernest J. (ed.). *Continuity and Change in Russian and Soviet Thought*. Cambridge, Harvard University Press, 1955.

————. *Through the Glass of Soviet Literature: Views of Russian Society*. New York, Columbia University Press, 1954.

Slonim, Marc. *Soviet Russian Literature: Writers and Problems*. New York, Oxford University Press, 1964.

Solzhenitsyn, Alexander. *One Day in the Life of Ivan Denisovich*. New York, Dutton, 1963.

Struve, Gleb. *Soviet Russian Literature, 1917–1950*. Norman, University of Oklahoma Press, 1951.

Swayze, Harold. *Political Control of Literature in USSR, 1946–1959*. Cambridge, Mass., Harvard University Press, 1962.

Tarsis, Valeriy. *Ward 7: An Autobiographical Novel*. New York, Dutton, 1965.

Terz, Abram. *On Socialist Realism*. New York, Pantheon, 1960.

Tompkins, Stuart Ramsey. *The Russian Intelligentsia*. Norman, University of Oklahoma Press, 1957.

Trotsky, Leon. *Literature and Revolution*. Ann Arbor, Michigan University Press, 1960.

Uspensky, L. and V. Lossky. *The Meaning of Icons*. Boston, 1952.

Vernandsky, George. *A History of Russia*. New Haven and London, Yale University Press, 1964, 4 vol.

Wolfe, Bertram D. *Khrushchev and Stalin's Ghost*. New York, Praeger, 1957.

Yevtushenko, Yevgeni. *Precocious Autobiography*. New York, Dutton, 1963.

Zenkovsky, V. *A History of Russian Philosophy*. New York, 1953.

Zinner, Paul E. (ed.). *National Communism and Popular Revolt in Eastern Europe*. New York, Columbia University Press, 1957.

Western Newspapers and Journals

Encounter (London)

Grani (Munich; in Russian)

Journal of Aesthetics and Art Criticism (Cleveland, Ohio)

Bibliography

Le Monde (Paris)
Les Lettres Françaises (Paris)
Times (London)
Ruskaya mysl (Paris; in Russian)
Saturday Review (New York)
Slavic Review (Baltimore)
Sunday Telegraph (London)
Sunday Times (London)
Survey (London)
New Leader (New York)
New York Times
Russian Review (New Haven)